Slowly I'm swallowed by the shadows that grow in the cold evening. Without light bulbs, the only light in the house comes from our telly in the front room. I climb into my cot bed and curl into myself in order to hide from danger. I lick my teardrops as they roll down my face and miss my mummy.

'The best book we have ever read.' **Gilbert & George**

'One of the most moving accounts of non-fiction ever written. Powerful and beautiful, this elegant and heartbreaking memoir immediately brings to mind *Shuggie Bain*.' *Guardian*

'What a brave and powerful story. If you like *Shuggie Bain* then *Slum Boy* is for you. When I read his story I thought "how can any child survive this?" But he did.' **Lemn Sissay**

'Juano Diaz writes with great beauty... A heart-breaking and inspiring read.' **Alan Cumming**

'A powerful and at times harrowing memoir. *Slum Boy* is a remarkable and moving tale of survival.' *Times Literary Supplement*

'This is a heart-breaking story. Beautifully told.' **Andrew O'Hagan**

'Fans of Douglas Stuart and Damian Barr will pounce on this startling debut. It's compulsively readable and Dickensian in its rich cast of Glaswegian characters.' **Patrick Gale**

'An extraordinary survival story.' **Sophie Fiennes**

'The literary debut from Juano Diaz is a tour de force that paints a picture of trauma and triumph.' *Herald*

'I laughed and cried. It's a masterpiece.' **Joey Arias**

'The writing is beautiful.' **Scooter LaForge**

'A heart-rending story that has you constantly holding back tears.' **Dr Pam Hogg**

'A reminder that beautiful things grow and flourish, even in the harshest of places.' **Christie Watson**

JUANO DIAZ'S

SLUM BOY

brazen

February 2025

2

First published in Great Britain in 2024 by Brazen, an imprint of
Octopus Publishing Group Ltd
Carmelite House
50 Victoria Embankment
London EC4Y 0DZ
www.octopusbooks.co.uk

An Hachette UK Company
www.hachette.co.uk

An authorized representative in the EEA is Hachette Ireland, 8 Castlecourt
Centre, Dublin 15, D15 XTP3, Ireland (email: info@hbgi.ie)

First published in paperback in 2025

ISBN 978-1-91424-083-6

A CIP catalogue record for this book is available from the British Library.

Printed and bound in Great Britain.

Typeset in 9.68/15.84pt Farnham Text by Jouve (UK), Milton Keynes.

13 5 7 9 10 8 6 4 2

This FSC® label means that materials used
for the product have been responsibly sourced

Author's note

These recollections are as I remember them, though some names and distinguishing features have been changed to protect identities. The Romany Cant dialect uses spelling presumed from my father's pronunciations.

Content warning: This book includes depictions of self harm and childhood sexual abuse.

'Slum Boy: A Portrait', the title of my memoir, is not meant to be derogatory. It's a reflection of my roots, a testament to the boundless potential that resides in each of us, regardless of where we come from.

In the broader context of society, the term 'slum' is often weighed down with negative connotations. However, in Glasgow it represented much more than a place marked by economic hardship. It was a place of spirit, heart and togetherness. Although my early memories of living with my mother were marked by poverty and addiction, this is not a reflection of everyone who came from these areas. The poorer communities that were labelled as 'slums', in Glasgow, across the United Kingdom and worldwide, have given birth to some of the most interesting, humble and hardworking people I have met. The close-knit community was a source of profound strength. The word 'slum' was not synonymous with despair; it was a canvas upon which the intricate tapestry of life was woven.

As I share my journey from the Glasgow slums, I hope to convey that one's beginnings do not define the entirety of a story. 'Slum Boy' is a title that encapsulates the essence of my early childhood, but it also speaks to the universal message that, regardless of the circumstances we are born into, we all have the power to shape our destinies.

It's important to note that while South Nitshill faced economic difficulties and challenges in the 1980s, it was also a place where people came together, supported one another and created a sense of community. The spirit of resilience and solidarity often characterises neighbourhoods like South Nitshill during challenging times. Over the years, communities like this have evolved, and South Nitshill, in particular, has seen profound changes in its housing and economic landscape.

I'm strong enough (I'm strong enough)
I'm tough enough (I'm tough enough)
I'm full enough, I'm crying my mother's tears
I'm warm enough (She's shed enough)
I've played enough (She's pled enough)
I'm loved enough, I'm crying my mother's tears

—Grace Jones
'I'm crying (Mother's tears)', from *Hurricane*

For Mum

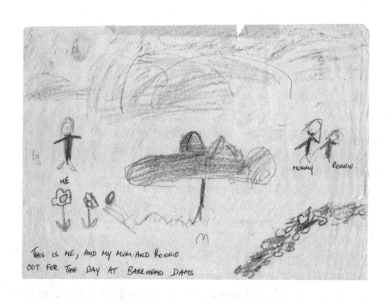

1

Splash!

Daddy Ronnie dives in and I run around the grassy bank with excitement, waiting for him to resurface. It's good to be home again with him and Mummy. I have spent five months living with foster carers and in children's homes because they were too sick from drinking beer to look after me. They did come and visit when they felt better, and each time they left me, it broke my heart. When I settled and grew attached to my new carers, the loss would strike once more when I had to return home to the chaos of the two drunks. The tug back and forth was confusing. But things are better now, they must be because social services have reunited us yet again and a family day out at Barrhead Dams is just what we need.

I wait for Daddy Ronnie, scanning the light that shivers on the surface, the grey sky reflected back.

Rah! he roars, breaking through the dark water, having hidden under it for what seemed an eternity. I let out a roar of delight back as he splashes my entire body. His blond hair glistens, and ribbons of water rush down his shoulders. I'm holding an empty crisp packet like a trophy, tight in my hand. It swells with murky water and tadpoles. Ronnie carefully scooped them out of the shallows for me earlier.

Mummy is sitting on the grass with other men. She is happy, chugging beer and talking loudly, using those big sweary words she loves, 'fucking', 'shit' and 'cunt'.

Ronnie smiles at me as I lean towards him in the water.

You be careful, he sings, holding out his arms in case I slip into the mire.

When he is sure I'm steady on my little legs, he wipes his hands down his face and over his nose, expelling the water out of him before clasping his hands together like he's in prayer.

Look at this, he says, thrusting his strong body through the water on his back, still facing me, his eyes looking deep into mine, as he floats for a second, suspended in the murky expanse.

His shining face contorts as he twists and spins, turning onto his front. His freckled arms push him far into the reservoir. I watch with pride as the water fragments behind his body and he speeds away under a cloud of midges. Ripples pulse towards me on the grass from his movement until I lose every trace of him.

I run back to Mummy, stepping over Daddy Ronnie's jeans, trainers and Celtic football top that lay heaped in the grass like a shed skin. She is performing, playing the fool for the men, her animated arms are mocking them and they love the show. I push the tadpoles into her face and, still laughing, she opens the crisp

2

packet and we peer inside to see the soup of newly emerged tadpoles and frogspawn writhe in a panic in their plastic, shiny prison. A faint pong of salt and vinegar mixed with dirty water rushes up our nostrils and Mummy makes a yuck-face, crinkling up her small round nose and black eyes.

Fuck sake, she says, snapping her head away to dodge the stink. The men laugh harder at her.

When the hilarity settles, she pulls me to the side and, with a roll-up cigarette hanging from her mouth, she lifts me into my buggy and clicks me in with straps. *Time to go home,* she says through the side of her mouth, careful not to drop the precious fag. I'm too big to be riding in a buggy but it's a long way back, plus it helps Mummy balance when she's tipping from beer. I'm getting my shoes pushed onto my feet, the blue ones that my real daddy's sister, Aunt Ellen, had sent from South Africa. I have one shoe on when one of the men jumps up and rushes towards the water. Mummy turns to see what's happening.

Hoi! Ronnie! Ronnie! Ronnie! the man shouts as he runs into the reservoir, cutting the amber-coloured water with his hands and wading out deeper and deeper towards a body bobbing up and down in the spring sun.

It takes Mummy a few seconds to realise what she is looking at. As if her eyes are playing tricks on her, she blinks hard, forcing her drunken gaze to reset. When it does, her expression sobers in an instant and becomes frightening. It's the same face she makes when she is in a rage: a million demons all at once, framed by a now ghostly white complexion.

Naw, naw, get him out! Get him fuckin out! she shrieks.

I slam my hands over my ears, crushing the cold wet crisp packet

into my face. I can feel the tadpoles wriggle against my cheek. The rest of the men leap into the water and start shouting while Mummy runs around in a panic. Back and forward she goes, towards the edge, then back to me.

Mummy! I scream with terror as she falls to her knees in front of me, her head slamming into my lap. I try to grab at her hair with my one free hand, the other still clutching my packet of wiggling jelly, but I miss as she jumps back to her feet and starts running around again. The men pull Ronnie closer and closer to dry land. He is half floating and half submerged. They drag him up onto the bank and lay him flat out. A man slaps his face, trying to wake him.

Ronnie man, Ronnie, Ronnie; come on, Ronnie.

But Ronnie Mckelvie, the man that Mummy made me call Daddy, is gone. She shakes his torso, her pointy yellow nails digging deep into his flesh.

Oh, for fuck sake, somebody get the polis, she pleads, with her face up to the sky for amplification.

A man runs off to find help while another lurches towards me, grabbing my buggy and spinning me around violently in the other direction. I twist and turn, screaming into the bushes that now face me. I tug at the straps that hold me to my seat. I need to see the scene. I need to see that Mummy is safe. I hear the panic, the cries for help, Mummy screaming and the men shouting.

Five months have passed since Ronnie drowned. I have been back and forth between Mummy and the care system so many times, with so many faces, so much confusion, that I have lost count. But

the last few nights have been bliss because I have been staying with my Granny Gormley.

I am peering into the bathtub and resting my chin on the edge.

Good morning, Tinker Bell, I shout at the top of my lungs, trying to activate the slow-moving tortoise that lives here.

Shush, son! Don't shout; you'll scare her, says Granny, kneeling next to me.

Come on, hen, come on. She coaxes the tortoise forward to eat by brushing a limp lettuce leaf around in front of its nose.

Granny's thumb and fingers are a dark yellowy-brown from years of smoking Woodbine cigarettes, almost as dark as Tinker Bell's shell. It's no wonder the tortoise won't eat. I love the pattern on Tink's back, it's all swirly with circles trapped in hexagons. Nibbling on a slice of lettuce myself, I squint up at Granny with a grin. She looks at me and throws her head back, laughing. Her piercing blue eyes twinkle, magnified through her thick brown-rimmed glasses.

Apart from her one manky, tarred smoking hand, Granny is always immaculate and smart. This morning she is wearing a frilly white Victorian-looking gown with a big bright red fluffy feather pinned over her heart. It looks like her heart has ruptured and is spraying blood. Her red hair is fixed in waves like the fancy ladies on telly.

It's breakfast time here in Drumchapel. It's very rare that I'm given breakfast or get time with Granny. I know I won't be here long, so I savour each moment.

Granny scoops me up in her white frilly arms and carries me to her kitchen through swinging pine saloon doors. She sits me on the countertop against the pillar-box-red, gloss-painted cupboard doors. She hands me a red plastic-handled spoon from the cutlery

carousel and shakes cornflakes into a bowl, topped with a splash of milk. As she lifts me down, my face nuzzles into her chest, and her feather tickles my ear. She smells of clean soap and cigarettes.

We move into the living room and Granny pushes Trudy the dog out of our way with her leg. Trudy always nips and bites us.

Git fuckin back, Trudy! Granny spits with venom at the black Border collie.

Fucking back, Trudy! I repeat, mimicking her and flashing my red spoon towards the dog like a sword.

We sit by the fire. On the mantel are her collection of dry pufferfish, sea urchins and corals.

Here, son, you keep that safe for sweeties, she whispers, stuffing a folded pound note into my trouser pocket and patting it with her hand as if to lock it there for ever. I start stuffing my face with the cornflakes. Between mouthfuls, I draw Tinker Bell with a biro in Granny's 1980 Letts diary. A big round shell with a smiling face, four claws and the lettuce. Granny had another tortoise called Sydney (named after Sydney Devine) but he died and it was all my fault because he had eaten some phlegm I had spat out in the garden when I had whooping cough. *That wee bastard killed ma Sydney.*

Granny lives in a council house and it's nice and clean. Outside, all the houses are the same, classic 1950s tenements in endless rows. This is one of the few nice streets in run-down Drumchapel, known to locals as 'The Drum'. Some streets are notorious – overcrowded slums with boarded-up windows – but not Granny's house. To the front, there is a tidy lawned garden, with a chipped gnome standing next to a windmill ornament. Her gas fire warms

us on this grey October morning. Trudy the dog must be cold because she sits right in front of it, roasting herself, one eye on Granny and the other on me.

On the brown dresser behind us are ornaments: a little ceramic lady holding a basket of flowers, a plastic puffin-shaped money box and a big bamboo birdcage with no bird inside. Around these are photos of children.

Where're my sisters? I ask, looking at the smiling school portraits in the grey and gold card frames.

Away in a children's home, Granny says, flicking her cigarette into a seashell ashtray and turning her head from me.

Then there is a knock on the door. Trudy flips out and starts barking. She nips at Granny's heels as she heads to answer it.

Git fuckin back, Trudy. For fuck sake, git in, Granny shouts, balancing a lit cigarette in her mouth and hitting the snarling dog away with a hard kick to the ribs.

I can hear my mummy, Margaret, over the barking dog. I know it's her because Granny starts shouting something about *You left that wee fuckin bastard in there* and *stolen money.* I continue drawing.

This is Tinker Bell's house, I mumble to myself as I draw a big box around the smiling tortoise, keeping her safe in the lines of my biro. *And these are your friends – Mr Pufferfish, Miss Sea Urchin and Shelly Shell the Clam.*

Before I can finish my drawing, or my breakfast, I'm being dragged around the room by Mummy while Trudy barks and nips with fury at us. All of a sudden I'm out in the cold street without a jacket, still clutching the pen. Granny is shouting after us, but I can't hear her exact words, only the sweary ones and 'Mahgrit',

7

not 'Margaret'. This is how Granny and most people from Glasgow pronounce Mummy's name.

I'm being swung from left to right, then I am yanked forward as Mummy staggers away with me.

We step onto a bus that has gasped to a halt in front of us. I'm holding Mummy's hand. It feels dry, cracked and cold. She is shaking and it makes my whole arm quiver and jiggle.

Can I give a name and address please? I've lost my purse, she pleads with the driver.

This is how she pays her fares. 'Name and address' is the Glasgow code for 'I have no money, can you take my details?', a kind of IOU. The driver lets us on, and we sit at the very front, ready to get off first. Mummy pops a Polo mint into my mouth, then rifles my pockets and finds the sweetie money that Granny has hidden there. She crumples it away into her shaking hand without looking at me. I rest my head on her lap and look up at her face. She is looking out the window; her black eyes scan the passing streets with a desperate panic.

I wonder where we are going now. I'm just getting comfy when we are off the bus. I stumble and Mummy drags me by the hand before heaving me back up to my feet. She rushes towards another Strathclyde Transport bus on Argyle Street. I twist my neck to wonder at the impressive red sandstone building that is the Kelvingrove Art Gallery and Museum, but Mummy breaks my frame as we climb onto a number 57 bus. She uses her name and address again, this time with tears, even though she has my pound note crushed tight between our hands.

Please can I give a name and address? I've lost my purse and I need to get my wee boy home for his medicine.

8

But I'm not sick, am I?

I'm not an ambulance, doll, the driver says firmly, cocking his head at her blatant lie, but he takes Mummy's fake details and waves us on.

I slide down in the seat, making my jumper ride up and exposing my bare back to the prickly brown-and-mustard-coloured seat padding. I'm exhausted by her panic. The padding irritates my skin, so I rub my back around on it, making it worse.

Mummy moans at me, *John Mckelvie, sit still; we'll no be long.*

She claws and scrapes at her head as she looks out the window. I watch her lips open and close slightly as if she is whispering a prayer to the River Clyde as we cross Victoria Bridge and go up through the Gorbals. I recognise this route so I close my eyes.

I've got Ronnie's last name, Mckelvie, but my hair is jet black, not red like Mummy's and not blond like Ronnie's, and my skin is olive, not red like Mummy's or white like Ronnie's. My name is John, but Granny has always referred to me as 'the wee bastard'.

The bus swings and wakes me up as we stutter to a halt in South Nitshill, where we get off. South Nitshill is not like Granny Gormley's in Drumchapel or Netherkirkton Children's Home, where I lived for a few weeks with my two older sisters, Hannah and Colette, before they disappeared, or Granny McCall's foster home in East Kilbride.

South Nitshill is a slum and it's where I lived with Mummy and Ronnie, when he was around, which wasn't very often, and when he was, he was always blind drunk.

We walk down the street towards our block. Some of the houses are boarded up completely with dull yellowing fibreglass panels,

some with metal grates. Some are burned out and missing roofs, making the perfect home for pigeons to roost. The communal lights in most of the buildings are smashed or missing and they have become urban caves where gang members lurk. The streets are littered with broken glass and rubbish, and the yellow plastic bins that were once strapped to the broken lamp posts are burned down into runny egg yolks. Some kids have lit a bonfire by burning a car tyre in the street. The acrid smell of burning rubber fills the black air around us. All the buildings are covered in graffiti by different local gang members. *Here be dragons* is scrawled a few doors away from our close; further on it reads, *Davy Mullen is a grass.*

Mummy marches us into our close past the words *Maureen is a slag,* painted in red nail polish next to a door. Our front door has footprints all over it and wood is nailed over a hole that has been kicked into it. The sounds of the boys playing echo around us and the smells of burning rubber and urine start to make me feel sick.

Mummy opens the door. The house is silent, empty and cold. The stink of dampness in our house is permanent, like wet clothes that have been left to rot, but we have none, only the clothes we are wearing. In our living room, Mummy switches on the telly. Ronnie stole it from another house when we were first given this place by the council; it's all we have left of him. I settle down to watch *Words and Pictures*; it's the magic pencil, and the letter is T.

Top to bottom then across, top to bottom then across. The magic pencil draws the shape of a small t, which looks just like the woven palm crucifix above our gas fireplace, the only decorative item we have.

Mummy disappears into the kitchen and returns with a bowl of jelly melted in boiled water, like a sweet red soup. It's my staple

at home. Sometimes I get a boiled egg, too. Folding into the only armchair we have, she dips her fingers into an overflowing ashtray and dusts the black ash from half a roll-up cigarette dowt. I sit at her feet and slurp up the raspberry-flavoured liquid. I look at her between glances at the telly; I need to see her face, feel out her mood and know what's coming next. With a flash from a match, Mummy drags the flame into her roll-up and blows a big cloud around us. She stares right through me as if hypnotised by the Aniform puppet named 'Charlie', who is jumping around and teaching me about the word tomorrow. *Tomorrow, capital T. Tomorrow is the day after today,* Charlie says from the telly.

Mummy scrapes and picks at her head. My nits got combed out by Granny; it was the first thing she did when I got dropped off a few days ago. I was totally scrubbed clean with Prioderm lotion, killing every egg that lived on me, and my clothes were boiled to kill anything else that lived in them. But Mummy must still be crawling, and it will not be long before I'm reinfested.

Is that nice? She gives a beautiful smile, finally noticing me.

I nod my head and the delicious runny jelly dribbles down my chin. I tip the bowl right up, getting every last jewel of syrupy goodness. When I look back up at her she is putting on her jacket and her smile is replaced by a trembling thirsty mouth.

I'm going to the shops; don't you move fae here. Before I can plead with her to take me with her, she walks out of the house, leaving me sitting alone with *Words and Pictures*.

I go to the window and watch her bolt down Woodfoot Road, a trail of black smoke floating behind her from the burning tyre. She hugs her jacket around her chest with her hands. Her bare legs

topped by a mustard-coloured corduroy miniskirt march at speed. Passing all the chaos and debris outside, she disappears into the distance. I glance at a Stork margarine tub sitting on the window ledge. It once housed my many wriggling tadpoles, but the water evaporated months ago, and the little black creatures dried up before they had a chance to morph into frogs. They now lie infused into the bottom of the plastic tub like crispy little raisins. The window ledge has hundreds of flies that died trying to escape. I push them around with my finger as I wait for Mummy to reappear with real food.

Hours pass and the prize board is being announced on *Bullseye*, blasting through the telly.

In One: You'll soon get the picture and enjoy it on this colour TV. In Two: Sparkling craftsmanship in these crystal whisky glasses and decanter. In Three: Never miss a call with this handy telephone. In Four: Get your coffee hot with this luxury coffee maker. In Five: A truly timeless prize with these matching his and hers watches. In Six: You will be the centre of attention with this midi music centre. In Seven: Something you will warm to with this electric duvet. In Eight: Be a cut above the rest with this handy lawnmower. And here's Bully's special prize. Escape the cold winter nights with this luxury trip for two to Malta. Enjoy seven days soaking up the sun.

There is no sun, and it is getting darker as I play alone in the cold house, with only the darts keeping me company.

I go to my bedroom, where the walls are stained with dirt and long strips of black mould that look like tall shadow beings. My bedroom window is broken, and outside the backcourt is full of rubbish bags, dumped carpets and waste. The overgrown weeds – which are taller than me – have crept into my room through the smashed windowpane. In the corner of the room, I have a cream-coloured cot bed that has a

blue cartoon lamb with a big pink bow around its neck and a happy face frozen onto the chipped headboard. The only toy is an old-fashioned painted doll's house which belonged to one of my sisters.

Slowly I'm swallowed by the shadows that grow in the cold evening. Without light bulbs, the only light in the house comes from our telly in the front room. I climb into my cot bed and curl into myself in order to hide from danger. I lick my teardrops as they roll down my face and miss my mummy.

The morning light wakes me, and I run through to Mummy's room; her mattress is empty and there are no sheets on it. I walk through our home calling for her, but she hasn't returned.

I drag a stool around the cold concrete kitchen floor and climb up to look in the wooden cupboards, but they are bare. The kitchen does not have a fridge. Some of the cupboard doors are missing and others hang by their hinges like injured bird wings.

I go from room to room in search of something to eat, occasionally stopping at the window whenever I hear people pass, just in case it's her returning. I pause for a moment in front of the telly to catch a moment of Zippy, George and Bungle on *Rainbow*. I love George's long pink eyelashes and soft nature. Geoffrey has a little cat on his lap and is showing the gang how to stroke it.

I don't like cats! I like dogs, and you don't stroke dogs, you pat them on the head like this, says cheeky Zippy as he shows us how to pat a dog by patting George on the head.

I wonder if Zippy would like Granny's dog, Trudy? I don't think Trudy would like Zippy, she would probably rip him to shreds.

13

In my bedroom, I crawl underneath my cot and find a single piece of hardened orange peel which I nibble and suck on. Ronnie sometimes gave me fruit when he was alive, but this orange peel is solid and rancid. I gag with dry boak and spit it out.

The front door is not locked, so I head out into the close and knock on doors. I've done this before, and someone usually answers. Apart from the time I got locked out in the rain with not a stitch of clothing on and had to wait for Mummy to return.

The lady upstairs answers and leads me into her small kitchen. She doesn't have much herself, but she does have a kind smile.

Where's your mammy? she asks, glaring at me from the side of her eye and smearing brown sauce onto a slice of bread.

Away out, I say, with my eyes on the meal.

God sake, see that fuckin wummin, she hisses, shaking her head and handing me the sandwich.

The lady wipes her hands on her pinny and looks down at her daughter, who is washed and dressed, her brown hair plaited neatly at either side of her small skull. The little girl stands right in front of me staring as I eat the bread, watching every mouthful.

Can a git a bit? she asks, but her mummy quickly checks her, allowing me to enjoy the food.

Right! Git oot an play. The lady pushes us both out her front door with a hand on our backs. We play together on the communal stairwell which separates the floors in the building. The little girl has a toy typewriter that she bangs on furiously as we play post office. I am so glad of the company. Now and then she runs back inside and reappears with other toys, teddy bears and dolls.

Right. I'll be the mammy, and you be the da. And make it that I'm washing the dishes and you're goin ti yur work.

The little girl has the entire game mapped out for us. Her hands dunk into an imaginary sink and, like a mime artist, she washes the invisible dishes. It's a scene of domestic bliss, a scene I have only ever seen on television, and I'm not sure how to play. I don't want to be the daddy! I want to be the baby, I want to be nursed and rocked, cuddled and loved.

I hear a familiar sound from outside. Mummy is shouting, and as she approaches her loud voice echoes around me and the little girl. Mummy is not alone. She has two men with her this time and a plastic bag. She does not notice us sitting on the steps above her as she approaches our door. She's swaying from side to side as she talks loudly, cursing with the men. The little girl's mummy must have heard the drunks also. *Right, you, git in.* She gestures for the little girl to follow and without a word to me closes her door and I'm left alone.

I follow Mummy and the men into our house and watch as the shopping bag is emptied, it's more jelly, and then beer, and then more beer, and tobacco. One of the men talks and laughs with a booming voice, he is just as drunk as Mummy, but the smaller man is quiet and sits down on the floor with the beer. I try to involve myself in their fun, but Mummy doesn't see me. She has a laser-like focus on the beers being cracked open.

Later, I find Mummy unconscious on her bed. The tall drunk man is gone; he staggered outside making big circles with his feet, arms stretched out to steady himself after passing out on the floor in the

living room while I watched telly. The shorter quiet man is on the bed with Mummy. Her top is off and I can see all the blown-out tattoos over her arms. Tattoos that had been marked into her skin with a needle and ink by my real daddy, two years before. The dark blue stains bleed into one another, and make no distinctive words or images. The man is hurting my mummy, stabbing her front bum fast with his willy. I watch for a moment, as her limp body is moved around. It's called fucking. I know it, I've seen it before, but it's scary, he is hurting her. She's either sleeping or drunk, or even dead. I start to cry and get onto the bed. I clutch at her arm and shake her, but the man doesn't stop the fucking. He just looks at me.

Git tae fuck! he says, flicking his head towards the door as if I am an annoying stray begging for food.

I'm only four years old and I don't understand what's happening. I get off and stand in the hallway, peeping around the door, half watching in terror through my tears and listening to the man's breathing and the mattress springs ringing around the bedroom. When it's over, the man walks past me as though I'm a ghost and disappears through the front door. Mummy rolls onto her side and curls into a fetal position with her bare bum sticking out.

Silence fills our cold house again. I walk around the bed and watch her mouth. Little bursts of air pip through her dry closed lips, making the same sound as the keys of the toy typewriter. I'm just glad she's alive.

Our house is freezing cold. It's 22 December and Christmas programmes are on the telly. I'm loving the single strand of tinsel

wrapped around my head, a gift from the kind lady upstairs. I gleefully skip from room to room, shouting and singing,

Jingle bells, jingle bells, jingle all the way.

In my bedroom, there is a ceramic cartoon ornament that smells funny but tastes like sugar, so I suck it and try to scrape at the ceramic with my teeth. Mummy is not feeling well after her beers and sleeps on the armchair. Her belly gargles and boils with growling sounds; she must be hungry, but she is safer in this state. I stand next to her, listening to her irregular breathing. Her face is freckled with thread veins and red blotches, like an old map that took her on a perilous journey. Her red hair is tangled and matted, and she is thin, like a skeleton. And I'm safe too as I play at her feet in front of the gas fire and my loyal friend, Telly.

Suddenly the front door knocks loudly, making me jump. Bang, bang, bang!

Mrs Gormley! a voice calls from the other side. Mummy doesn't move.

I head out into the hallway past my cold bedroom and our junkyard kitchen towards the front door.

Hello, Mrs Gormley! the voice calls again.

I open the door but it jams on the lock chain.

Hello.

A lady with short grey hair appears through the open gap with a warm smile.

Is Mummy home? she sings in a very friendly voice, her big eyes blinking, framed by clumpy black mascara.

I nod and run off to get Mummy.

Mummy, people are here, I say, shaking her bones awake.

She staggers to her feet and lifts me in her arms.

Who the fuck is it? Mummy shouts from the hallway, slurring her words.

Mrs Gormley, it's the social work department. I'm here with the police; can you open the door?

Mummy staggers forward and closes the door in the woman's face. She undoes the lock chain, allowing the door to swing wide open. I look at all the adults standing there waiting to enter. Mummy walks away, carrying me back into the house without an introduction; she knows what's happening. I peer over her shoulder at the woman followed by police who enter the house.

What a beautiful little boy. What's your name? a policeman asks, the cold air visible on his breath.

FUUUCK, I shout.

The lady and police pile into our dirty living room and Mummy puts me down on the floor before collapsing back into her chair. A policeman sits on the floor beside me and plays peek-a-boo. He does a magic trick by hiding a shiny 50-pence piece in his hand, then makes it vanish into thin air.

Do that again, I squeal, and he does, with a smile.

Another policeman walks through our house looking in all the rooms while the lady talks to Mummy.

Mrs Gormley, my name is Claire Mckay, OK? and I'm here from child protection because we have been contacted regarding your little boy, John.

Aw, who the fuck was it this time? Mummy says, making her neck long just like Granny's tortoise, Tinker Bell.

I'm not at liberty to discuss that with you, I'm afraid, the lady answers.

Mummy starts to make a roll-up cigarette, but her hands shake so much that she has difficulty folding the papers.

I bet it was that auld bastard in Drumchapel again, she says, concentrating on licking the papers and sticking them down.

The lady looks through her notes and writes a few things down while Mummy strikes a match and puffs on the pathetic roll-up.

Mrs Gormley, the social work department views with some concern that John is only four years of age and has been received into care six times in the last eighteen months.

I've not been well, plus I just lost my husband, Mummy pleads.

But the woman has seen enough and has all the damning evidence she needs in the files in her hand.

Child protection has been contacted on five of those times, in one of which an anonymous call was made claiming that John had been badly beaten by a . . . The lady refers to her notes. *Mr Mckinnon?*

Aye, and you lot came out with the polis and backed me up when you saw there wasnae a mark on him, Mummy answers with growing defiance in her voice.

The lady smiles down at me, trying to reassure me that I'm safe even though I can feel the tension building.

Each of these receptions into care is related to your consumption of alcohol and lifestyle choices. It would appear that you are making no effort in controlling your drinking.

I haven't been drinking for over a week. Mummy starts crying but it is the same crying she does when she needs a free bus journey or money for a drink, the tearless kind. I go to her and cuddle in tight; her body shakes and rattles against me.

Mrs Gormley, I can see that you have been drinking even today.

When was the last time you both ate anything? a policeman asks Mummy in a more gentle voice than the lady has used.

I made us chips and egg, just an hour ago, Mummy says, scraping at her skull with her nails.

Was that here at home? he asks.

Aye, just an hour ago, didn't we, son? We had chips and egg, she says, nodding down at me and giving me a sharp nudge.

I look around the room at all the adults in total confusion at the situation.

Mrs Gormley, I've just been in the kitchen and the cooker doesn't work, the policeman says with some guilt in his voice.

The woman takes over again, finally closing her folder of notes.

We just don't feel that the level of care John is receiving is good enough. I'm sorry. Is there anything we need to pack up for John? Clothes or toys?

No. We've no got anything, Mummy says.

The fake sobbing becomes real when Mummy is asked to sign her name on a form. Somehow, I sense what is happening. I hold on tight and cry hysterically as the woman pulls us apart, prising my hands and fingers from Mummy's cardigan. She carries me away, followed by a policeman. Mummy will not look at me as I plead, arms stretched out towards her.

Mummy, I scream. *My mummy.*

But Mummy does not get out of her chair. She faces the other direction, looking at the window, at the dead flies and dried-up tadpoles.

As we get further apart, I absorb this last image of Mummy, sitting there with police standing around her. I will her to get up, to fight for me, even to look at me, but she doesn't move and so I accept my fate and bury my face into the woman's shoulder as she carries me away.

2

I arrive at night. It's only a thirty-minute drive from Mummy in South Nitshill to the children's home in Glasgow's South Side, but it seems like a lifetime. The journey is filled with loss, confusion, fear of the unknown. The lady who separated me from Mummy is sitting in the passenger seat and when she talks to me she doesn't turn her head right around. I only see a slice of her face and her hand, which appears from the gap between her and our driver as she passes me tissues. The man who's driving us glances at me with smiling eyes in the rear-view mirror. He hands me half of a Bounty bar that's been sitting on the dash.

It's dark outside and the lady helps me out of the car that's turned into the sweeping gravel driveway of a huge villa. My eyes scan everything around me. Even from the front, I can hear the laughter and chatter from the kids inside. Another lady with short grey hair

is waiting to greet us, and after a quick chat and an exchange of paperwork, the first lady jumps back into the car and heads off.

Hello, what's your name? the new lady asks.

John.

John! That's a nice name. My name is Maria. Shall we go inside and get some supper?

I nod and follow.

Inside, children in pyjamas stop running around momentarily to stare at me. They are used to new arrivals appearing at all hours and soon run off. Peeking out from behind Maria I can see a big Christmas tree twinkling with coloured lights. Home-made paper chains hang pinned from doorways, and plastic Santas are stuck to magnolia walls. Shiny Christmas decorations bounce and sway in the rising heat from big cast-iron radiators.

Hello, I'm Kirsty, what's your name? asks a heavy-set lady with short dark hair. I say nothing and hide behind Maria. *Has the cat got your tongue?*

Another lady, carrying a little boy, gives me a big smile as she walks past.

Before I can see any of the house, Maria takes me to a bathroom where I'm stripped off.

I've never seen such a long bathroom. There are two baths here, end to end, and two toilets side by side under a small sash window. It's the first time I smell carbolic soap flakes.

Maria washes her hands and puts on a pair of yellow domestic cleaning gloves. She lifts me into a shallow bath and scrubs my hair with smelly cream, then starts to comb out lice and eggs. Around the bath are plastic toys and a little yellow watering can, so I entertain

myself while she picks at my scalp with a comb. This has happened many times before when I've been received into the care system. Standing me up, she rinses me off and lifts my skinny body out. I'm covered in scabies and dry itchy patches.

Oh dear, Maria says, smothering ointment all over my body and legs.

She hunches down to face me, her gloved hands kept well out of her way to avoid touching her clothing or skin.

Do you like jam on your toast? she asks with a smile.

Aye! is all I can muster, but inside I'm screaming, *I do, I love the stuff.*

After I'm dried off, Maria dumps my clothes and sandals in a plastic bin bag and ties it up. She takes off the yellow gloves and washes her hands again, then dresses me in baggy button-up pyjamas and leads me into the reception hall.

I can hear distant voices as all the children are now being settled in bed. I'm frightened. The house seems even larger without the children running around. My tears for Mummy pour from me, as the realisation sets in that I'm here for the night.

Maria finally takes my hand in hers and I hold on tight, the physical comfort is so welcome. I am led into a large room with lots of different armchairs and two long sofas. She sits me down in front of a telly and another lady wearing a cook's apron brings in a tray. Smiling down at me, she hands me a plate and a mug. Then they both stand just outside the doorway chatting, every so often looking in at me while I drink some hot orange and devour toast with jam. Finally, I fall asleep from sobbing, but warm, fed.

*

The sound of a child's crying wakes me up. I look around. How did I get into this strange room with a single bunk bed and a small sink? Where is Mummy? Is she OK? Is she missing me? There is a small window with no curtains set high on the wall. A little boy with mousy brown hair climbs down from the bunk above me.

What's your name? he asks, drying his eyes.

John Mckelvie, I say.

My name's Patrick.

He stands beside me, as the hugeness of this strange place hits us both. We share a moment of eye contact, solidarity and pity for each other. I begin to cry and wail for my mummy. Patrick gives me a concerned look, the corners of his mouth twitch down as he holds back tears. He stares into my gushing eyes for a moment, then his eyes pour again and he runs out of the room, leaving me alone.

Maria returns holding a paper bag full of creams and lotions.

Oh, what're all these tears about, eh? she asks.

I want Mummy, I cry.

Come on, you will be OK. Dry your eyes.

I don't know this strange lady. Am I safe here? Is she violent?

After another wash with the lotions and creams, she gets me dressed in nice clean clothes. She doesn't offer me any cuddles, just tells me everything is going to be OK.

Back in the main reception hall, children filter past us, down from the massive staircase; they are backlit from the morning light that spills down the steps from a stained-glass window. The noisy children rush towards a dining room. From the doorway, I can see a man in there with long grey hair. He is shouting at a little blond boy

who seems a couple of years older than me. I freeze in the doorway, digging my heels down to stop Maria from pulling me in.

The man grabs the little boy's face in his hand, and with a yank, he forces the child to make eye contact.

Do you hear me? Scary Man repeats in a quieter voice, realising that I am standing with Maria, watching in terror. The boy nods his head, his little mouth is puckered up and squashed in the man's grasp.

Now get this cleaned up, he says, releasing his grip and pointing to cereal scattered all over the floor.

He turns directly towards Maria with a smile but before he can speak I turn my head away. I can't bear the thought of being in the dining room with this angry man.

I don't want to go in there. I'm not going in there, I want my mummy. I twist and turn, pleading with Maria, pulling her away from the door and back into the main hallway.

Give us a moment please, she says, nodding to the man.

I have seen Mummy scream in rage and shake in fear while being shouted at by men. I have seen her hit men and men hit her. I have hidden behind Mummy as she has taken slashes to her arms with knives, shielding me from the violence of drug addicts. I have seen her nose explode with blood on a bus by the fist of a man, all over a drink. I've developed a fear of shouting, loud noises and violence, knowing that they lead to slaps and punches, tears and blood.

Maria takes me away and lets me eat breakfast alone in front of the TV, but I can't relax. I watch my back in case the horrible man comes in.

After breakfast, Maria takes me to the basement. I don't have the

shoes that Aunt Ellen sent while I was living with Mummy. They were lost in the endless moves or sold for alcohol. I only had sandals on my feet when I arrived and those are gone.

Washing machines and tumble dryers whizz and beat with fury in a dark laundry room. Another room has a huge steel machine clamped to the floor for peeling spuds. Mops and buckets stand lined against the wall. Their fort is a stack of odd broken chairs and yellow-stained pissy mattresses. Maria pushes open heavy swing doors, and light gushes into the dark basement.

We walk into a long glass corridor. It's sunny and warm in here despite the season. At the opposite end, she opens a big cupboard full of black bin bags. She pulls at the great wall of bags and they tumble down onto the floor in front of us.

Here we go, she says, opening a bag full of shoes, sandals and slippers, all second-hand.

The shoes smell of mouldy leather, damp and sweaty feet. She hunts out a matching pair. She tries several on me, but they slip off when I walk.

Is that your toe there? she asks. *Is that your toe?* Pressing the top of the shoe and trying to feel where the leather ends and my foot begins.

Too big, she mutters and pulls them off, then dives back into the bag and lifts a pair of green canvas army-print trainers. I like them.

She squeezes my feet into the trainers that are too small and fastens the Velcro over them.

Walk around a bit, she says, lighting a cigarette and exhaling a long streak of swirling smoke into our space.

I walk in a small circle, looking down at my feet. The shoes are

pinching me hard, but I can walk in them without them slipping off. Maria presses my toes again.

They seem fine.

Satisfied that she has made the correct decision, she packs the bags away and takes me back along the glass corridor and up through the creepy dark basement into the house.

Mrs Knowles is the manager here in the children's home, and after a brief chat in the office at the very top of the house, I decide I like her; she makes me feel safe. She also keeps a dog here, a Labrador called Sandy, who follows her wherever she goes. I like Maria, too. She is friendly. But above all I crave a hug from Mummy, the ones she used to give me just as the first can of beer or neck of cider hit her gut and she felt happy.

Maria holds my hand and leads me around the rest of the huge house. The villa is joined by a second villa attached to it like an arm by the long glass walkway. They share a large garden at the back that is littered with plastic toys. In my house there are around fifteen children, a mixture of boys and girls, and the second house has older children and children with disabilities. The building itself is cavernous, gloomy and run-down; sound echoes and travels down unknown corridors. There's too much commotion here, the sound of crying children throws itself around the building at all hours. It smells like cheap soap, cigarette smoke, dust and that cloying cooking smell. Little dirty handprints cover the magnolia wallpaper, a testimony to all the children who have passed through here, their presence preserved on the woodchip.

Treacle-coloured gloss paint smothers the skirting boards and door frames. In the main reception area, a grand, mahogany

staircase forks off at the top and leads to different rooms where the other boys and girls sleep.

My room is tucked under the stairwell; it's where the new kids are taken to settle before being placed in the upstairs dorms. As Maria's tour continues, my feet begin to throb from the too-tight shoes, so I walk on my tiptoes to ease the pain.

My first day is spent observing, checking for danger and keeping away from noise. When I am formally introduced to Scary Man while playing in the back garden, I hide behind Maria. When he smiles, his wet lips reveal a thin mouth with yellowing teeth.

That evening, and after reassurances that the scary man with the long hair won't be there, Maria walks me into the noisy dining room and I am handed a plate of watery fish pie. I don't like the smell in here. I start to cry, unable to eat the food. I'm offered toast instead. The furniture is an odd mishmash of items which no longer have a place in their former homes. There is a long dining table and two small tables. I sit at a small one next to the inbuilt kitchen dresser that holds all the plates and cutlery.

The children shout over each other as they eat. Patrick, the boy from my room, is sitting at the big table; he is silent and looks lost. His fear seems to feed my own. The same blond boy that Scary Man told off points over to me and shouts.

Who's at wee guy?

Maria goes over to him. I can't hear what she is saying but she is having a word, and the boy's attention drifts back to his meal.

With so many people around I can't tell who's who. I sit in front of a little girl with red hair. She is pretty and is wearing a floral dress. Maria introduces us.

John, this is Morag – Morag, this is John. John will be living with us for a wee while.

The little girl gives me a big smile.

Ma big brother's called John as well, she says, swinging her bare legs, her toes brushing my feet under the table.

We're getting a new ma and da, aren't we, John? she shouts over to the blond boy, who looks at us but doesn't answer.

After toast and a sponge-cake pudding, I'm taken off to bed. Patrick is no longer here. He has been moved to the rooms upstairs, so I cry in the room alone, wondering where Mummy is and how long I will be here. I replay my last vision of her over and over. Her sitting with her back to me.

It's Christmas morning and still dark outside. Maria comes in holding a black bin liner.

Merry Christmas, John. Look what Santa has left. She shakes the open bag. *Take out a present.*

I dip my hand in and pull out a large crinkly gift and open it up. It's a stuffed toy, Scooter from *The Muppet Show*, with big plastic googly eyes and little black glasses. I love him.

Maria washes me down with her rubber-gloved hands and applies my skin creams.

Am I going home soon? I ask her.

No, not soon, John, but Mummy will be coming to visit, she says, helping me to get dressed.

When? I ask, holding on to her shoulders as I step into my trousers.

Oh, I'm not sure, but soon.

And Granny Gormley? I ask as my head and arms pop through a jumper.

Maria tucks in my T-shirt, then adjusts my jumper to cover the waistband on my trousers.

Tell you what, why don't we go and have breakfast and show everyone what Santa has brought you, eh?

Will that man be there? I ask.

She screws her face up with a puzzled look.

What man?

The man with long hair, I say.

Oh, him, she replies, letting her breath out and realising who I am referring to. *No, he won't be back until tonight. Come on, don't be silly. You'll be OK.*

After a porridge breakfast and a few pulled Christmas crackers, I have a run-around with Morag. She seems to know her way around and her confidence is comforting. The boys' games don't interest me; they are too rough, too loud and shouty. We sit on the bottom steps of the stairs, wearing the adult-size paper hats that we got in our crackers. I rock my Muppet teddy like a baby in my arms. Morag got a Sindy doll from Santa this morning, so we take turns playing with the toys until I refuse to hand her doll back over. We pull Sindy, back and forth in a tug of war.

She wants me!

No! She wants me! we roar, screwing up our faces at one another as Sindy is pulled by her hair and legs.

The argument is settled when a lady steps in from the cold outside. Morag makes a hasty retreat up the huge staircase with her

prized doll, sitting at the top and peering down on us through the banister spindles.

The lady puts down a big leather case containing a guitar.

Merry Christmas, Morag, she calls up to the little girl as she removes her big brown outdoor coat.

The lady walks over to me and sits down on the bottom step to meet my eye level.

Hello there, I'm Sister Pauline, she says, looking into my eyes with the warmest smile I've ever seen.

Her voice is different to our Glasgow accents: she speaks softly, like the English people on the telly.

That wee boy is called John, Morag shouts down from her hiding place.

Sister Pauline turns her neck to look up. She gives Morag a wink and turns back to face me.

Merry Christmas, John, she whispers.

Without consent, she hugs me tight. It's the first cuddle I've had since I arrived.

Merry Christmas, I mumble into her shoulder.

When the hug feels safe, I allow it to soften and my body melts into her. I push my Muppet towards her, and her blue eyes light up behind the frame of her huge rimmed glasses.

Oh, look at that; he's fantastic, she says, squeezing him close to her heart.

She is wearing a blue cardigan that's covered in badges and buttons of different sizes and colours over a white shirt, black trousers and a black veil that tops her white hair and hangs down her back like a Superman cape.

Do you want to hear a story? she asks.

Aye, I say.

Sister Pauline takes me away from the rabble of the other children and into the big front room that overlooks the gated driveway. She sits me on her knee and begins to read from the New Testament, Luke Chapter 2. I chew my fingernails in concentration as she recalls how Mary and Joseph are carried on a donkey through Bethlehem, fleeing persecution and looking for a place to birth the Christ child. I've never been read to before and it sparks my imagination as I picture the scene in my mind. Soon we are joined by Maria, Morag and other children, who sit around us to hear the woman read. After the story, Sister Pauline pops me onto the floor. I sit right at her feet while she plays 'Little Donkey' on her guitar. I mouth along to the words, encouraged by her and others to sing along. Finally I relax my body and mind.

It's been three weeks now, and today is Mummy's day to visit. I wait in the privacy of the front room, looking through the big brown National Health glasses I now wear to correct my squinting left eye. Gazing through the lenses, I look out of the bay window for a sign of her coming. It's raining hard. I like the raindrops' rhythm as they hit the windowpane. I follow them with my finger as they race down to merge and form little rivers.

My new social worker is called Daniel. He is a mixed-race man in his early forties and he has been preparing me for the visit by asking me lots of different questions about how I feel and what I remember.

I don't think Mummy is going to make it, he says, looking at his watch.

I glance up at him, then back at the window and the raindrops' race. Daniel takes a seat on the sofa behind me.

What do you think my job is, John? he asks, waiting with a pen and paper.

I turn around to face him, scared to take my eyes from the window in case I miss her walking up the drive.

My social worker, I mumble, but my eyes turn back to the window. I need to see her running up the drive, smiling at me with open arms, begging forgiveness for ignoring my tears on our last goodbye. She must have missed me, she must be ready to take me home now.

My job is to make sure you are happy and that you are safe, and to make sure that Mummy is feeling better.

Hm? I say, half hearing him.

I'm trying to concentrate on the space past the wet window, between the driveway and the street.

And John, do you know that my job is also to look for a new mummy and daddy? he asks, tapping my shoulder gently with the top of his pen.

I turn my body round to face Daniel. He is sitting cross-legged and smiling at me.

You know, lots of boys and girls who come to the children's home don't stay here for ever because we are all working very hard to find them forever families. Do you know what that means?

I get up and stand in front of him. From this vantage point I can see him while keeping my eye on the street outside too.

No, I say, shaking my head.

Daniel pats the brown sofa cushion next to him and I reluctantly sit down, my back turned away from the window.

Well, it means that sometimes when Birth Mummy and Daddy can't look after their children, a new mummy and daddy come along, and if they all feel good then the child can have a family to live with for ever. A forever family, with lots of love and a very safe home and no more moves.

I smile at the idea, but I always go back to Mummy, so it doesn't interest me. The front doorbell bursts into song with a ding dong and breaks the moment between us.

Mummy is here, I squeal, jumping to my feet.

Daniel stands up and composes himself.

You stay here and I will bring Mummy in. OK?

I watch him exit and I stand in the centre of the room waiting for my mummy. I'm ready to show her what I got from Santa, and all the drawings I've made her. I want to tell her about all the nights I have cried for her and that I am ready to go home.

Daniel brings Mummy into the room. She is dripping wet, shaking hard and her face is red and blotchy. The scruffy mess of her shocks me. I assess her mood for a second before pulling off my new glasses, throwing them onto the sofa and jumping into her arms.

It's not your fault, son, she cries, trembling from alcohol withdrawals and stinking of beer and cigarette smoke that the rain has infused into her skin and hair.

I cry into her, getting damp from her smelly wetness. Daniel brings Mummy a towel and a cup of tea, then sits down and waits, supervising our interaction.

Where's Ronnie? I ask, knowing the answer but checking that

I hadn't made it up. When he was alive they would always show up together for visits to the different care homes I was in.

Ronnie is away up to heaven, she says, still sobbing, her head bobbing up and down as she shakes.

Am I going home? I ask.

Naw, son, ye cannae come home yet. Mummy's still not feeling well, but I will come and visit.

It's not the answer I want to hear, but I won't complain. I realise that although I want Mummy, at least in the children's home I get fed, washed and loved.

Can I take him out for a wee walk around, Daniel? she asks, turning to the social worker and drying the back of her neck with the towel.

Daniel stops writing in his notebook to look at her pleading eyes. He sucks the air in through his teeth, making a hissing sound. He looks at his watch, then at the rain outside hitting the window.

I don't think it's a good idea just now, Margaret. I'm sorry.

She looks back down at me, resigned to the finality of his answer.

He's looking good, eh! Curly Tops, she says, running her yellow-stained skinny fingers through my mass of black curls. *Guess who I saw?* she asks with a breaking smile, her mouth trembling with nerves. *Hannah!*

I don't respond.

You remember your big sister Hannah?

I think hard, scanning the archives of my young brain to find the face of my sister Hannah, but I've been moved around so much and met so many different people that I can't quite place the face. I do

35

remember the girl, but the details of her features are mixed up with other children's. So I lie to appease Mummy.

Aye, I say, flipping through my drawings that I'm desperate to show off. *Look,* I squeal, pushing a drawing I've made of the resident dog into her face. *It's Sandy!* But Mummy turns away and starts to beg Daniel for money.

That's my oven broke, and I need money to get a new one; I don't know how I'm going to manage! I haven't even got the money to get home today.

I've heard this story many times before.

From outside the room, I hear the familiar voice of Sister Pauline, so I run out on my tiptoes to greet her.

Mummy is here. I'm going home, I shout, throwing myself at the lady and pulling her towards the room.

Sister Pauline follows me in and nods a polite hello without saying any words. She gently prises my grip from her hand and holds her arm out to make me stay, then closes the door, leaving me with Mummy and Daniel.

Daniel is counting out change into Mummy's cupped hand. Her eyes watch the coins, lusting for more and more. I go back to my crayons and decide to draw a smiling Sister Pauline.

After twenty minutes of discussing the health of my squinting left eye, my diet and my skin with Daniel, Mummy's withdrawals become unbearable. She now has enough change for a drink and so it's time for her to go. She gets upset as she tries to adjust my big brown glasses back onto my face, but I turn away from her attempts.

Gie us a cuddle, she says, holding out her arms and beckoning me in.

I stand there as she wraps herself around me, sobbing.

See you soon, Curly Tops. I promise you, as soon as I feel better you'll be coming hame. Love you.

She hasn't noticed that I'm walking on my tiptoes because my shoes are too tight; it seems nobody has. I watch from the front window as she walks away into the rain, her shoulders hunched up into her neck. Only then does the grief hit me like a tidal wave. I hammer on the glass, wailing for her to return, but she doesn't look back.

As the months pass, I am taken from the holding room under the stairs and moved up to a room at the top of the house. I'm in a big room at the back of the building which sleeps three boys. It's very bright up here. It has high ceilings and overlooks the gardens at the back. I'm in a bunk with Patrick above me; a blind boy called Kenneth is at the other end of the room in a single bed. I watch Kenneth with curiosity as he feels his way around, his pearly eyes turn and flicker from side to side in his head as he talks to us.

When I get my forever family, I'm going to have a guide dog called Orval, he tells us, looking past us at the big brown wardrobe.

My mummy is taking me home soon, I tell him.

But Mummy hasn't visited again. Daniel said she is still unwell and he is now looking for a forever family for me. But I always go back home.

It's the middle of the night. I'm at the side of the bunk bed, pacing up and down to shake off the memories of a nightmare.

Suddenly the bedroom light flicks on and Scary Man stands in the doorway. I freeze with fear. I don't often see the night staff, because Maria usually puts me to bed, and I'm normally asleep.

What's this noise? he shouts, standing over my tiny body.

My stomach lurches. My heart sinks and I start to cry.

Kenneth is fast asleep in his single bed at the other end of the room and Patrick is either asleep or pretending to be on his top bunk.

Clothes off! Scary Man orders like a sergeant in the army, pointing his hairy-knuckled finger at me.

I take off my top.

Everything! the man says.

Reluctantly I pull down my pyjama bottoms and step out of them.

Get your pillow and follow me.

I fumble around in the nude, picking up my soft pillow and using it to hide my private parts.

In the darkness, Scary Man marches me to the top of the twisting staircase. It looks so high up here, and I use one hand to steady myself on the banister.

Hands up. Hold that pillow above your head, he says. So I raise the pillow.

Stretch them up, up to the ceiling. He shows me with his arms what to do.

I stretch up my arms, pushing the pillow high above me. I am balancing on my tiptoes, which is now how I walk – even when barefoot, because the shoes have been crushing my feet.

I feel very unsafe in this strange position and worry I might fall.

Now, wait here. He walks to the bottom of the stairs and I wonder what's happening. The house is completely quiet, the other staff won't return until the morning, Maria is not here to protect me and all the children are fast asleep.

Right! he calls up. *Get back down here.*

I start to walk down the stairs. I have to take great care not to lose my balance.

Run! the man yells.

I pick up my pace and run down the stairs with care.

Right! Arms up. Run back up, he shouts.

I turn back to the stairs to climb again.

Hold that pillow high. RUN! he barks through his horrible thin mouth, and with fear I push against gravity with the pillow. *Faster, faster!* I rush to reach the top.

Again and again and again I run up and down the stairs until my arms start to ache, but at the first sign of slacking he shouts and thumps the banister in anger, his scary eyes always on me.

Run up! and *Get down!* over and over.

Sobbing and exhausted, I can't go on. My soft pillow has become a dead weight on my tiny frame. I stop halfway to the top and look down at my tormentor; my tears are begging him to stop.

Right. That's enough, bed now!

He takes me up to my room and puts me back in my bed without another word. I fall asleep, shattered and scared.

In the morning I must be carried by other members of staff up and down the stairs trembling. Scary Man told them that I had fallen down the stairs in the night. It is confusing to be comforted by Maria on the man's lie. *Oh dear, how did you fall?* and *What hurts? You should*

have stayed in bed, John. The idea of being safe with a forever family now takes root in my imagination.

I am finding my bearings and sometimes Patrick, Morag and I wander through to the adjacent house. It is similar to our house only smaller and the staircase is not as grand. There is a girl called Jane living in this building. She is tall and thin and has cerebral palsy but manages to wander around unaided, bumping into door frames as she goes. She has long golden hair right down her back and sometimes I come alone and play with her; the staff even let me help to brush her hair. Jane is always smiling and happy, although she can't talk and has no teeth left, due to bad hygiene by the people who abandoned her; it has led to her face collapsing into itself.

Her carer is a man called Ian, and I love it when he bounces Jane on his knee and sings a funny song. *Dum-de-dum-de-dum.* Jane likes it too and smiles a big gummy grin. Then Patrick, Morag and I get a turn.

Dum-deedle-dum-de-dum.

Are you Jane's forever family? I ask Ian when the bouncing stops.

No, I'm just her houseparent, he replies with a smile.

When I know Scary Man is going to be working, I hide from him under the rhododendron bush in the garden. Staff spend hours looking for me. I use my time trying to understand the concepts of forever family, mummy, birth mummy, daddy, houseparent, social worker, night staff and sisters.

*

I like to visit Morag and the other girls in their room; boys are forbidden from going in there, but because I am the youngest Maria allows it.

There are three beds lined against one wall and another three at the opposite end of the huge room overlooking the front driveway.

The girls fuss over me, playing dress-up and covering me in bright blue eye shadow and red rouge from a big butterfly-shaped palette filled with beautiful colours.

Aw, look at my wee baby, he looks dead nice, Morag squeals with pride as she scrapes my hair up with a hairbrush, fixing my curls into place with an elastic bobble grip.

Mama, I say in a baby voice, looking up at the girls.

I love the attention the girls give me, and I love being a baby. I remember Mummy wearing make-up. She would apply eyeliner to her small eyes whenever she left to visit her money men at night. Sometimes she would take me and my sisters with her to the city, but we would have to wait in a phone box while she went away with the men in cars. She didn't need eyeliner but when she wore it, it lifted her slanted eyes higher in line with her angular cheekbones and strong jaw.

I wait until the girls are distracted and I steal the butterfly-shaped palette of eye shadows, so I can give it to Mummy when she visits. I run off to my room across the hall and hide it in my bed.

That night when everyone is asleep, I reach for my stolen bounty but it's gone. I look everywhere, under the bed and covers. No, not there. Perhaps the girls found it and took it back? Defeated, I settle down to sleep.

I wake up to Scary Man growling down at me. He holds out the plastic butterfly containing the make-up and pushes it right into my face.

You stole this, he says, jutting his bottom jaw out, showing his wet bottom lip and yellow teeth. I had learned to steal while living with Mummy. She would pop eggs, crisps and even bacon into my pockets or under the seat of my pushchair, then casually stroll out of the shops. When she was unlucky and got caught she would laugh, apologise politely in her softest voice and say her wee boy must have lifted it.

Without waking Patrick, Scary Man takes me out of my bed and down towards the basement. When I realise where we are going, I scream and climb up his body in fear. Without empathy, he pushes me into a cupboard and closes the door. I freeze in terror with my eyes shut tight, afraid to look into the inky blackness, afraid to allow my eyes to adjust in case I see the monsters that live down here. I lose my nerve and thump on the door, screaming for my mummy. After a few minutes, he lets me out and comforts me in his arms. It feels so strange and stops me wailing. After a few moments he carries me in his arms back up to bed.

I get my revenge days later when, during a meal, I chuck a full tub of white pepper right in his face, sending him into a painful rage. Then I hide behind my houseparent, Maria.

What the hell did you do that for? she yells at me in utter confusion.

I try to explain to Maria what had happened and why I feared him. But my trauma does not translate properly. *It was just a bad dream, John.*

*

It is late and everyone is ready for bed. Sister Pauline sits on the bottom step of the stairs. A group of us are gathered around her as she tells us a story, her guitar resting on her knee. I am sitting close, listening to the tale of faraway lands and magical beings. She plucks the guitar strings and starts to sing.

Puff the magic dragon lived by the sea. And frolicked in the autumn mist in a land called Honah Lee. She nods her head down at me. *Little Johnny Paper loved that rascal Puff. And brought him strings and sealing wax and other fancy stuff. Oh . . .*

All the children join in on the chorus. Later, the other children sit around eating cold chewy toast while I play in the main hall. I run my hand along the top of a high unit just outside the door and find a small thin strip of silver metal with little holes perforated in its centre. Not knowing what it is, I run it across my lips, blowing air through the gaps, trying to make it whistle. But my music is met with chaos as I walk into the room where all the children and staff are unwinding.

The children gasp and scream as adults jump towards me in a panic. Suddenly I taste it, a warm, wet metal. I smack my lips and look down at my pyjama top. I am soaking in red shiny blood.

He's got a razor blade, Maria shouts, grabbing my hand, holding it high and lifting my gushing face to the ceiling with her other hand.

I look up at the musical instrument that has caused my wounds and drop it to the floor. Blood runs from little cuts on my fingers, down my wrists and up my arm, slowly turning my brown paisley-patterned pyjama top a dark glossy red. Maria and another woman rush me away to the bathroom.

Maria is pale with panic as she holds a compress onto my mouth

and fingers and waits for the bleeding to stop. But my stinging lips rage and burn in agony.

It's Sunday morning, and everyone is getting ready for a day out. Sister Pauline lives only a few buildings away from the children's home and arrives to pick us all up in her minibus. My mouth is sore, crusty, and black with dry blood. I have grown used to asking who is looking after me each day and night, and when I'm told I must stay at home for the day with Scary Man it sends me into a blind panic.

At lunchtime, Scary Man barks orders at me to stay in the front room and watch while he eats biscuits with tea. I have not been able to eat anything because of the pain screaming from my mouth. With every dunk of the KitKat into his cup of tea, he makes a 'mmm' sound, tormenting me. I reach out for the biscuit with fingers covered in flesh-coloured Band-Aids, still unable to talk properly, but he pulls it away, laughing viciously.

After he has finished, he takes me to the holding bedroom under the stairs and fills the sink full of water. He soaks toilet paper, making big wads of soggy pink mush to clean the gore from my lips. I twist and wince at the stinging, but he tells me to stand still, so I try my best. He gently pats my mouth, removing the sticky black-and-red congealed blood. But then he starts to pack the area behind the lens of my glasses with the blood-soaked paper.

These are your new glasses, he laughs.

I try to take them off, but he tells me to *Stand still!* I do as he says. Unable to see, I feel him start to pack my underpants with the wet paper until a huge wet bulge rests in my front. He squeezes the wet

wad with his hand. I feel the water piss down my legs, and he repeats the process. I stand there with bloody water running from behind my glasses, down my legs into my socks.

I am sitting at the small table with Morag, Patrick and Sister Pauline. The sound of cutlery clinking is chaotic against the chatter from us children as we finish our meals.

I am going hard at a bowl of custard. Between mouthfuls, I look up at Sister Pauline.

My mummy is very poorly, I say.

Oh, dear! I'm sure she will get better, she replies.

Yes, and my mummy is coming to visit. I smile with pride.

Oh, that is exciting, isn't it?

I nod my head, but the memory of Mummy is defragmenting.

Are you my new mummy? I ask Sister Pauline.

No, I'm not your mummy, John. Come on, finish your pudding, she answers firmly.

Maria enters the room with a smile on her face.

OK, boys and girls, those who have finished may leave the room and go to play. Many of the children jump up and rush out of the room. I look up at Sister Pauline.

Do you want to play and wait for Mummy to arrive? I nod and jump down.

Sister Pauline wipes the custard from my face with a tissue and I walk out, but hover outside the door, listening.

I doubt she will turn up, Maria says as she helps clear the table. *Three times she's made arrangements to visit and never arrives.*

What a shame! Sister Pauline tuts. *The wee lad doesn't know whether he's coming or going.*

It has been months since I last saw Mummy. When Daniel, my social worker, visits, he asks how I feel and tells me that an order has been passed by very important people in court and Mummy has given her permission for me to be given a new forever mummy and daddy. Mummy won't ever be able to visit. But I should not forget her, and I must now call her 'Birth Mummy'.

There have been so many different faces flooding my senses at this stage of my life – staff members, houseparents and children – that I have to concentrate very hard to hold on to an image of Birth Mummy. I replay my memories over and over in my head every night and day, dreaming of her face and recalling all that has happened in my short life: my house back in South Nitshill, the slums, the drowning of Ronnie, the orange peel I found under my bed. Over and over, I draw pictures of Mummy, a small thin stick lady, with long red hair and long eyelashes. I also draw Sister Pauline, who has now become familiar. My spiritual mother. The more time I spend in her company the more I need her.

I start at the local Catholic primary school late, missing almost half of the term due to a 'settling-in period' and adjustment to the care system. The other children attend the school for Protestant children, but I'm lucky my friend Patrick is with me at the Catholic school.

We are dressed the same, in dark blue sweaters and grey trousers. I have different shoes now, black ones; these are slightly bigger than the shoes I'm having to wear around the children's home, and my heel slips out with each clumsy step I take because I've learned to walk on my tiptoes.

Maria walks us here each school day and leaves us in the care of Miss Miller, our Year One teacher.

During class, I am quiet and shy. I sit right at the back, hiding behind a big orange fold-out card that I'm meant to slot words into to make sentences; my mind boggles at the words and letters in front of me.

Who can put their hand up and tell me what word I can put into this sentence? The Cat likes SOMETHING the milk, Miss Miller says, holding up the word sentence card and pointing to each word as she says them.

A sea of hands shoots up and children bounce with anticipation at knowing the answer, but not me or Patrick. I shrink down in my chair, trying to make myself invisible to the teacher. Miss Miller scans the room.

Let's see who has the answer. She fixes on a girl next to Patrick. *Claire Lafferty,* she snaps, pointing at the girl.

All the little hands go down with a universal sigh of disappointment at not being picked, and I can relax for a moment.

Miss, the answer is: the Cat likes DRINKING the milk, Claire says, standing tall at her desk.

Very good, Claire, Miss Miller says. *Come on up and get a sweetie from the tin.*

Claire skips to the teacher's desk, bursting with pride, and pops a Fruit Pastille into her mouth from the sweetie tin that Miss Miller keeps in her desk to reward the smart children.

OK, boys and girls, I want you all to think about the word 'drinking' and put it into a sentence. Then I want you to draw me a picture to explain your sentence. I stare into my little tin and push around all the different words that are cut out on card. I really want one of those sweeties.

I think of my sentence: *My mummy is sick from drinking beer.*

Miss Miller makes her way around each child, offering support with the challenging task of finding the correct words to slot into place in the card.

'*I like drinking hot chocolate.*' *Very good, Martin,* she says, leaning over a desk.

I've chosen to ignore the words and have gone straight in with my crayons to draw my mother's face. A lovely smile, eyes with long spider-leg lashes, arches of red hair on each side of the head, and a round can of beer on her thirsty sick lips. When Miss Miller approaches me, I'm asked about my sentence, I give the story for my drawing. And say, *My Mummy is sick from drinking beer.*

Try again, John, Miss Miller says, looking embarrassed. She pushes my drawing of Mummy's face to the side.

Can you think of something else with the word 'drinking' in?

I shake my head; I have no other thoughts.

How about, 'the man likes drinking tea'? she suggests.

Reluctantly, I nod, but I know there is no such thing as 'the man drinking tea'; men drink beer!

Patrick looks over at me without a smile or a word, but I know from

his eyes that he feels the same way I do: confused. Inside our eyes is already a life lived, a life a child should not have seen. I watch as he struggles with the words, his distractions and setbacks are mine.

During the break, noisy kids run around, and Patrick plays football with other boys. His thin anorak flaps as he runs and jumps, screaming for a pass of the ball. Here, he is alive with fury and wild energy, hacking at the shins of bigger boys, no tears, no fear, no confusion. I don't understand it; I don't share that passion for the ball, the fast pace, and angry shouting scares me. Girls with plaited hair dart past me playing tig, dragging skipping ropes behind them like long rat's tails as they bolt back and forth on the cold concrete. I look at them and wonder which are my sisters; could they be here among this rabble? I watch children crunch through packets of salty crisps and chew on sweets that mummies and daddies have packed for them as treats for break time. At the children's home meals are strict, like clockwork, and with no snacks in between. Us kids never get a snack at break time or weekend treats; I rely on Sister Pauline to slip me the odd lint-covered mint from her pocket or an extra biscuit at supper time.

What do they taste like? I ask a girl, in the hope she will answer me by offering a Monster Munch, but the girl pulls the packet close to her chest and skips away.

I try to join the games of those who have snacks, but I'm so small and quiet that I'm just jostled around in the excitement of everyone playing. Something in me needs food, even though I am being fed at the children's home; the need to get more sits in the cave of me.

Defeated, I leave the noisy children and sneak back into the school, where I spin around in the dark corridor alone. My

classroom is dull without the overhead strip lights on; the energy is different in here without children and the squeaking chairs and the clap of Miss Miller's duster on the blackboard. When I open the sweetie tin that lives inside her desk, I reward myself with a blackcurrant Fruit Gum, then a lime one, next an orange Fruit Pastille, which sparkles with sugar. I reward myself until my mouth is claggy with a sweet, sticky gak. When the tin is empty, I head into the cloakroom and rifle the packed-lunch boxes and school bags looking for more food.

Right! You, whit's goin on here?

I didn't hear Mr Shaw, the school janitor, behind me, so I don't know how many bags he has seen me open. I freeze, then burst into tears. Although Mr Shaw does not have the long hair of my abuser, I fear his punishment might be just as dark. Instead, he smiles.

Dry your eyes and git oot an play.

I don't need to be told twice and run out of the cloakroom and into the playground.

Back in the classroom I try to compose myself and wait for Miss Miller to discover the missing sweets. As the day goes by nothing is said, but sometimes Miss Miller looks me right in the eye while she speaks to the class. It isn't an angry contact; it's a sure one, almost loving. She knows who took those treats – I don't know how she knows but she does – and she has chosen not to reprimand me.

I have spent two birthdays in the children's home, with no visits, no presents or cards from Mummy or Granny Gormley. Instead, I spent my special day sharing a cake with all the children in my group.

Today Maria has dressed me up in green tights and a green jumper with a big yellow headdress to look like petals that Sister Pauline has created. I am a sunflower, and we are going on a trip to Troon beach in a taxi. This day is known as 'The Big Day Out'.

The drivers of the Glasgow black taxis have organised this special trip for all care children every year since 1945. In decorated taxis, they collect children from underprivileged backgrounds and, after a parade, drive them to a beach for a day out. The theme this year is *Alice in Wonderland*, and everyone is dressed as a character from the story. I am given a shoebox decorated with wrapping paper and shiny ribbons by my taxi driver, who is dressed as the Mad Hatter. The box is filled with sweets – a Mars bar, Smarties, Spangles – and a packet of cheese-and-onion crisps. The box still smells of the fresh leather of the shoes that once lived in there.

At the front of the children's home, a jolly man with a microphone is interviewing boys and girls, asking them all about the activities of the day and handing out balloons with the words 'Radio Clyde' printed on them. I sit next to Sister Pauline, who is travelling with me. We wag and bounce our Radio Clyde balloons from the windows of our taxi, which is decorated with tissue-paper flowers and vines. After the parade, I am changed into red flared trousers, a white T-shirt with a red collar, and shoes that still don't fit from the second-hand bag, then we set off for the beach.

We drive in procession along the A77, honking our horns and waving at passing cars.

On arrival, Sister Pauline sets up a picnic on the sand while I run around exploring. Scary Man is with us, but he travelled in a separate car with other children. He doesn't even look in my

direction. I watch him lounge out on the sand; but I know I'm safe when Sister Pauline is around.

Standing at the edge of the water, my thoughts drift to Ronnie and Mummy and that fatal day when he drowned, the chaos that stung my soul and sealed my mother's fate. Surrounded by stones and smashed limpet shells, I think about the seashells that Granny Gormley collected, and peering into the lapping sea I hope one might make its way towards my feet. I look back up the beach to where Sister Pauline is unpacking Tupperware and foil-wrapped treats onto a tartan blanket. I am overwhelmed and start to cry. Sister Pauline strides down the beach towards me, kicking the sand up as she walks, her dark veil flapping behind her in the breeze. She takes my hand, and we stand there looking into the distance at where the blue sky melts as it meets the sea.

I miss my mummy and Ronnie, I say.

I know, love. It's very confusing, isn't it? she says, looking down at me.

Slowly and with care, she walks with me in the cold shallows. I plead with her not to go too far in in case she drowns, but she distracts my fears by talking about the coloured stones and how the water feels around our feet. Just as I am starting to feel confident, the conversation changes.

Has your social worker been telling you that they are looking for a new mummy and daddy? she asks me tenderly.

Yes! I say, squinting up at her.

That would be lovely, eh? she says with enthusiasm.

Will you be there? I ask.

No, John, I have to stay here and look after all the other children, don't

I? You won't see anybody from the children's home if a new mummy and daddy come along.

I look back at Scary Man and my friends. The man doesn't see me; he looks lost, lying fully clothed on the beach, scooping sand in his hand and allowing it to filter through his closed fist, while children run circles around him.

Sister Pauline, I'm hungry, I say, diverting the conversation.

Come on then, let's get our lunch, she laughs.

I run back to the picnic blanket and watch her lumber towards me through the sand. I know that change is coming; the adults talk about forever families often and I think of what that means while I eat crisps and sandwiches.

What's happened to your toes? Pauline asks, pulling at my sandy feet.

I wriggle my feet at her tickling touch and shrug my shoulders, enjoying my lunch. My little toes on both feet are permanently crossed over my fourth toe. She wipes them with a towel and pushes my sandy feet into the shoes that have been given to me.

These are far too small. She tuts and pulls them back off.

After lunch, Sister Pauline plays her guitar and sings to the sea and to all the taxi drivers, who have so generously given up a day of earning money to take us here. The men are gathered further back against the tide wall eating foil-wrapped packed-lunch rolls and enjoying a rare sunny day out in Scotland.

When we return to the children's home, with me holding my decorated shoebox full of sweets, Sister Pauline talks to Maria and explains that the shoes I have been given don't fit. I am told to be barefoot as much as possible while I am indoors.

*

Barefoot and in tears I stand in the back garden, gripping the chain-link fence and peering through at the street ahead. My heart is broken because today is Sister Pauline's day off and I know that Scary Man will be arriving to do the night shift later. Morag, who has been playing close by, walks over.

What's wrong? she asks, placing her tiny, freckled hand on my arm.

I want Sister Pauline, I wail.

She's not here today. Do you want me to get Maria?

I shake my head and wipe my snot and tears along the sleeve of my sweater.

I can get under there! I say, composing myself as I crouch down and point to a tiny gap under the fence. Morag crouches down beside me and we investigate the space.

With our bare hands, we begin to claw and scrape at the dirt until the gap is big enough, then like a soldier I wriggle through on my stomach.

Wait for me, Morag squeals. I stand up straight on the other side, dusting myself down. The little girl crawls under the fence after me, her dress riding up as she wriggles in the dirt. We giggle with delight, filthy from the soil.

Hand in hand, we run out of the front grounds and down the street in the direction of Sister Pauline's villa. We make it halfway when an old man in a flat cap stops us, grabbing at my arm with his wrinkly hand.

Hey! Where are you two going? the old man wheezes.

I point back to the children's home.

We live there, but we are going to see our mummy, I lie.

The old man laughs and hands me ten pence from his pocket. My mouth gapes open at the sight of the coin.

I never got any money, Morag sulks, letting go of my hand.

I'm telling, she sings, sticking out her tongue, and she takes off, running back up the street to the children's home. I continue and run around the corner.

Sister Pauline lives in a villa owned by the Daughters of Charity and run by the Archdiocese of Glasgow. She has taken me here a few times before for a quick visit: a game of Mousetrap or to listen to her records while we draw pictures together, angels from her stories and flowers. The villa is like a fairy-tale castle. Its huge stone pillars stand strong to welcome me into the doorway.

I clamber up to her door and knock. The door opens and Sister Pauline smiles.

Hello, John, she says, sticking her head out to look around. Her smile drops when she realises I am alone.

Where are your shoes? she asks, looking down at my dirty feet.

Maria said I could come and live with you! I smile.

Is that so? she replies, nodding her head. *Well, you better come in then.*

I run past her and stand in the entrance hall. The floors are polished hardwood, and it's full of antiques. To my right is a big room clad with mahogany wall panels. In the hallway stands a wonderful grandfather clock. Ahead is the big staircase that has a carved wooden cherub adorning the top of the banister.

But best of all it is dead silent: no sound of greetin' weans, no shouting staff, no screaming-drunk Mummy. The only sounds in here are the ticking of the grandfather clock, guitar music

and the occasional sound of a record, 'Fleur de Cactus' by the Singing Nun.

Sister Pauline takes my hand and leads me to my favourite room.

You wait in here.

The huge music room has a big high ceiling. Light floods in from a tall bay window, and musical instruments stand like regal figures all around me – a cello, guitars and an electric organ.

A huge artist's easel stands close to the window, holding a small unfinished pastel drawing of a single yellow flower. I push my finger into the loose pastel dust that has collected in a small pile on the wooden easel frame. Behind me is a brown upright piano. I walk over and lift the lid. My fingers press the keys, leaving yellow pastel dust on the white ivory. I delight in the crisp, sharp sound that vibrates around me in the room.

Standing on the piano stool, I look at the brown wooden metronome that sits on top. With a flick of my finger, I start the hand going, TICK, TICK, TICK, TICK. Lifting it down, I lie on my belly with my chin resting in my muddy hands. I listen to the ticking and watch the hypnotic hand bounce back and forth. The sun streams into the room, bathing me in light, and dust particles settle in the rays around the metronome, like a tiny snowstorm. I breathe deep and slow. At this moment I feel an intense calm, a feeling of blissful love, as if an angel from one of Sister Pauline's stories has danced from the pages of her Bible. I can see Sister Pauline through the doorway talking on the telephone; she looks at me with a warm smile as she talks to the staff from the children's home. I tune my ears into the conversation.

Yes, Maria, he's here. He is safe. Oh, ten minutes ago. That is no problem. We will see you tomorrow morning then. OK. Bye.

Sister Pauline hangs up the phone and shakes her head at me, and I smile.

I never did get to live with Sister Pauline, and after spending the night, cuddled up in bed under heavy knitted blankets, I was returned to the chaos of the children's home.

I am playing in the grass, in the huge gardens, with a plastic dolly that I have hidden by burying it in the dirt under some bushes. Scary Man had tried to take the dolly away from me, telling me dolls are not for boys, but Mrs Knowles gave me it back. Maria comes outside and sits down beside me as I rip up handfuls of grass and sprinkle it over my baby doll.

I've got some good news, John, she says. *Come, let us go sit over there on the bench.*

Clutching my doll, I head to a seated area under the big tree that has a rope swing.

Someone special is coming to visit today, Maria says with a big, excited smile.

Sister Pauline? I ask, squinting up at her.

No, she laughs.

My mummy?

No, John, Mummy won't be coming back. Remember we spoke about that with Daniel? Maria pauses for a second. *A new mummy and daddy,* she says. *How do you feel about that?*

I swing my legs around under me and smile, hugging my dirty,

soil-stained dolly. I try to get my six-year-old brain around what Maria has said, and although I do not understand, I know I am meant to be excited. She goes on.

Mummy and Daddy MacDonald have two children, a young boy called Jack and an older girl called Deborah. They live in a big house and have lots of toys, and guess what? I look up at her with suspicion. *A pet dog! And they want to visit you and be your new forever family.*

Before I can even give it some serious thought, I am being led by the hand and cleaned up in the bathroom. Maria wipes my hands and face and washes my plastic doll. From under my bed, she opens a small shoebox and inside is a brand-new pair of shoes. I pull them on, and they fit perfectly. But the damage is done; I have worn small shoes for so long now that my toes are permanently deformed.

We head up to the front entrance and wait for Mummy and Daddy MacDonald and their two children to arrive. I sit on the huge staircase holding my baby doll and my Muppet. I wonder about the new family.

Who are they?

Will they laugh at my crushed feet?

Will the daddy be angry?

What if I don't like them?

What if they shout?

What if they don't like me?

When I hear a car pull up, I run to the TV-room window to look. I watch as the visitors are greeted by Mrs Knowles and Maria. I run back to sit on the stairs and wait for the adults to stop talking, and

soon enough in the doorway stand the MacDonalds, who have been scouting for a child to adopt. They had come to the children's home before to look at a little girl and instead had spotted me playing and had fallen in love with me without me even noticing them.

Mummy and Daddy MacDonald, Anne and William, stand smiling down at me. Mummy MacDonald is smart looking, wearing a white blouse and a long patterned skirt, with a great big white leather bag strapped over her shoulder. Her neck and fingers sparkle and glitter with diamonds that flash at me as she hunches down and opens her arms to beckon me in. I cannot resist. I am sucked towards the two smiling adults and hug Anne tight; I feel William's big hand on my head, rubbing my curly hair.

I am introduced to the MacDonalds as my new mum and dad.

Where are the little boy and the big girl? I ask.

Mummy MacDonald can't stop smiling.

We will bring Jack and Deborah the next time we visit.

We walk through the children's home with Mrs Knowles as kids dart around shouting and playing. I am so proud to show everyone my parents and I grip Daddy's hand tightly in my own. Now and then he gives it a little secret squeeze and when I look up into his handsome dark eyes, he is smiling at me. One little boy runs along beside us and tugs on Daddy's arm.

Hey, mister, take me, you should take me, the boy pleads.

Mrs Knowles ushers the little boy away and leaves us alone in the garden.

Scary Man is out here with the children, and when he looks over, I don't feel afraid, I don't run and hide. I have Daddy's hand in mine; I am feeling safe and very proud.

Mummy tells me all about Jack, who is three years younger than me, and Deborah, six years my elder. She tells me all about the new house and describes a garden. Dad does some magic tricks with a coin, just like the policeman did the day they came to take me from my birth mummy. When it is time for Mummy and Daddy to go, I cry but they tell me they, at least, will return.

Within days I meet my new brother and sister and we are taken for a family day out. We visit Edinburgh Zoo in the morning and then the transport museum in Glasgow in the afternoon. I have my photo taken beside an old 'Gypsy wagon', holding hands and standing between my new brother and sister, unaware of the huge significance that the wagon has to my family.

Then we drive away from the city, through smaller towns, and eventually, I see green fields and cows. They take me to my new home to see where I will be living, just a wee quick look. Everything around me is calm, beautiful and happy. We head back to the children's home, and I play with Jack and Deborah in the garden. We were bought wind-up monkey toys from the zoo gift shop and when you wind them up, they turn their monkey arms 180 degrees like a jump rope, making a mechanical hiss. I look at my new mum's face sitting on the side of my small bunk bed; she is sober, clean and gleaming with treasures that hang around her neck and sparkle on her fingers. When the time comes for everyone to go home, I become hysterical. Knowing that my new family are returning to the beautiful big house without me is incredibly difficult.

Don't leave me here! I scream as they drive off the gravel path and disappear behind the trees. I believe the forever family will not return and I am being left behind.

I wait for Scary Man to make his rounds; surely my crying will alert him. I worry that somehow he will hurt me, jeopardising my imminent move. But he does not come back to my room.

Daniel is working with me on my 'life-story book'. He explains that I need to understand my past and future as much as I can. He hands me two scrapbooks, some felt-tip pens and Crayola crayons in a big yellow box. He asks me to draw my birth mummy, Margaret, and my memories of life before the children's home.

I draw a picture of myself and Margaret with Ronnie at Barrhead Dams. I draw myself in my buggy. I draw my mother's twin sister, Aunt Crystal, standing beside me and my Uncle Bobby, Margaret's younger brother.

This is Granny's house, I say as I draw. *And these are flowers.* It all looks incredibly cheerful and colourful.

He points down to a little blue stick figure.

Is this you? he asks, and I nod.

What are these little dots around you?

Those are my fleas and nits, I explain.

But he does not write this description down.

On another page, I draw a window with flames coming out.

What's this? he asks, pointing at my drawing.

That's the fire and that's me climbing out the window with a fireman, I tell him, pointing at the drawing with a snapped red Crayola.

I suddenly remember the fire very clearly. I remember being with a little girl in a burning flat. I remember having to climb through a smashed window towards a fireman while flames tore around me and the little girl. I remember being lifted down a huge metal ladder to safety, where Mummy was waiting outside for us, surrounded by a big group of onlookers. But I just can't remember who the little girl was. It doesn't matter anyway because Daniel doesn't include my drawing and rips the page out.

Will Mummy come to visit me in my forever home? I ask Daniel.

Birth Mummy won't, John. When you move to your forever mummy and daddy, Birth Mummy won't ever see you again, but I'm sure she will be thinking about you. Is there anything you want me to tell Birth Mummy for you? he asks.

I look up at him and think for a moment.

Yes, I say, looking at my drawing. *Tell her I'm sad that Ronnie drowned.*

Daniel uses tape to add some photos of my friend Patrick and me standing in the hallway of the children's home. He sticks in some photos of my days out with Sister Pauline. On the opposite page, he tapes my birth certificate. There are photos of Aunt Crystal, Birth Mummy's identical twin. I look at the photo and recognise the face; I cry for the loss. Another photo has Granny Gormley. Others show my sisters, Colette and Hannah. I look at the images and recall the faces, voices and feelings. The smell of rancid dampness in my old house, the constant hunger, the melted jelly, the sex, the constant shouting and fighting with her many partners, the physical abuse and neglect. It's amazing how much a photo can make every out-of-focus memory sharp again.

And with that sharpness, a sudden sensory overload cripples me with emotion, and I am once again there, back in the slums, being punched by the pain of my memory.

It is August 1983. My friend Morag has gone. Her forever family took her and her brother away over two weeks ago. One day they were here and the next they had been whisked away to a promised paradise. Today is my turn. I have a small bag of clothes packed up in the hallway, all new ones, fresh and clean, T-shirts, sweaters and shoes that finally fit and belong solely to me. Mummy and Daddy had been filtering out the second-hand clothes, replacing them with new ones from McKay's clothes shop in Coatbridge high street. I have said goodbye to Maria, Patrick, Jane, Sandy the dog, Mrs Knowles and the other children. I'm waiting for my family to arrive and take me to my forever home. Daniel tries to keep me occupied as my anxiety surges, in waves of fear and excitement.

When are they coming? I ask him.

Over and over he reassures me: *Soon, John. soon.*

Sister Pauline has arrived to make her last visit. I am so excited to tell her all about Mum, Dad, Deborah and Jack.

My name is John MacDonald now, I say, tugging on her arm.

I've got a brother and a sister; we've got a sandpit to play in, and swings, and a big house; you will love my new doggy, she is called Cinders, I tell her breathlessly.

She leans down and hugs me, rocking my body in her arms. And I am filled with peace, as if I am home already.

Oh, you are a lucky boy. That sounds exciting, John. I think you will be very happy.

She breaks the hug and clasps my face in her hands, holding my gaze.

And will you be a good boy, and work hard at your new school? I nod.

Sister Pauline is trying to say goodbye, but amid my excitement, it doesn't register that I will never see her again.

When I hear a car pull up outside, I let out a scream of delight.

They're here. My forever family are here!

They returned, they came back for me, and I'm finally going home for ever.

Daddy stands next to Mummy as she opens the back door of the red Mercedes and Jack, my new younger brother, climbs out, followed by my new big sister, Deborah. I stand in the doorway with Sister Pauline, Daniel and Maria.

'Hello,' Mummy mouths from the parked car across the short distance between us.

I look up at Sister Pauline. *Go on then!* she says, and I bolt towards the family like a dog chasing a ball. I throw myself at Mummy, and she hugs me tight in her clean perfumed arms.

Well, son, are we ready to go home? Daddy says, leaning in and pressing a kiss on my cheek.

Yes. I am ready for my new life.

I lead the family back into the main hall of the children's home. I can't wait to introduce my forever family to Sister Pauline. I search for her face through the excitement and chatter from the adults, but Sister Pauline isn't here and my heart shrinks. She has quietly disappeared around the corner back to her villa.

3

I run from room to room. Five big bedrooms, an enormous kitchen, a dining room, a utility room, three bathrooms, a toy room. It is all mine to explore. I am shadowed by Cinders, our family's West Highland terrier, who is just as curious about me as I am about my new house. I rush into the hallway and open a door, eager to see what is within these walls. What's in here? I pull at a stack of towels that are folded neatly on shelves and scan the space before rushing off to the next.

In the long hallway, I open the door of an antique unit and pull out a sewing kit and then a big metal tin. What's in here? I pop open the lid and different-coloured buttons jump out and scatter around me. What else is here? The phone book, pens and a three-way electrical adapter; I leave a trail of destruction and mess. I'm up and away

again, followed now by my brother Jack, who tries to keep up with my manic pace, but I move too fast for him.

My bedroom has two beds, one for me and one for Jack, and a big wardrobe. The toys are kept in boxes and old bread crates next door in the toy room. I look in the wardrobe and sigh, all these new clothes and shoes are mine. All lined up on hangers or folded, pressed and neat on shelves.

John, look at this. Jack is holding out an Action Man doll, but I'm already running past him and into the next room.

That's Deborah's room! Jack states, hesitating at the door as I rush into my big sister's bedroom.

I walk over to a dresser and grab make-up and lipstick. Is this mine? Little dog ornaments and ribbons catch my eyes. Are these for me? Beads and bangles. Gold trophies with little figures of Irish dancers adorning the top are lined up proclaiming first prize. I turn over vinyl records, cassette tapes and perfume bottles; everything is lifted, examined and dumped at my feet.

We're not allowed in here! my brother pleads.

I've never seen so many pretty things in all my life.

In the children's home I owned nothing. Everything was shared, right down to my underpants; you got what was served to you when the clean clothes were distributed. Toys were never mine alone, they were shared between the many children who lived there. When you were given a personal gift, you had to hold it close, hide it or fight to get it back. I came here to my forever family with nothing, even my Muppet Scooter was left behind and replaced with new toys. Mum got rid of everything that came from my past.

My new sister's room feels like a good space, a safe space, a visual room of colour and softness. I am overwhelmed by every detail in this promised land.

Right, John, calm down! I spin around with fright, but that firm and loving voice comes from Dad, standing in the doorway. After the chaos and hardships of the children's home, I am finally home, and nothing can bring me down.

In our huge living room, calm is restored. Dad holds me up in his strong arms. Years of teaching boxing to locals in the village and working as a scrap-metal merchant have built this physique.

We are looking at a gold-framed painting that hangs high up on the wall above our big stone fireplace. I feel safe with Dad, even though my previous experience with adult men has been traumatic; his energy is different, and I trust it.

Right, see that woman there? He points at a smudgy woman painted in oil.

Well, that is your Aunt Katy. And the girl standing next to her is your Aunt Jeannie.

I reach out and touch the painting. My fingers read the surface and impasto bumping across the figures that I'm told are 'my family'. I follow with my eyes across the canvas towards the male characters. One man looks slightly menacing because he has long hair.

Who's that? I ask, touching.

That's Uncle Charlie.

Who's that wee boy? Is he crying?

That's your Uncle Wully. Dad points to the little boy, who rubs his teary eyes with clenched fists.

At the front of the painting there is a campfire with a kettle brewing over it, supported by three metal legs.

And that young man standing at the back next to the wagon and the horse, well that's your granda.

I don't remember ever having a granda!

It is a scene from a Romany Gypsy camp, painted by Dad's friend and taken from old family photos Dad had provided. There is so much detail. A man holds a dead rabbit in his hand; it hangs down by his side like a limp rag. A woman further back stands next to the door of a brightly painted barrel-top wagon with what looks like a steel basin for washing clothes or dishes. There is a wee dog that has probably been the culprit of the rabbit's demise, its fuzzy face frozen for ever into the hardened paint.

Although I am told these people are my family, Dad's side, the Gypsy side, my granda, my aunties and uncles, I can't find Aunt Crystal, Granny Gormley or Sister Pauline.

Am I in the painting, Dad? Jack asks with curiosity.

No, you weren't born, Jack, Mum explains from behind the ironing board as she slides the hissing iron over little shirts, making them sharp for her two sons. *That is a scene from when Dad was a wee boy.* She nods, standing the iron up on its end to take a puff from her cigarette that sits in a big crystal ashtray at one end of the ironing board.

Am I a Gypsy? I ask, as Dad puts me down on my tiptoes.

No, but Dad is, says Mum.

You are a MacDonald, Dad says, smiling and punching the air with pride.

Sitting at the kitchen table, we eat fish fingers, chips and beetroot for dinner followed by a big piece of Arctic roll and canned fruit smothered in Tip Top cream.

Nothing wrong with your appetite, eh? Dad laughs, as I push a big spoonful of food into my mouth, emptying my plate.

I furnish the family with stories of the children's home, of Birth Mummy and Ronnie and all that I know.

Sister Pauline has a piano; have you got a piano? I ask my sister Deborah.

No. She smiles. *Would you like a piano?*

I nod.

Has Patrick got a forever family? I ask, my mind wandering to the little boy I had left behind.

Mum looks up from her plate.

Who's Patrick, son?

The wee boy from the children's home.

I don't know, son, she says, looking over at Dad, who is finishing the uneaten food from everyone's plate.

You are a MacDonald now, John, Dad says, placing down his fork. *We love you. Be proud and forget the past. Do you understand?*

I nod, staring blankly into the distance.

DO YOU UNDERSTAND? he asks again, with a harder tone.

Yes, I say.

Yes, what?

Yes, Daddy

Tears start to fall from my eyes into my empty bowl. He reaches over and puts his massive hand on my head.

That's better. Aw, come on, what are you crying for? You're not in trouble.

I am settled in my new bedroom and kissed goodnight by Mum and Dad, tucked under my quilt with Jack already fast asleep in our shared bedroom.

Lying here, I listen to the new sounds of my forever home: the soft rumble from the boiler room down the hall, a slow dripping tap from the big posh avocado-coloured bathroom and the occasional moo from the cows in the endless farmers' fields that surround the village. It is quiet here, peaceful, with no shouting children, no orchestra of echoing coughs and giggles or crying coming from the different dormitories. I feel buttered into these thick quiet walls. Am I staying for ever? Is it true? Or will these adults break that promise just like Birth Mummy did so many times? No, I think they like me, they really like me. Slowly I allow my body to become soft.

My mind drifts back to the children left behind in the children's home, to Sister Pauline, Maria and Sandy the dog, Scary Man, Morag and Patrick. I replay running around the corridors like a ghost. I can still see it, smell it, feel it. My mind fires up the images of Sister Pauline, and I soak in the details of her warmth. I add this to the archive of memories I have already banked of Granny Gormley and her tortoise. I see now the colours of dear dead Ronnie: a Celtic football top, blue denim and brown water.

Birth Mummy comes next. I remember her face, those minute details, the way her mouth was often dry and her lips would stick together with a thirst for drink. Her smell, like wet tobacco, her dark

eyes full of mania and panic, her shaking, the shouting, dampness, and the black mould that marked our walls. Those spores are shot from past to present: from the hunger and violence of the slums.

I remember her. I remember until I fall fast asleep in this new bed and, like a boat, I'm taken to new lands with new dreams far away from my memories. But I have a secret telescope, and when I need it, I can close my eyes and see far into the past and remember.

The morning air in my new village stinks. The farmers have been busy spreading dung in the fields to fertilise the land, leaving a sickly-sweet pong. The village was once a thriving mining community, but the mines closed long ago and now Dad owns much of the surrounding land, along with the cattle farmers. Our house sits on a huge plot behind the tiny Main Street, which has one shop, a post office and two pubs, known as the big shop and the wee shop – one for the Catholics and one for the Protestants – only yards away from each other.

Our garden is enormous and beautiful. At the back door are several red-chipped gravel paths that lead to different areas, vegetable patches and a sand pit. Enormous mounds of earth are heaped into rockeries full of flowers and bushes. Three of these big islands dominate and separate different areas of the garden. Manicured lawns blanket areas to run. It feels like paradise reborn.

Mum's dad is my new papa, and he comes here every day to look after the grounds and garden while Dad goes out to work. Papa Bill is a tall man with balding white hair kept under a greasy bunnet. He has an enormous tummy that protrudes from the bottom of his

knitted sweater, and he smells like petrol, earth and alcohol. Papa sits in a greenhouse reading the papers when he takes his breaks from gardening; he seems to have lots of breaks. I zoom around with Jack, playing with toys that are shared equally between us.

My favourite part of this garden is our swings; they aren't those flimsy green-framed swings with orange ropes that you can buy from that Great Universal Catalogue. These have solid steel bars set into paving with thick rubber saddles supported by heavy chains and well-greased brackets. This kind of effort to satisfy play, hand built by my dad, is so reassuring. Dad says that kids come from all over the village to play on the swings he built; they are for everyone, he tells us.

I swing for hours. I love that motion and the feeling of flight, the tingle in my lower tummy. It is like meditation, and as I go backwards and forwards, I feel like the hand of Sister Pauline's metronome. Her face flashes into my mind, overlapping the senses of the new home. From my perch here I can see everything around me because the swings are central to the land. To my left is our big house, it is as long as four double-decker buses back-to-back; in front are Dad's transit vans and our family caravan, then Mum's Mercedes car parked on the drive in front of our garage. Behind is Papa's greenhouse; he's in there reading the papers. Up here as I swing, I can absorb the world around me, think, remember and dream.

As the day ends, Papa Bill goes to the Catholic pub and drinks beers and whisky until he gets plastered, then Dad drives him back to his own house before dinner. The forever family life is working out.

*

In the evening, Jack and I are bundled into the front seat of Dad's big, battered transit van, which smells of diesel. Soiled tools and papers sit on the dash. Dad has a fat sports bag packed full of brown and blue boxing gloves. We are visiting his gym. I'm not sure what that is, but I'm happy to be going along for the ride. We pull up outside an old church which is just up the hill from our house and past Dad's scrap yard. As we pass I can see mountains of old cars and twisted metals towering over the fence.

I've been in churches and chapels before with Sister Pauline, but inside this church there is a different kind of service. Men are in shorts and sweatpants, some running, some skipping fast over a rope that skelps and whips the cold ground. Thuds, groans, shouting. Men laughing and men panting. Most of these boys are Gypsies, my new cousins or second cousins. Dad has seven brothers and three sisters who all have kids, who also have kids.

Boys from the housing scheme come here too, encouraged by my dad to stay away from the heroin pandemic that has gripped our village. Some of these boys have brothers, sisters, even mums hooked on the drug. I stick close to Dad and Jack.

The main church hall has been stripped of its pews and adornments, it is a dark and dusty skeleton of the once holy. Brown punchbags hang by chains from beams. Big boys are dancing around and battering them with hard fists and concentration. Old, mottled mirrors stand the full length of the walls, reflecting the dull room of swirling and sweaty virility. Big tan-coloured suede medicine balls lie around next to roughly welded iron weights for lifting. The stained-glass windows that once illuminated the church with dazzling colours and images of saints are gone and covered by

water-damaged plywood, shutting out any light from the heavens. It reminds me of the slums.

Hiya, John. I'm your cousin; my name is John as well, says a big lad with a huge mop of curly black hair and massive muscles. He shakes my hand and smiles.

Everyone has a thick accent, it's somewhere between Irish and northern Scots. Some words I hear are alien to me, and this tongue is spoken fast, but I like the rhythm and the sound.

Hiya, John, I'm Cousin Wully. Are you ready for boxing?

I nod, but I am terrified.

Tucked up where the minister would have stood to give his sermon stands an enormous elevated boxing ring. A different kind of altar, where kneeling is seen as a weakness and God is not an angel but the winner of a brutal fight. The platform and ropes bounce and creak under the weight of two men dancing around. They land hard punches on each other with bursting hisses through clenched teeth, as their bodies lurch, raining sweat.

Right, boys, away and play, Dad says, waving us away as he disappears into the changing room to get ready.

Jack and I stick close to each other and play in the cold building with apparatus that isn't being used, most of which is old, rusting and home-made. We play tig, weaving in and out of the punchbags, making them swing as we push past. Somehow, I feel comfort in the ruin of the old building; something about it feels familiar, the damp, the dank.

Dad is in charge here; and when he appears, he has a stopwatch hanging around his neck and gives his sermon to the large group of

men who stand in a circle around him in reverence. On Dad's word, the men start to run in a huge circle around the hall.

Arms up! he shouts, and they raise their arms above them as they run. Dad times them on his watch, shouting at those slacking or not pushing hard enough. I remember Scary Man giving such orders on the stairs, but these men are enjoying the pain; they are happy to obey. Next, they dance as they run, legs moving in a complex pattern. Fast feet make zigzags and training boots squeak against the floor. With fists up to their faces, they punch out into the air in constant motion and formation.

Change! Dad shouts and, in unison, they turn and run in the opposite direction.

Jack and I join in.

TIME . . . Dad calls out, allowing the word to stretch as all the men slow to a stop and walk in slow procession, gasping for breath, pacing the panting in preparation for the next exercise.

Big strong hands are placed on my tiny shoulders by these new cousins, giving a light squeeze at my skeleton as they pass: solidarity and encouragement for keeping up the pace with the men while we ran. I feel part of something strong and safe.

At break time, everyone has a moment to catch their breath, to have a small drink. Men have yellowing sweat-stained bandages and are wrapping their fists up for protection, like mummies from ancient times. Some are lacing up or adjusting high boots, others spring around, shadow boxing in the mirrors, fancy feet and bobbing heads, a beautiful but tragic dance.

Without warning, a figure enters through the front door and all the men look up and call out.

Jimmy Banks, how's it goin, auld yin?

The men look pleased to see this new arrival, but not me. Dread pulls the blood from the top of my head down to my feet, like a full bath is being drained inside my body. This man has long grey hair and, as he approaches me, I am stuck to the spot.

Are you aright? a bigger boy asks, noticing the fear spreading over my face. The new man lunges towards me and smiles, flashing short, yellow-stained teeth.

Hiya, he whispers into my terrorised face, landing a soft fake punch on my jaw, along with a wink.

Daddy! I cry out.

I run around, scanning the men's faces until I find Dad and he comforts me, without question. I know I'm not allowed to talk about the man from the children's home.

Over the manicured and floral expanse of our back garden, a secret pathway meanders through a tangle of bushes and young silver birch trees. Then across the road is an old house that was once part of the abandoned railway leading to the brickworks and mines. The house sits on a parched plot of dirt, unadorned save for the wildflowers, dandelions and shrubs that seem to flourish in its neglect. Dotted around the house are caravans – a big shiny silver one and two smaller ones with green mildew glowing on the roofs. I don't think anyone has lived in them for some time, and nature has buried them in a mossy-covered embrace. At the back of the yard, there is an apple tree throwing shade over two dismantled cars that are bereft of wheels and perched on bricks, left here to rust in peace.

Mum, Jack and I make our way to the house. Mum looks out of place; she is immaculate, in a long skirt patterned with brightly coloured watercolour flowers, a white blouse and her trademark diamonds. Her black hair is set back, and a warm smile spreads across her beautiful face.

Mum is not a Gypsy; dad says she is a 'gorja' woman, which means she is not from travellers. Her accent is different, her voice is crystal clear – the Queen's English, she calls it – and when I say 'Naw' or 'Aye', I am quickly told to 'speak properly'. *It is yes and no and please and thank you, and I beg your pardon.* My Glaswegian slang is slowly taken from my tongue and replaced. But old habits die hard and occasionally I slip back into willy, bum, shagging, boobies, shit or fuck. Mum's smile constricts when I do this and it creates little lines around the edge of her lips. *Right, that's enough of that dirty talk,* she will say. Even the slightest disapproval in an adult's eyes is enough to upset me. The fear of not being enough, not being wanted, not being impressive, stings like jaggy nettles in my infant heart.

This wee cottage is where my dad's mum lives, my Gypsy Granny MacDonald. It has one bedroom and a toilet but no bath – everyone baths in the front room by the glow of a fire, cooking in a big steel basin filled with pan-boiled water.

Lots of my Gypsy family live here. Two grown men, Granda and Uncle Charlie, two grown women, Granny and Aunt Jeannie, and her two teenagers, my cousins Emma and Joe-Joe. They all sleep in this one-bedroom cottage which once belonged to the railway master. The old abandoned line adjacent to the house was one of Scotland's first ever railways, taking clay, coal and steel to and from the now abandoned mines. The original house was bigger, but Dad

divided it, and now it has a tiny one-bedroom house attached to the end. In this part live Aunt Mary and her two sons and daughter. But mostly everyone meets in Granny's side during the day.

At bedtime, tables that have patterned curtains around their bases fold out to become beds, and sofas transform into beds, until the front room is just one cramped bedroom for the three men. Granny and Aunt Jeannie get to share the bedroom at the front, and Cousin Emma sleeps in a small cupboard-sized room by herself. It's the same in Aunt Mary's next door. Her boys sleep together in the one bedroom and Aunt Mary and her daughter sleep on transformed sofas.

Granny collects things just like Birth Granny Gormley did. Here is a veritable Aladdin's cave of ornaments, Crown Derby and Royal Doulton plates, shiny brass figures and comfy knitted blankets. Although this is not a wagon and the family have long been settled from travelling, it feels like the one I was shown on our day out at the transport museum in Glasgow. Around the house are also reminders of a time when Granny and Granda travelled in a wagon. Framed black-and-white photos take pride of place on the fire mantel, showing images I recognise from Dad's painting of the wagons and campsite.

The house buzzes with the fast Roma language that these people speak. Sitting in an armchair, my Granda Jock has a cheeky twinkle in his eyes. He wears a waistcoat and has a scarf tied with an intricate knot around his neck. He loves teasing us, telling jokes and singing wonderful songs, whistling and belting his gums together as he warbles out a tune. Already Granda is teaching me new words in the Romany language called Scottish Cant.

Jougals jeer, he says, throwing his head back with laughter, exposing a gummy mouth.

That means 'dog's arse' or 'dog shit'. It's my favourite phrase, although I never get to say the words, or I'll get a skelped bum and shouted at by Mum.

Jack always sticks close to Mum when we go out anywhere, barely saying a word. He is her baby. I'm curious and more inclined to wander into other rooms. I'm high on nervous energy, always clawing at my clothes and chewing my nails.

Jack is playing at Mum's feet with a toy car; he hates visiting Granny's house.

I'm bored, he moans. *When are we going home?*

Granny MacDonald is the head of our family; both households, sometimes fifteen people, congregate around her. When she talks everyone stops to listen, not because she is loud, far from it – her gentle quietness is regal. She is very different to Granny Gormley from my old life, softer, more graceful, and she is magic.

I follow her into the kitchen, where she begins the process of peeling carrots to make soup. She is singing softly in her thick Scots Roma language, allowing me to be in her presence although not acknowledging me.

She is a wee short woman, with long white hair that she keeps in neat, plaited coils around her head and held in place with beautiful mother-of-pearl hair combs. When it's not pinned up it almost touches the back of her knees. She has a pinafore covering her long floral skirt, which gives the illusion that she is floating as she walks, just like Sister Pauline. She wears layers of beautiful beads, coral and amber, which hang over a neckerchief scarf, and gold sovereign

earrings that over the years have weighed down her lobes, turning them into long slits.

She pushes half a peeled carrot and a biscuit into my hand.

Here, she says, folding my fingers over the treats.

Back in the living room, Mum is finishing her cup of tea and her chat with Aunt Jeannie. Mum sits upright, slim legs in brown nylons crossed over each other, and her chin held high. She looks very elegant. Aunt Jeannie hunches over with her elbows resting on her out-turned knees. She has unbrushed hair and her top lip has a thin layer of black fuzz resting on it. Her clothes look old-fashioned, a long skirt covering her ankles, and a tatty cardigan. Her Roma accent is sharp, and in between sentences, she gasps for breath muttering, *Jesus fucking Christ! A cannae get a breath,* then sooks on a brown inhaler and coughs up lung butter that she spits into a hanky. Sometimes she swears at the TV and spits into the palm of her hand, then rubs her wet palm into her knee. If text appears on telly, she will ask someone to read it, because she never learned to read herself.

When she speaks to me, she becomes softer, changing her tone to talk in a childlike way. She expresses love with cuddles and snuggles. It's funny to see Mum in this environment: a Catholic woman, full of manners and grace, accepted by her Romany husband's family. Jack and I are stuck between two worlds, but I love it here.

We walk home the long way, past the big shop Catholic pub and down the village's main street, then past the wee shop Protestant pub. I walk ahead, then stop dead in my tracks, cock my leg like a dog and let one rip.

Good arse! I say with a huge smile.

How dare you! Mum shouts, her face flushed with embarrassment. *Where did you see that?*

Fae my granda. I smile with pride.

My native Glasgow slang has been possessed by this new Roma accent. I'm a natural mimic.

Mum grabs my arm and spins me around to face her. She is furious, and her eyes have changed to a cold glare.

Don't you dare do that again, do you hear me? she barks.

Aye, I say, returning to my Glasgow slang as I try to wriggle my arm free from her grasp, but her grip tightens to a pinch.

It's not aye, it is yes, she corrects.

Yes, I say, defeated.

Disgusting. This is her final word on the matter.

Amid the shuffling of desks and the clatter of pencils, I find myself once again starting a new school. Even though Mum is a Catholic and my earlier experience of school was at a Catholic school, I am joining the Protestant one at the top of the village.

I'm sitting at a little desk. Mum is sitting beside me, supporting the transition into Mrs Dunbar's class. I'm doing what I love most: drawing. It's a race car, Mum's Mercedes that she is so proud of.

Oh, that's lovely, son. She smiles and nods as I hold the drawing up to show it off. But it feels like Mum is a million miles away, lost in thought and unspoken worry, just like my birth mummy would be at times.

I love being called 'son'; it's the most reassuring word an adult

can ever use. Birth Mummy called me 'Curly Tops' because of my hair, and when she was sick from drinking she would scream my name.

After some reassurance that Mum will return to collect me, I settle and immerse myself into school life. I sit beside Kate Mcgee, who has very plump rosy cheeks, and wild blonde hair in bunches. She tells me to look under the desk because she isn't wearing any knickers, so I do, and she isn't.

You're a Gypsy, she says as we roll big, long snakes of plasticine onto our desk with the palm of our hands.

I'm adopted!

Our teacher, Mrs Dunbar, looks like our prime minister from the telly. She shows me how to shape the plasticine snake into the letter 'J' for John.

I am behind. My parents have instructed my teachers not to treat me differently, to hold me to the same expectations as everyone else. And while my dad has threatened to allow the teachers to belt me if I misbehave, it's an empty threat.

My classmates are all locals to our small village and after a few months in their company I become aware of my difference. I am a Gypsy, I am adopted. My eyes are dark and almond shaped. Iain Cameron is the first to point that out during playtime by chanting *Gypo*, *skinny*, *Chinki* and *specky four-eyes*, until he has whipped up enough of a frenzy to have all the boys on his side in a circle around me.

I don't want to play with the boys anyway, their energy terrifies me, but the girls tease me just as badly. It hurts more that the girls won't include me in their imaginary games of galloping horses or

mummies and daddies or shops, because it is in those gentle games I feel safe. At playtime, it is better to hug the perimeter fence at the far end of the playground looking out into the distance. I stand there feeling confused by life and dreaming of Birth Mummy, Sister Pauline and my friends from the children's home.

Mum is busy in the kitchen when I return home from school one afternoon, she is slicing peeled potatoes into thick chips for dinner.

Mum, am I a Chinki? I ask.

Mum doesn't turn around. Looking over the huge spectacles she's wearing, she concentrates on the knife cutting the white spuds.

No, you're not! And we don't use that word. Her voice is tinged with disapproval.

She looks down at me for a second, her eyes narrowed to show her distaste, before returning to the task at hand. Then she talks to the cut potatoes as though they are the only ones listening.

We think you might be French or something, she says, waving the knife in the air and making a little circle on the word 'French'. But the words come out quietly and seem to be said with some reluctance.

French? I repeat, screwing up my face with confusion. *Why?*

There is a long silence before Mum finally looks back down at me and sighs.

Because on your birth certificate, your name was Juan. That's the name you were given when you were born.

Mum turns away and plops big handfuls of chips into a colander ready to rinse.

I think about this new foreign name and being French. I've always been called John; I don't remember being called Juan.

Can I see my birth certificate? Where is it? I ask.

It's put away, John, she says.

Ah, my name is Juan, I correct.

She whips her head around to face me.

Your name is John MacDonald, OK? she tells me with a nod of her head.

I nod back.

She drops the potatoes into a pan of hot fat, which erupts and hisses.

Have I got funny eyes?

You've got lovely dark eyes.

I don't believe her.

Why do I have to wear glasses?

You just need a wee operation to fix your squint, but your eyes are nice. Go and play with your brother.

Does my birth mummy need to have an operation on her eyes? I quiz.

Mum gets exasperated and wipes her starchy hands dry on her floral pinny. When she turns to face me, her eyes look hurt.

I don't know, John.

Can you ask her?

Mum's face turns red.

John, go and play and we can talk about it another time.

I shouldn't have asked. I'm bad for asking, it is clear from Mum's energy. Unsatisfied and afraid of disapproval, I head off in search of my brother to play before dinner is ready. But the seal is open.

I need to see the life-story book that Daniel my social worker helped me create; the answers are there.

At primary school, I eventually make friends with a little girl called Sarah McPhee. Sarah is also being bullied because her grandfather, who looks after her, only has one arm.

He delivers little cartons of milk in orange crates to school each day, carrying the heavy load in one arm while the sleeve of the missing arm flaps around, like a haunted ghost arm. Boys laugh and point, and girls run screaming when they see him coming.

Mr McPhee the one-armed milk monster, they call out as they bolt away.

Sarah always looks so embarrassed when he arrives.

During breaks, we play girls' games, dolls or houses. The same games I had grown used to playing with the girls at the children's home.

One day I turn up to school with Mum's jewellery, thousands of pounds' worth of diamonds and gold. I had snuck into Mum and Dad's room just before Papa Bill took me and Jack to the bus stop to catch the school bus. It was where I thought Mum and Dad had put my life-story book, along with my birth certificate and photos of my family, but when I searched the bottom of their wardrobe, it had been moved and instead I found diamonds and gold.

I opened a big red leather box brimming with heavy gold chains, rings, charms and bracelets. Further digging uncovered a little felt bag and inside were tiny baby teeth. I held up a sparkling diamond ring and a gold bracelet that twinkled with tiny charms – a little

bunny, a lantern with a diamond in the centre and a little wagon. On impulse, I popped them in the pocket of my school trousers.

At school interval, my pockets jangle with the treasure until I produce the gifts.

These are for you, I tell Sarah. *My mum said you can have them.*

Later that evening Sarah's mother knocks on our door and quietly returns the jewellery, and I am branded a thief.

I don't understand the boundary of taking my adoptive mother's things. Taking things that weren't mine was something I learned from Birth Mum and in care. You took what you could, otherwise it would disappear. After a sit-down talk with Dad and Mum and a lecture about right and wrong, I cry and ask if I'm being sent away for stealing. Mum says, *It doesn't matter if it's even one penny that isn't yours and you take it, then it's still stealing.*

I realise that I must stop asking about my identity or if I am going back to the children's home or when I will see Sister Pauline again. I must accept that I am John MacDonald, a boy who was adopted. A boy who has a secret past. These people are my real mum and dad, in my real house with my family and my things.

We've given you everything and this is how you repay us, by stealing.

I feel bad. I guess that's why I was in care, that's why I had been abused, that's why I was adopted and that's why I couldn't read or write.

I claw at my head, this time not because of lice but because of the Scottish midges that swarm around the loch. We are on our first family holiday together and have come to Arrochar for a long

weekend. When Dad hitched the small, avocado-coloured caravan to the back of the car, I could hardly contain my excitement. It is a tiny home, following us wherever we go. I can't help but glance back again and again, just to make sure it's still there, still a part of our journey. The thought of having a home that followed us, no matter where we went, was something I had needed for a long time.

Mum has dressed Jack and me in identical outfits, little uniforms, spick and span, red and blue shorts, and T-shirts with a cartoon Loch Ness monster on the front and the words: 'I'm a wee monster from Loch Ness'.

While Mum sets up home in the caravan, unpacking the bunks and setting out dishes and clothes, Dad takes us out for a walk along the shore for ice cream. It is beautiful here. There is a fjord-like sea loch framed by distant hills and huge trees. The air smells different to our village, it's missing the acrid tang of fresh cow shit from the farms, and the oil from Dad's working clothes. Here it smells fresh, like sun-baked stones and earth, with an almost metallic breeze that drifts from the surface of the loch.

Dad is teaching Jack and me words to say in his native Roma Cant. As we stroll around, ice cream runs down the cone onto our hands.

Sossi tiro nav? Dad says with a wink, making Jack and me laugh. *Do you know what that means?*

I shake my head. Jack couldn't care less; his face is buried deep in his cone and he isn't coming up for air.

Well, it means, what's your name? You say it. Sorri tiro nav. Dad nods down at me to repeat after him.

Sorri tito, I try, between licks of the soft vanilla.

Ti-ro nav. Try it again, Dad commands.

Tiro nav. I smile, happy at being able to mimic, and it's clear from Dad's pride-filled face that I got it correct.

He is a patient man, and his love for us is tangible.

He is OK, Anne, he will say when I'm getting super high.

HEY, SIR! BEHAVE! are usually the words he barks when my excitement or nerves get out of hand. His eyes will narrow, and his tone drops as he says it and it's enough to ground me again. I know it is an empty threat because as soon as I have registered the words his eyes will fill back up with love. The fear of letting him down or losing this love is enough to stop me.

Back at the caravan, Mum has finished setting up home. All the dishes that were put away for travelling are now set out, along with a cutlery carousel and kettle. There are even patterned cushions on the bunks. It's so perfect, neat and cosy. With a windbreaker under one arm and two fold-out chairs under the other, Dad leads us back out to the beach.

Mum has prepared gammon rolls, wrapped in foil, just like Sister Pauline would make for our days out. The wee beach is alive with families taking advantage of the Scottish paradise. Mum and Dad settle down, Mum puts on her large dark glasses and begins to read a book. It's her chance to unwind and let Dad take charge of playing with us boys. Armed with plastic buckets and spades, we begin digging in the soft, gravelly sand. Building a sandcastle that stays upright proves to be a challenge, but with Dad's encouragement, we persist. As I gaze up at my dad, in awe of his skills, I suddenly become aware of her presence.

I recognise her immediately, the red hair, the freckles. It is my

friend Morag from the children's home. She must be here with her forever family.

I bounce to my feet. Finally, something that comes from my memory manifests itself into reality. I rush forward to greet her; maybe Sister Pauline is here too?

That's Morag from the children's home, I scream at the top of my voice, pointing with one hand and giving the girl a wave with the spade in the other.

I look around: all the mums and dads on the beach are now staring in my direction. Mums who have been relaxing sit up and look over their ugly sunglasses. People are nosy and the words I've just shouted, 'children's home', sound like dirty gossip.

Hi, Morag, I shout. Morag smiles and waves back at me. Her adults smile also, although they look embarrassed. Mum, who was deep in a book, now sucks the air into her mouth through her teeth as though she has smashed her wee toe on something hard. I'm heading in the direction of my friend, but Dad is fast behind me and puts his hand over my mouth with a nervous laugh.

But I know her, I say, wriggling free from Dad's grip.

Just be quiet, he says, pulling me back to our nest in the sand.

Mum and Dad have some words together, then slowly we move our picnic blanket and deckchairs far along the beach and away from my memories. Why was I not allowed to recognise her? My seven-year-old brain cannot understand.

I can't stop thinking about Morag and Sister Pauline; I can't settle. It's not often that someone I've been separated from in my life – an important person connected to my past – reappears. I might even see Birth Mummy.

Later that day Dad takes me and my brother out on little blue rowboats. He tries to explain to me that I must not question things so much.

Look, John, I am your dad and I love you. You have to put the past in the past, son.

When we are far out in the loch, my excitement that was replaced by confusion has gone and dread sets in. I worry that I might fall into the loch and drown as Ronnie did, so I stick close to the centre of the boat as it slowly moves around the water. Dad keeps reassuring me that I am safe.

Look, boys, there's fish! he says, pointing into the clear water.

Jack isn't afraid and leans right over the edge in his excitement to look, but with his quick movement, the boat rocks and I jerk with fear and grip the sides.

What kind of fish are they, Dad? Jack asks with enthusiasm, huddled next to Dad at the other end of the boat.

I try to relax; I try to be interested. But every muscle feels tensed with dread.

Mum and Dad know about Ronnie drowning, my social worker told them about it during my transition, but nobody has ever asked me about that day. Chaos lingers in water like a fishing line to my past.

I take off one of my new black plimsoll shoes and stare into it, distracting myself from looking over the edge and into the imagined ghost face of Ronnie. The shoe is full of grit and sand, so with a thump I bang it on the side of the boat to loosen the sand and make more space for my feet, but it slips from my grasp and with a plop it sinks to the bottom of the water.

Ohhh ahhh! my brother sings, and Dad's face grows beetroot with anger.

Why the hell have you done that? You are a big fuckin eejit. You did that on purpose, John!

I shrink down in fear and shake my head.

I didn't. It slipped out of my hand, I plead.

I look down, willing the lost plimsoll to rise back to the surface, but it remains stubbornly at the bottom of the loch.

You're a liar. I watched you, John; you tossed that in on purpose.

I have not the time to explain, as the shock of this loving figure, now enraged, looms over me. Angry men, angry eyes; I've seen them so many times before.

Dad rows the boat back to shore, shaking his head in disappointment. I cry all the way, shamed with one shoe on. Jack sits beside Dad as he rows. Everyone hates my guts. When we get back to the caravan Dad makes me tell Mum the story of what happened, but his version.

I threw my shoe in the water.

You did what? Her voice rises at the end of the question. *Brand-new shoes?*

Mum's tone and looks aren't of disappointment like Dad's, they are of utter disgust.

What have you got to say for yourself, eh? You don't deserve new shoes!

They have no idea that a couple of years previously I had been subject to such shouting, yelling and violence from my birth mum and the men around her.

*

As the weeks turn into months and the months into years, I feel lost. Mum is at her wits' end with my manic behaviour and Dad just can't get through to me. I can't understand my feelings myself. It is a numbness. Then one day Dad lets me look at my life-story book, in the hope it will give me some form of closure.

It's brought out in private in Mum and Dad's bedroom and only for a wee minute. Dad sits right beside me on his big bed, but Mum stands at the door just watching. Jack is playing in the other room at a safe distance, where the book and any trauma that might spill out from it won't tarnish their good boy. The front cover reads, 'Big Value Sketch Pad for the Young Artist', in orange and brown Seventies circus font. The front is yellowing under Sellotape that holds it together. Someone has written 'John MacDonald's Life Story Book'.

The first page reads, 'My name is John Mckelvie. This is my life story.' Under this there is a photo of me age four with puffy red eyes and wild, unbrushed hair. Next to this is a drawing I made of myself and under this it reads, 'This is me. I drew it in the children's home on the 8th of December 1982.' I read the words aloud. Dad lets me do this, showing empathy by rubbing my back. Behind me in the photo is the main entrance hall of the children's home; it is out of focus, but I know exactly the place I am, I can smell it. The next page is my birth certificate. It is a photocopy that has been copied so many times that it's faint and part of the text is missing at the side.

That's your birth name there. Dad points to the swirling joined-up name. Juan Gonzalez Diaz Abara. He tries to say it but pronounces Juan like Joanne.

Before I can look down the page, at mother's name, father's name

and mother's address, Dad turns the page. The next couple of pages give a brief explanation of why I was in care, written by my social worker Daniel in a childlike way, a safe edit. It says I was taken into care because Mummy was depressed and sick from drinking beer. Dad turns the pages quickly until we reach the photos. There are several pictures of me, one with Patrick. I point and look at Dad.

That's Patrick who I told you about, I say with excitement.

Dad acknowledges by nodding to go on. The next page has me and Sister Pauline. *That's Sister Pauline,* I say, placing my hands down onto the pages to hold our time there. I smile, looking up at Dad.

Now somebody else has seen these images I don't feel so alone, because these people are real in someone else's eyes now too. The next page is full of drawings.

I remember doing these with Daniel, I explain.

One of the drawings is of Barrhead Dams. It looks like a big blue swirling cloud; this represents the furious water. I yearn for Dad's enquiry, a prompt to unlock the floodgates of memories and conversation. Yet without his words, I hesitate, fearing that sharing these recollections may betray the loyalty I owe to my current parents, stirring up a lost love that still lingers. Next to the dams are drawings of Birth Mummy and Ronnie. The memories flood into me. Memories and feelings tangle around my mind, forming a complex knot. The next page has two photos missing; I know this because the Sellotape that held them here is still fused to the page. The last pages have photos of my sisters. It looks like Hannah is mid-roll, going down a hill on her side, the person has snapped the photo just as her face has turned to the camera. It reads, 'Hannah

age 12.' The photo of Colette is the kind social workers take when a child is received into care, it looks like a mugshot. It reads, 'Colette age 9.' I have no memory of either of these girls, they are strangers to me, and that is very confusing.

The very last page has two photos of faces I do remember. Granny Gormley stands in one of her Victorian gowns. She looks caught off guard. I can smell her cigarettes through the image. Aunt Crystal, Birth Mum's twin sister, is sitting down in Granny's house; I know the location because I recognise the old birdcage behind her. She is so beautiful. Long glossy red hair frames her face, a face like mine, with dark eyes like mine and an identical face to Birth Mum. She is smiling at me, and it makes my heart hurt. Dad closes the book and that's that, moment over. I'm back in their bedroom.

My birth family looked so normal in the photos, so happy, so I can't understand why I am separated from them.

I look up and Mum is busying herself folding things into drawers. She doesn't want to acknowledge the feelings in my eyes. A numbness creeps over me, slowly paralysing my heart. Memories, long forgotten, rush back with an intense ferocity, each one more poignant than the last. The photos are a time capsule, preserving a life that was once so real and yet so far removed. My birth mum's twin sister's smile fills me with a sense of longing and loss that I cannot quite articulate. The fading tones, the blurred edges, the worn corners – all speak to me of a life that was ephemeral, fleeting, and yet imprinted for ever in my mind.

The life-story book is never mentioned again.

*

At school, I sit at my desk with a pair of scissors in my hands. I am daydreaming of my past and focusing on tiny details that I have seen in the life-story book. Thinking of Birth Mum and remembering incidents that happened during my time with her and in care, I get lost in my thoughts. With a sense of detachment, I start to cut into my school sweater. The dark wool suddenly splays open over my tummy, leaving a big, frayed hole right in my middle. That was cool, I like the way it just opened.

I look around the bright classroom and nobody has noticed. I look down at my leg. I wonder what would happen if I just . . . Yeah, I will. I start to cut into my trousers. My hands are tense and tight, gripping the small plastic-handled scissors.

Mouth breathing in concentration, I slice all the way up my leg, carving a jagged line up to my knee. Satisfied the pointless slit is long enough, I settle back into my lesson. I remember that my clothes used to look like this; I always had holes in my sweaters.

Mrs Dunbar comes around the tables checking our work. The other children have been cutting coloured paper to make bar graphs with strips glued into their jotters. Suddenly, Mrs Dunbar appears at my side.

How's your graph coming along, John? she asks, leaning down towards me. But then her mouth gapes open when she notices my handiwork, aghast at the ruin I have wrought. *I mean, what on earth has happened to your school jumper?*

My eyes follow her gaze downward. I'm in utter disbelief at what's happened, as though I've had an out-of-body experience.

Stand up! she demands. I stand and all the children turn to see what's going on. Mrs Dunbar looks me up and down in astonishment,

her mouth still open. Now my classmates are pointing at me and screaming with laughter.

Right, go and stand over in the corner. I start to cry and stand facing the wall. Once she has hushed the class with a loud *BE QUIET*, she comes over and asks what has happened.

I cut it, I whimper, staring at the wall.

Why?

I don't know, I cry, an admission of ignorance that enrages her further.

Right, out you go. She opens the door and pushes me down the corridor, her hands on my shoulder steering me, with a shove in my back to move me. Turn shove, turn shove.

You want to be a baby, then you can go to the Primary Three class.

She shoves me through the corridors in tears. I don't know why I've cut my clothes up. I can't explain it.

In the Primary Three class, where my brother Jack is, Mrs Dunbar announces to Miss Williams and the children that *John MacDonald has cut into his clothing with a pair of scissors and doesn't know why. He will remain in here until he has an answer for doing this.*

I look up and catch my brother's eye. All the children are snickering but not Jack; he looks genuinely sorry for me as I stand sobbing in my rags.

Annoyed that her lesson has been interrupted by me, Miss Williams drags a desk across the room with a loud screech. She makes me sit facing the younger pupils.

STOP CRYING AND SIT DOWN! she yells.

I do as she says, and she slams a pencil and a sheet of paper in front of me.

Exasperated, she turns back to her class.

I want you to write a sentence about something you really enjoy: swimming, running, reading. Please use adjectives in your sentence. You have ten minutes.

Miss Williams paces the room, weaving in and out of the pupils' desks, her hands clasped behind her back like a prison guard. I suck the end of my pencil for a moment and wonder what an adjective is. I've heard the word many times, but I was too busy dreaming when that lesson happened.

I focus and think about something that makes me happy. I love the movie *The Sound of Music*; that makes me happy. In my mind, I can replay it over and over, scene by scene, line for line. The nuns playing the guitar remind me of Sister Pauline, and Sister Pauline made me happy. I look up at my brother Jack; he is already writing, deep in concentration. He likes aeroplanes, birds, computers, spitting and football. I start to write my sentence in my neatest handwriting.

Time's up, pencils down, Miss Williams booms, making me jump.

She stands beside me and looks over my shoulder.

What does this say?

Without letting me answer she snatches my sheet of paper and makes me stand, a sad ragged scarecrow.

John MacDonald has written the following. She clears her throat and reads my sentence, holding my sheet of paper at arm's length.

The sound of music film makes me ver happy when the little girl likes pink socks and likes sings, I flit, I float, I fleetly flee, I fly. She reads my sentence mockingly, delighting in enunciating all my mistakes and misplaced words with a manic flutter from her twitching eyes.

My face burns with embarrassment and tears roll down my cheeks. The children shift uncomfortably in their seats, their gazes flickering between Miss Williams and me. Some kids look at my brother to see his reaction, but he looks down at his desk, humiliated by association.

At home, Mum goes mental.

What the hell is wrong with you? Her eyes narrow into black slits. *Have you any idea how much those clothes cost?* I stand there, staring into space. *Look at me when I'm talking to you.* I look. *And you can take that stupid, glaikit look off your face.*

Jack stands beside her like a loyal dog, looking at me with a mix of disappointment and concern.

Mum, John got sent to the Primary Three class, he says, and Mum erupts.

What? Primary Three? Her voice rises to a shrill pitch. *You're in Primary Five, John! Are you an idiot? Get out of my sight.*

4

Mum, can you roll the window down? Jack moans from the back seat of Mum's car, his mint-green shell-suit jacket covering his mouth and nose. He's coughing violently.

Her eyes glare at us from the rear-view mirror as she exhales smoke through her nostrils. Without a word, she rolls down the window of the Mercedes just a couple of inches, making her diamond bracelets jingle. The fresh air absorbs her cigarette smoke.

But I am used to cigarette smoke blowing in my face, my lungs are made of asbestos. I'm even trusted to run round the corner to Mrs DiNardo's shop to buy Mum's fags for her. Sometimes I open the plastic seal around the box and walk home slowly smelling the delicious fresh tobacco inside, and then I'll take one out, hold it between my two fingers and suck fresh air through the filter, pretending to be Mum, making sure to slot it back with its other

nineteen ciggy pals before I get home, so I'm not caught and don't get a skelpit lug.

At home, in our big dining-room cabinet, where all our best china is on display, Mum keeps a big Jacobs Cream Crackers tin. She collects the coupons that come with her brand of fags, Regal King Size. If she smokes enough and saves the coupons, we can buy a digital alarm clock or a paddling pool for the garden from the catalogue. She has thousands of coupons in that tin, all stacked neatly in bundles held together with rubber bands.

Every Saturday, Mum drives us to visit Papa Bill in Bargeddie, just a few miles from Glasgow, and on the way, we stop off at Linda's Cakes in Coatbridge.

Can I have half a dozen rolls, six of your fresh cream meringues and three empire biscuits please, hen? Mum asks the lady serving us in her best Queen's English.

Can I have a fresh cream meringue? I ask, salivating at the cake display.

With an exhausted sigh, Mum snaps, *No, you can't, John. They are for the adults; you can have the same as your brother.*

I hate empire biscuits, I whine. *I only ever eat the bottom biscuit half.*

I love empire biscuits, Mum, my brother grins.

Don't you dare be so pigging ungrateful! Do you hear me? I nod. *You'll have what you're given. Now move.* We are jostled out of the shop and back to the car.

I can feel the disappointment building inside me, but I know better than to make Mum angry and keep my mouth shut.

We walk into the housing scheme where Papa Bill lives. It's so different to what I have become used to in the small village that is

now my home. It isn't that it is run-down, but the architecture is the same four-in-a-block scheme that I knew from Drumchapel and Granny Gormley's house. And its presence plays havoc with my mind.

We are greeted by Father Andrew, an old Italian priest who lives here with Papa Bill. Father Andrew comes from Rome, a Verona Father sent out to Scotland in his youth to teach children and preach, and rather than retire to a home for old priests he came here to his friend's house.

Hello, Father Andrew, Mum says with grace.

Hello, Anne, the old man wheezes as he kisses Mum on her forehead.

Say hello to Father Andrew, boys. She nudges us.

Hello, Father Andrew, we mumble, dreading what always comes next.

The old man grips my face in his bony hands and plants a gentle but lingering kiss on my cheek, then turns to my brother Jack, who also squirms from the kiss.

In the living room, a thick cloud of cigarette smoke shrouds Mum's six sisters, who all sit together on the sofas and armchairs. Papa Bill sits like a regal tramp, head of the room in his armchair with his loyal collie dog, Sam.

We then proceed to walk around the room kissing each aunty.

Aunt Maureen, the self appointed head of the family, also lives here; she is very different to her sisters, choosing to wear men's jeans and keeping very short hair. She has been single all her life while the other sisters are married with children. In Aunt Maureen's bedroom, there are posters of Pope John Paul II waving from the

top of an armoured car, posters of a Celtic football player in mid-kick and posters of racing cars on the tracks at Le Mans. She has lots of chunky men's shoes and trainers and in her closet are men's coats and sweaters, but she has no husband or boyfriend.

One time on a visit I had my hair cut very short, and she singled me out from the other children.

I don't like that haircut on you, it makes you look like a lassie, she hissed, wobbling her head and slanting her eyes as she spoke.

Another time I had been playing in the distance with a group of boys and dry-humped a friend as a joke. When I got home, she cornered me away from my mother and told me she had watched me.

I saw what you did, I watched you skipping around, and I think you're disgusting! She ignored me the rest of the day.

I keep away from her. Jack and I have a private joke of calling her 'Uncle Maureen'.

Papa's room is small and simple, with a single bed, a wardrobe and the smell of greasy old-man hat, dog and alcohol. Father Andrew has the biggest room in the bought council house. It has an enormous double bed with a padded headboard and patterned and embroidered blankets. A huge dressing-table set with an intricate lace cloth is topped with beautiful religious figurines, flowers and little bottles of lotions, and there is a big bookcase and large wardrobes. There are beautifully painted idols of saints and Christ on the walls and photos of other priests.

Aunt Maureen treats Father Andrew like royalty; a man of the cloth residing in this Catholic house must be such an honour for her. Father Andrew seems to spend most of his time alone in his room; nobody ever bothers him, except me.

Who's that? I ask, sitting on his bed and pointing at the handsome young priests in the images. He smiles and puts down the Bible he has been reading. Slowly getting up from his armchair, he lifts the little framed photo down and sits beside me.

The Verona Fathers, he whispers in the softest Italian voice, *Father Luke, Father Paul and Father Peter; and that's me.*

That's you? I look at the old man's wrinkling smile and then at the young man in the photo. Time is cruel.

I accept his answer and gaze around the soft room until my eye fixes on a small painting of a burning heart, and my finger follows to point.

What's that?

The old man stands and takes down the painting for us to look at. It is beautiful. A bright red heart with light rays emanating from its centre and a burning flame shooting from the top. I can see the detailed brush marks in the dry paint and wonder how this three-dimensional heart could have been created, leaping out at us in such glory.

The sacred heart, Father Andrew whispers.

His words are almost tears as he places it into my hands, folding his fingers around mine as I cup the frame.

It is a symbol of the boundless love that God has for us. It's a copy taken from a painting by an Italian artist. Do you like it? he asks.

I nod. He looks at me with such love, and I know I have seen similar images to this one before with Sister Pauline.

Can I keep it? I ask.

The old man laughs and lifts the beautiful painting away from me.

I'm sorry, no; it was a gift from my sister.

Where's your sister?

As Father Andrew turns to rehang his pictures on the wall and before he can answer my question, his door opens.

What have I told you about annoying Father Andrew? Mum barks. *Get out of here now.*

Then her tone changes to speak to the priest and she is posh again.

I'm sorry about him, Father Andrew; that's us ready for you now. The old man waves his hand with a smile, and I'm pulled out and into the living room by Mum.

The room has been transformed. The coffee table that had held the smoking ashtrays and steaming tea now sits at the foot of a two-seater sofa and an altar has been created by Aunt Maureen. Two brass candlesticks with white candles burn. A gold plate and a gleaming silver chalice with gold inside sit neatly on top of a lace table cover which is overlaid by a long gold embroidered runner. All the sisters sit side by side in solemn stillness, crushed together on the sofas, and us children are quietened on the floor to wait.

Aunt Maureen draws the heavy burgundy curtains, shutting out the sunny day and leaving us in a dull and depressing gloom.

After five minutes of whispered chat, Father Andrew enters wearing white and gold robes over his black suit. He shuffles around the room, greeting everyone as though he was a celebrity from the telly and they are his adoring fans. Mum looks sad.

He sits down at the makeshift altar, placing the small painting of the sacred heart that we had looked at in his bedroom on the table

beside him. Then he does something new, breaking the monotony of our Saturday ritual. He beckons for me with open arms.

Can John please come and join me here?

Have I done something wrong? Perhaps I was not supposed to ask about the sacred heart painting. Mum looks bewildered and gestures with her head and a narrowing of her eyes for me to 'move it'. I stand from my cross-legged position on the floor beside my brother and cousins and sit beside the old man. He places his hand on my knee and squeezes gently with a smile, reassuring me that I haven't done anything wrong.

From here I can see the entire room, it's like I'm on stage; everyone is looking in our direction, except Aunt Maureen, she is sucking in her cheeks and looking at the floor. I know she does not want me up here. I try to fix my eyes on Mum. I want to see her pride at my new position, but she dodges my eye contact and looks past me at Father Andrew. My brother and cousins giggle under their breath until Mum notices them and mouths, 'Don't you dare' through clenched teeth, then they sit still and silent.

In the name of the Father, and of the Son, and the Holy Spirit.

Amen.

And with your spirit. The grace of our Lord Jesus Christ, the love of God, and the communion of the Holy Spirit be with you all.

And also, with you.

Grace to you and peace from God our Father and the Lord Jesus Christ.

The gas fire gently hisses, burning bright as we summon spirits, and my eyelids slowly pass up and down to the slow hum of Father Andrews's Italian voice.

I wake with a jolt, as Father Andrew stands to give out the body

and blood of Christ. The look on Mum's face says I'm in big trouble for falling asleep during mass. Aunt Maureen is first in line to take communion as I rub my eyes awake. Mum can't take communion because she is a retired Catholic, which we don't understand, and she couldn't explain it to us when we asked. She looks so sad sitting down alone while all her sisters get this strange sacrament. I wish I could have the first communion and taste the white wafer. The Catholic kids that we play with in our village get to dress in beautiful white costumes and white patent-leather shoes and they get loads of presents because they are getting married to Jesus and his dad, God.

The chalice is passed from mouth to mouth, with Papa Bill last in line as usual. I watch, slightly disgusted, as his greedy lips gulp the wine, tipping the chalice up to get every last drop.

From this day onward I'm allowed to sit beside the priest during mass, but I'm warned about falling asleep.

Stay awake and you might learn something, Aunt Maureen tuts at me quietly while passing me in the hall.

It's only after mass that the mood lifts and the energy becomes playful. We have lunch and then the cakes come out. Mum passes the big cream meringues around her sisters, and they sit with their thick legs up on sofas and proceed to lick at the fresh cream globs that drip from the middle. I'm not allowed a cream cake and Mum is not allowed to have the holy bread or wine; we are equal, but still, something in the moans and giggles of pleasure from the women devouring the cakes annoys me. It takes me back to Scary Man teasing me with biscuits, then pulling them away just as they touched my mouth.

I separate the top icing layer from my empire biscuit, making

two halves, both with a jammy blob in the middle. It looks like a giant communion wafer, equally as camp only speckled with pink sprinkles. I offer half to Jack, holding it up to the light between both hands and imitating the old priest.

The body of Christ. We snicker and laugh.

I love Saturday nights at home because Dad cooks us steak and we get to have it in front of the telly on trays and watch *Blind Date* with Cilla Black.

But before Cilla and steak, Mum calls me into the living room. I am asked to sit at her feet.

I want you to learn the Lord's Prayer, John; it's very important, OK?

I'll get Jack, I say, ready to fetch my brother.

NO, you WON'T get Jack, sit down. I'm asking you to learn it. Say this after me: Our father.

I look at her face and her eyes are sad, yet deadly serious, so I repeat.

Our father.

Who art in heaven.

I start to smile with nerves.

Who art in heaven.

Mum gives 'the look' and I try to be serious.

Hallowed be thy name.

I try hard to suppress a nervous giggle that is twitching in me.

Hallowed be thy name.

Thy Kingdom come; thy will be done.

The laugh escapes me, and Mum laughs with me for a moment.

But her smile quickly turns down and her dark eyes say she is serious.

Thy Kingdom come; thy will be done.

Forgive us our sins as we forgive those who have sinned against us.

She nods for me to repeat, but I can't stop laughing; it seems so ridiculous.

With exasperation, she gives up.

Aw, for goodness' sake. You should know this prayer, John! she huffs. *I'm trying.*

Don't you dare talk back to me. You're NOT trying. She gets louder: *YOU DON'T TRY AT ANYTHING. Get out of my sight. You can't even repeat the Lord's Prayer. I'm sick of you.*

And with a look of absolute disgust, she pulls a cigarette from her ciggy purse and lights it.

I stay away until dinner is ready.

It's 11:00. I should be asleep, since Jack and I were put to bed at 8:30, but I am wide awake. I am listening to my parents talk, and I can hear the low voices drift through the house. Jack is sound asleep below me, snug under his He-Man bedding. He was a baby when Mum and Dad adopted him, only weeks old. This family is all he has ever known. My family are far away in another world, scattered in care and fragmented dark memories. I was adopted mostly as company for Jack, so he isn't alone. I wish I had been a baby when I was adopted.

I lay here and rest my mouth on the pine guard that stops me from falling five feet out of bed and I suck and chew the wooden bed frame

and listen. But it's useless, there are no clues in my parents' voices. I suck the pine bed guard until the wood becomes soft enough; I strip it apart and eat it.

When I have had my fill, I settle and I dream of Birth Mummy. Her face is still so clear in my mind. I wonder where I went wrong in my path. I can't understand the barrage of feelings and memories I'm having; I can't put things in order, guilt, fear, loss and confusion.

Over the weeks I chew the entire wooden bed guard, most of it is inside my stomach but some has been spat down the side of the bed and stuck to the wall between the floors of the bunk beds. It is only when Mum does one of her big cleans, the ones where rooms get emptied of furniture and walls get washed right down to skirting boards with a basin of hot soapy water, that she discovers the wood.

If you don't stop this then you are going to have to speak to a doctor. All these nice things we give you that you destroy; you deserve nothing, do you hear me? Mum threatens. *Is that what you want? Is it?*

I shake my head, tears run down my face.

LOOK AT WHAT WE HAVE DONE FOR YOU! rings in my head. *And you destroy a good bed.*

I am trapped in my mind.

On Sunday I'm sent early to the local village church for Sunday school. Jack doesn't have to come; he can stay at home and play. I don't mind; I like singing songs with the three other children who attend.

As soon as I enter, I'm met by the stout Minister Robertson. I'm the first here because I live so close by. The minister makes me a

sugary squash in the back kitchen and allows me to run rampant around the empty church while I wait for the others to arrive.

Inside, the church blooms with colours from the early sun spilling through the stained-glass windows, and I'm reminded so much of Sister Pauline's big villa. I feel so alive here, away from the watchful eyes of home and alone with my thoughts. Sometimes I get up into the pulpit and dance and sing to an imaginary audience.

This is not a chapel; there is no offer of Holy Communion or the confusing Latin words that Father Andrew speaks at Papa Bill's home-made chapel service. There seems to be no fear, guilt or pain and suffering in the service that Minister Robertson gives when he is reading from the Bible. This church is more for stories and happy songs.

When our lesson is over, the other children leave for home, but I stay behind with the minister as I have a special job to do on Sundays. Minister Robertson leads me to the front of the church. Just before the big wooden doors is a plush red curtain and behind this is a secret door with a stone staircase behind it.

At the summit, we emerge onto a balcony, a realm aglow with a resplendent mosaic of colours, cascading from a colossal window that stretches the expanse of the wall. It is an exhilarating spectacle, for it seems as if I stand beneath an iridescent rainbow, its vibrant hues illuminating an image of Christ, cradled amid roses and sheltered beneath the hands of God. And here, in this lofty vantage point, I am granted the honour of commanding the church bell, my role imbued with a profound sense of purpose.

Side by side with the minister, I tug at the bell's thick rope, its sonorous toll resounding through the air and calling the village to worship, its rhythm a testament to my meticulous timing.

I have learned, through practice, to count in unison, to attune my senses to the bell's song, to release the rope at precisely the right moment, or else my skinny wee body will be hoisted up by its weight. In these harmonious moments, the same rhythm can evoke visions of Sister Pauline's metronome, a symbol of stability and reassurance.

As we await the congregation's arrival, I feel good that my steadfast tempo has summoned them. When Minister Robertson heads back downstairs to meet people arriving, I stay up here and collect a few pieces of coloured glass that have fallen from the scene in the stained-glass window and lay on the bottom ledge. These go in my pocket. Treasure.

Later in the day Dad takes me and Jack to Granny's. The apple tree in her yard offers some shade from the Sunday-afternoon sun. Granda had planted that tree years before, but since his death two years ago, it has taken on a special significance, as though Granda's ghost lives inside it. We have all been well warned to keep away from swinging on its branches. Sometimes Granny wanders over to it and silently picks at the leaves, gently singing with her Roma twang.

Today it is heavy with fruit and as Granny and Aunt Jeannie bend down and collect the apples that have fallen, Jack and I play close by in the old caravans and abandoned cars. Inside a car it smells like warm leather. We take turns at yanking the steering wheel and pressing buttons to go on an imaginary journey. Jack wants to drive to Disneyland in America. I want to drive to the children's home. I allow Jack to drive.

While Jack steers and reaches down to press on pedals, I watch Granny through the mouldy window as she gently glides around the yard. She holds in her weathered hands a plastic bag now full of apples that Aunt Jeannie will bake into an apple pie.

Granny stops, her gaze fixed high up at the roof of the crumbling work sheds next to us, then she glances at me and beckons me out of the car with a come-here finger. I approach.

Look up there, she says, holding me in front of her, one arm draped over my shoulder and one pointing up. *Magpies.*

We watch the black-and-white bird bob along the rooftop, cocking its head as it searches the tapestry of moss and rotting wood for insects. Granny spits into the palm of her hand and rubs it into her pinny.

Why did you do that? I ask, looking at her hand.

These are magical birds. That's how you acknowledge the spirit, by spitting any curse away. She nods at the bird, then looks down at me with eyes so full of knowledge.

The magpie flies away and I spit into my hand and drag the white bubbled mucus down my trouser leg. Mum hates spitting. I look at my brother Jack, he is busy whacking a huge stick around, slicing though nettles at the far end of the yard, no time for magic.

Magpies collect treasures and shiny objects for their nests. An offering to attract a mate. If you leave them a treasure, you will be lucky in life, Granny says with all the wisdom of her life.

I feel inside my trouser pocket. I have three small round pieces of glass carefully plucked from the church window earlier in the day, and I flip them between my fingers.

Do you know this song? One for sorrow, two for joy, three for a girl, four for a boy, five for silver, six for gold, seven for a secret never to be told, Granny sings down at me.

No, I admit.

Well, we've just seen the one magpie. She glances at the heavens. *So that's one for sorrow, but we've spat the curse oot wur mouths. No sorrow will come to us.*

Sing it again, Granny, I ask. She wraps me in her arms, and we saunter back to her house with the bag of apples. Granny has me repeat the rhyme after her.

In Granny's living room Dad is chatting with my cousins, one sitting on the arm of the chair, one standing beside it next to the fireplace full of ornaments and boxing trophies. When Dad is around his family, his accent strengthens, twangs and lilts with tones of his lineage. In between words I hear the Roma language and feel proud to recognise some of the words spoken. In Dad's hands is a newspaper.

That's King Charles Faa Blythe there, Dad says to the men, pointing to whatever he is reading. *King of the Gypsies.*

I'm curious. I lean over Dad's shoulder and peer at the newspaper. I see a black-and-white photo of a man with a white beard and a huge heavy-looking cloak around his shoulders. The man does look regal and wears a crown.

'*On 30th May 1898, some ten thousand people gathered in the Borders village of Kirk Yetholm for the coronation of Scotland's Gypsy King,*' Dad reads. *So, your granny,* he nods to the kitchen where Granny is preparing the apples with Aunt Jeannie, *was related to him through marriage. Queen Esther, King Charles Faa's mammy, had a sister called*

Bella and she married Jock Tait, also known as Stovie Jock Tait. Well, he was the nephew of your granny's great-granny.

Wow, are we royal, Dad? I ask.

My cousins laugh at my remark and Dad glares at me, pursing his lips.

We are, you're not. He laughs. *I'm only kidding, son,* he says, noticing my crestfallen face. He leans back and ruffles my hair.

The conversation between him and the older boys shifts from the subject and becomes hard. Now they are talking about fighting, full of pride as though it were more magical than stories of ancient Gypsy kings and queens.

He landed a jab, then a left hook. Jeezus, what a fight; the laddie went flying. Near broke his jaw. Aw, what a fight, excellent fight.

Then the conversation moves to the market price of scrap metals. I back away, leave the men, shying away from those exchanges, and head into the kitchen.

Aunt Jeannie is a clairvoyant; her job is going round the doors of Glasgow selling little trinkets and treasures just like a magpie. Sometimes she is invited inside the homes of the non-Gypsy people to read fortunes by looking at messages in cards and tea leaves. It's called durreking. I'm fascinated by her.

Mum, can I go durreking with Aunt Jeannie? I had asked one evening at supper after hearing all about her job around the fire.

Absolutely not. Get your head out the clouds, Mum had scolded.

Although my families are close, the Catholic side reject the work of a clairvoyant. It is against the faith and the teachings of Christ.

John, durreking is women's work. You can come and learn how to strip cable with me when you're old enough, Dad had said.

As Granny stirs the apples bubbling in sugar over a pan with cinnamon, I linger by her and my aunt. I listen to Aunt Jeannie as she talks about the previous night's work around the schemes of Glasgow and the woman she read cards for. Granny listens to her while keeping an eye on the apples.

Can you read fortunes as well, Granny? I ask. She nods her head and looks down at me for a second before looking back at the pan.

Can you read mine? I ask.

Granny shakes her head, this time keeping her eyes on the pan.

You don't read your own people, she says as she stirs.

I head outside to find my brother. Standing on a rusting oil drum, we pull ourselves up onto the roof of the old work shed at the back of the yard, stepping carefully on the rotting beams. Up here I can see the village's loch sparkle in the sun; behind me I can see the roof of my family's home. I show my brother the treasures I have in my pocket from the church window.

Where did you get that? he asks, wide eyed.

Promise not to tell? I ask.

I promise, Jack says.

I got it from the church window; it's precious stained glass.

Let me hold one, he asks with an open palm.

I pass Jack a small orange disc of glass. He holds it up to his eye.

We're leaving it here for the magpies, I tell him. *They are magic birds.*

Don't be stupid. Birds aren't magic, he says, squinting through the glass at the sun.

I place the colourful glass shards down on the roof and silently make my wish. My moment is interrupted by Aunt Jeannie standing watching us from the back door.

Jesus fucking Christ, get doon fae there; you'll break yir neck.

I turn in fear, but Jack has already jumped down from the oil drum and makes his way across the yard with the last piece of glass in his hand.

I'm telling my dad you stole from the church, he yells back at me.

A doctor guides my head into a huge machine that is testing my eyes and we wait for the familiar beep.

OK, John, tell me when you can see the magic bird going into the cage, the doctor says as he lifts levers and presses on a switch.

The machine's purpose is to have a different image in each eye: a little bird in one lens and a birdcage in the other. With the correct lens attached, the doctor can tell whether my squinting left eye is turning in or correcting itself.

It's in the cage now. One for joy, I say, swinging my legs and watching the little bird overlap into the image of a birdcage through the binocular-looking apparatus.

OK, good; sit up. I look at Mum and she supports me with a loving smile.

The doctor talks to Mum as though I'm not there.

So, the left eye is no better! Let's continue with the patches.

Right, sit up straight, Mum says as she fixes my glasses onto my face and the doctor prepares the patch.

Continue with these and we will see you in the hospital in a couple of weeks, John.

He sticks the big flesh-coloured patch over my right eye. I hate the medical-smelling patch of shame. I feel humiliated, like a cyclops.

I sometimes break my glasses on purpose or quickly pull them off my face if someone new is coming into my space. It's bad enough being the black sheep without the added humiliation of the glasses. Without them, my left eye turns right the way in towards my tear duct, which other people can see but I don't notice.

My eyes are a constant source of embarrassment and shame, their shape, their function and the things they have seen. Nobody else my age has to wear glasses. At school, I am specky four-eyes, one-eyed jack and spazzy.

Within weeks I have my first operation to tighten the muscle behind my left eye to correct the squint. It is a partial success, although I still have to wear glasses and on occasion wear the patch of shame.

Some time later, I have a second operation to further correct the squinting eye. I still have to wear glasses, but it means no more eye patches and no more blurring eye drops from the optometrist.

I am being corrected on many levels by my new mum. Every misaligned aspect of my being is pulled taut like a fiddle string and Mum is the conductor of this symphony of improvement.

John, shoulders back, sit up straight, she says, and I snap to attention.
Stop biting your nails.
John, get that tongue in.
John, walk properly, get off those tiptoes.
John, breathe properly.

I am sitting in the library and looking at the body book, which has drawings of a man and a woman and shows the intricate workings

of the human body in a childlike illustrated way. A man and a woman make a baby together. I remember seeing men do that to Birth Mummy and it didn't feel right.

In my ears I can hear a faint crunching sound; it sounds like someone walking through snow. The sound is familiar, but I can't place it. I have heard this sound many times before. In my mind's eye, I can see something in the distance; it is a smooth plane and looks like the smooth side of a pancake but the strange visual overlays with my eyes and the crunching sound gets louder.

She is coming.

Suddenly I see the woman's head. She has red hair – it's the kind of cut you would get if someone put a bowl over your head and cut around it – but her face is blurred, featureless. Then I hear her voice.

I can feel her lips moving, she is trying to enunciate her words by talking slowly. But I can't see her lips so don't know what she is mouthing.

The faceless woman senses that I do not understand and starts to shout, louder and louder, but still I do not understand her. I feel her frustration and she panics, her energy feels frantic and immediate. I panic also and my heart starts to race. The smooth circle where her face should be becomes a rotten distorted expanse and I am brought back to the present, the body book still open in front of me.

Whatever just happened was not supposed to happen. None of the other children here in the library have noticed – I do not tell anyone.

From this point onwards, when I'm feeling at my worst, the faceless lady arrives and tries very hard to get my attention. Although I cannot see her face, I can feel her words and her mood

as it shifts gears and becomes more and more frustrated at my lack of understanding. The woman knows me well, but I don't recognise her at all. She isn't Birth Mummy.

She appears at times of grief when I miss Birth Mummy. She comes when I am alone and still and when I am at school, surrounded by the other children. At church on Sundays there are times when the rhythm of the bell pushes her into my mind. There is no hiding place from the strange lady, no privacy from her urgency. She always leaves me with a horrible feeling of dread. I know instinctively I shouldn't be seeing and hearing her.

At home, I try to draw her, to understand the woman who haunts me, but it is hard because she is faceless. I lose myself for hours and with every stroke of my pencil, I can control the world. *That's beautiful, son,* Mum says.

My drawings are always the same: a woman with red hair, red lips, blue eye shadow with long spider-leg eyelashes. I'm turning Margaret my birth mum into a perfect mother.

I lie in my top bunk and hear sounds coming from the far end of the house, the toy room, which is the last room along the hallway, furthest away from where the family sleeps.

I must see what's going on. I climb down from my chewed top bunk and creep down the corridor to peek into the room: my mum is wrestling with the plastic wrapping from a brand-new single bed. I can see she is struggling, exhausted from heaving around furniture, I want to help.

Mum, what are you doing? I ask her with curiosity.

Go back to bed; you've ruined a surprise, she shouts, throwing her hands up and dropping a screwdriver in exasperation. As I rush back to bed, I hear her say, *You deserve nothing.*

Mum is making a new bedroom for me. I feel like I am being put at the bottom of the house on purpose, separated from my brother because I'm a bad influence and pushed furthest from my parents' bedroom and away from the family. There is a room closer and opposite our shared room; I don't understand why I can't be there.

The next day. The new bedroom is ready for Mum to reveal.

Do you like it? she says with a big, excited smile.

It is dressed in red-and-grey-striped curtains and matching bedding. A bedside unit, a lamp and a wardrobe. It looks so grown up. I don't feel ready to grow up.

Sunday afternoon I escape over the back garden and through the bushes to Granny MacDonald's house. The smell of her butterbean soup greets me as I walk in. Granny is sitting in her armchair; she has a strip of cling film that she sucks into her mouth, making tiny little bubbles that she pops and snaps when concentrating on the telly.

Here's my black-eyed boy, she sings, greeting me.

I kiss her on the cheek.

I confide in Granny about the faceless woman. She listens closely without judgement, only the occasional light gasp in between the details. Then she stands up slowly and beckons me to follow her.

We go into Granny's bedroom, which is very dark as the cottage has tiny windows. Her bedroom is basic like the new one which has been created for me, with only a bed, a free-standing unit and

a wardrobe. She walks over to her bed; it's bulky, with knitted blankets of different patterns and texture. She stands at the headboard and looks up.

See him up there, she says, pointing to a gold frame. I walk towards her, and we look up at a lenticular image of Christ on the cross. If I move slightly left the image changes and a white spirit floats above the scene surrounded by angels with long trumpets; then as I move back to the right the lenticular shifts to the dismal figure of Christ bleeding and suffering on the cross.

You tell the spirit of the woman that's bothering you to leave you and never come back. Pray to that man there, she taps the lenticular image with her finger, *and ask him to send the woman awa.*

I nod my head.

Do you think she is a spirit, Granny? I ask and Granny nods.

Sometimes they come to warn us of danger, John; sometimes they come to guide us.

She sits on the bed and asks me to sit beside her.

Are yi wantin to hear a story? she says, raising her eyebrows.

I sit down beside her, nodding with anticipation.

When I was a young wuman I seen spirits all the time. One night a went ti ma bed and I slept lovely and deep. The wind ootside wiz wild, but it didn't bother me; in fact, that wiz a comfort. In the early hours while it wiz still dark, I woke up, and without opening my eyes I could hear a babi gently sobbing.

I look at Granny's face; she is away, lost in her own story.

Waaa waaa! she wails in a baby voice.

But there wiz no babi here, I wiz alone wi yir granda sleepin next to me and nobody stopped near us for miles. I felt fear because I knew whit was

goin on, but slowly the crying faded away and I was left with the whippin wind, so a fell asleep again.

Granny rocks herself slowly, her arms wrapped around her waist as she does so. Then her eyes widen, and she lifts her arms to reach out towards the wall.

Only to wake again to the sound of a woman breakin her poor heart crying. Granny sobs, imitating the sound of a weeping woman.

Then I could feel a strange electrical charge in the air. She moves her hands, turning them up like dead spiders and her fingers illustrate the electrical charge.

She turns to face me and lifts her hands high above her head.

John, by God as my witness, every hair on my head stood straight up on end because I could see this wuman in front of my eyes at the foot of my bed and oh she was crying.

Then what happened? I ask.

Oh, she cried and she cried. I tried to shake your granda awake but he wouldn't wake up, so I hid under the blankets and I asked that man there, she points to the image of Christ, *to send this ghostly wuman away. I never slept the full night. Well, in the morning, I received a letter to tell me that my cousin's son had died.*

Granny gets a cotton hanky from her pocket; she dabs at the tears that have formed in the corner of her eyes.

So, you see, if the spirit's bothering you then it means something's afoot. You had better not tell your mammy aboot this because she wulni understand, you'll just upset her.

I agree with Granny and vow to keep the secret.

Are yi wantin a biscuit? she asks, and we exit her room into the kitchen. Granny never speaks of it again.

At home around the dinner table, I tell Mum, Dad and Jack about Granny's story.

Well, if your granny told you it was true, then it must be. Dad winks.

Have you ever seen a ghost? I ask.

I think I've seen a ghost, I say.

Mum sighs and drops her cutlery onto the table.

Away and don't talk a load of shit, John. Maybe if you gave as much thought to your bloody school work as you do to absolute rubbish then you might get somewhere.

Why are you such a poofy weirdo? Jack adds.

And you can be quiet as well, Mum snaps at him.

Soon after that Mum tells me to stop going to Granny's.

You spend all your time over there and none with your family. So I hide away, locked in my new bedroom.

I sit at the side of the boxing ring with my gloves on, all seven stone of eleven-year-old me, a super lightweight made of small solid muscles. Dad sold the old church and built a state-of-the-art gym for the local community centre. I had grown fond of the dingy old church, and this new clinical bright gym is more menacing.

I know these boys, most of them are Gypsies, some younger than me but all bigger. I watch as each boy takes a round at getting the shit smacked out of him in the ring and my stomach lurches – I know my turn is coming.

Right, John, in you come, Dad says with a flick of his head.

I duck under the ropes, and he points to Donald McManus, a big red-headed Gypsy boy who speaks so quickly and with such a Roma

twang that I always strain to understand the song that comes out of him. He is new at my school and is bullied for being a Gypsy, which makes him bully others in return, so I keep out of his way. But now we couldn't be closer. Donald is a beast compared to me. I dance around, keeping my distance.

Move in on him, John, Dad shouts, but his words distract me and earn me a smack on the side of the face as Donald launches forward. *Keep your fuckin guard up,* Dad screams.

I pull my fists to my face and peep at my opponent through the gap between the heavy blue gloves I'm wearing. I dance around, landing some weedy punches as I go, making no real impact. Again, I lose my focus and take a smack in the face, sending my whole frame into a wobble. I want to cry but I cannot show any weakness. I tighten my torso and push my weight in with a fast punch, hitting Donald square in the face. He flies back, stunned with a stinging nose. When he steadies himself again, he suddenly lifts his leg and kind of hops towards me. I close my eyes and twist my body away, with one leg bent up and curled into myself in defence.

WOAH, WOAH. What the fuck is that? Dad yells, and we both stop to catch our breath.

You, boy, OUT! he yells at Donald. *We don't lift our feet in boxing.*

Thank God it is over. I am saved by the Karate Kid's moves. I feel relief as another boy unties my gloves. But then Dad turns to me with a look of anger.

I'm getting you a fucking doll and a pram for Christmas, he shouts, and all the other boys laugh. It's just banter, it's just the way men speak. But it *cuts*.

By the time I am thirteen, I am a pro at the sport. The years of

tough love and training three times a week have done me good; my slim body is rippled with muscles, and I am in great shape. I can keep up with the older boys while running long distances and my footwork in the boxing ring is fast. I can dance and switch around the punches, giving as good as I get.

My nose is growing with my face as I'm hitting puberty. It is completely crooked and bending far over to the right. As I grow, the crookedness becomes more and more pronounced, and everyone notices. Now Jack calls me squinty nose.

During dinner one evening Dad says, *Aye, son, we will have to get that bent nose fixed! You need to get hit in the opposite direction.* He laughs.

At night I lie in bed and bend my growing nose in the opposite direction, trying to correct the thing. I even wrap Sellotape around my head, forcing my nose flat to the other side, held down with the plastic-smelling tape in the hope I will arise with symmetry. Instead, I wake up sticky, with the tape around my neck, stuck in my hair, and with a sore nose. Mum goes mental at me; she thinks I've been choking myself because of the tape marks on my neck.

I've been caught dodging school. I had taken the train into Glasgow city centre and made my way round the different galleries and museums. A place to hide away and escape. I've been experimenting with fashion, wearing home-made flares and make-up. I pierce my nose with a rusty '9th Birthday' badge that I find in the junk drawer in our kitchen and push a stolen earring from my sister's jewellery box into the stinging wound. I bleach the front of my hair with some of Mum's Jolen, female moustache bleach. It has

turned out a kind of ginger, which I hide by covering it in black mascara when my parents are around.

The head has told my parents and I've been put on an attendance card, and I am told to wear code uniform only.

John, I know you're having a hard time here at school, but you really need to stick in, my art teacher Norma says as she signs the attendance slip.

You have a real talent, John, and could go to Glasgow art school and beyond if you just stick in. I know your parents are really worried about you. Anyway, I want you to look at this. Norma's voice changes from concern to excitement.

She holds out a small sketchbook, and as she flips through the pages she gives me loving glances and smiles. The sketches inside are mesmerising – abstract bands of vibrant colours, rich textures, on home-made strips of paper.

I call these earth lines, she says, her eyes shining with passion. *My work is about landscapes, but not in a representational way. They are more about memory. You see, they hold the essence of landscapes. I mix soils and sands from both Scotland and my home in Spain.*

Norma's flame-red hair falls over her shoulder, and she pushes it away as we look at her art together. I feel a deep connection to her, as if we share a secret language that only artists understand.

Is there a way you can push your work further? she asks, her voice gentle yet full of curiosity.

She leans over and lifts a painting I have done, a portrait that I've been working on for weeks. A woman's face. My face, feminised.

You remember that time you told me all about your childhood in the children's home, she reminds me, her eyes filled with empathy. *Is it possible to add how you felt during that time?*

I think back to a time during a trip to a museum when Norma sat beside me, and we had a deep conversation about adoption and identity.

My real name is Juan, I told her. *My mum said it's a French name.*

Juan is a Spanish name, John. Your birth family must have been from Spain; that would explain your beautiful almond eyes.

Norma offers me the opportunity to swim in my memories.

At breaks, she allows me to use an unused art class to experiment with materials. It's a sanctuary, a chance to escape the school bullies and immerse myself in the world of creativity. I feel safe and free to express myself without judgement.

I'm trying to draw my birth mum's face, I say, my voice filled with both longing and uncertainty.

It's beautiful. Norma's eyes fill with admiration. *But there are other things you can do to show that feeling of longing. What do you feel when you look at her memory?*

Her question lingers in the air, and I ponder it. Norma has a way of probing beneath the surface, pushing me to explore the depths of my emotions and experiences through my art.

As I think about her question, memories and feelings flood my mind. The sense of utter confusion, the ache of not knowing and the search for identity – all of these emotions intertwine within me.

You're looking for something deeper about yourself and your identity, John, Norma says softly.

I look at the massive plastic watch clock that hangs on my bedroom wall. Mum brought me it back from a trip to Lourdes. She had gone

on a coach with some other Catholic ladies, and they took a cousin of mine along who was suffering cancer in the hope that the miracle holy water that springs from the earth would somehow shrink her tumours and cure her.

I wanted to go also, I wanted to see where St Bernadette had seen the ghost of the Virgin Mary with glowing golden roses on her feet. But I wasn't allowed.

Ugh, away you go, it's a ladies' trip, Mum scoffed.

She brought back two litres of the magic holy water and sometimes I drink it, in the hope it will cure me.

The Lourdes clock reads 3:25 in the morning. The built-in wardrobe in my bedroom also has lots of Mum's clothes along with her collection of mink coats. As a child, I used to cling to her arm and rub my face in the soft fur when she wore them for nights out with Dad.

Tonight is my night out. I slowly get out of bed and slip my hand under the mattress to feel around for a dress I have made in the middle art room at school. Norma has bags of interesting fabrics and old clothes put away for artistic use. I discovered those rags and reconstructed an old chocolate-brown party dress by removing the outside lace and making a slinky transparent dress using the art department's sewing machine during breaks.

I put on a bra and a pair of brown tights that I took from the washing and hid earlier in the day, then I slip into the brown lace dress. I run black eyeliner, taken from my sister's room, over my lips. My friend Laura has given me a grey wig that belonged to her granny. Her granny is dead now, so she won't miss it. I sprayed the wig yellow with acrylic paint earlier at school to try to make it look

blonde. It hasn't worked and still reeks of spray paint, but it's better than nothing. I feel excited and my heart pounds as I slip on a pair of my mum's mint-green and gold high-heel shoes, then one of her furs. I get back into bed fully dressed and turn out the light.

Holding my breath, I wait, listening to the sounds of the house for any movement that could blow my cover. I listen to the ticking clock from Lourdes. Five minutes pass and I slowly creep out of bed and climb with stealth out of my bedroom window, dropping down onto the backcourt.

The air is wet, with a slight mist, and I can hear and smell the cows in the surrounding fields. I run across the back green, but the heels of Mum's shoes sink deep into the soil. I fumble and lurch forward towards the safety and shadows of the trees, then dart behind the rockeries. Here I compose myself and light a cigarette.

I make my way around the village in the dark, walking with a swish in my hips, putting my catwalk to full use and looking directly into the lights of the rare oncoming cars. I wonder if I look like Birth Mum dressed like this. I think about her face and the fading memory of black eyes, exaggerated at the edges with eyeliner, like mine are now.

The night is dark, and the village is dead quiet.

I walk up to the housing scheme and aimlessly mince around the streets, occasionally stopping to light another cigarette and adjust my tights. I feel like someone else.

I turn a corner and stop again to adjust my costume. A light flicks on in the window of a house before me and a tired face appears. I drop my gaze as an old man glares out. His eyes widen at this strange female-looking creature lingering, alone, in the night.

I glance up at him for a second and slip Mum's fur coat off my shoulder, the way the models do at the end of the runway in front of adoring paparazzi. The way Birth Mum did when she was meeting men for money. I let him see the vision.

Satisfied, I turn away and start the walk home.

I continue testing out my creations the same way; sometimes the costumes are so ridiculous, made from old bedsheets and curtains. I make dresses from bin liners to imitate black PVC or leather.

What the hell have you done to your eyebrows? Mum yells one evening, placing down her cutlery and glaring at me in horror during dinner.

I don't answer, afraid to look up. I keep my head down, peering into the plate of mince and tatties that is sitting in front of me.

Look at me, she orders.

I look up, sending my brother Jack into fits of raucous laughter.

For God's sake, laddie, Dad says with a puzzled look. *Why have you done that?*

I don't know.

I can't tell them I wanted to take my eyebrows off because the supermodels in *Vogue* magazine have thin eyebrows; that would give me away completely.

You don't know? You must know. Your eyebrows didn't just fall out, John. I'll tell you what I don't know. I don't know what we're going to do with you, Mum says, rubbing her temples. *Are you stupid?*

No.

You better grow up, John, you live in cloud-cuckoo-land.

My outward displays of femininity are a real concern for my parents, so at age fourteen, on any breaks from school, I'm sent to work in Dad's scrap yard. It will make a man out of me, I'm told.

In the big work shed at the bottom of the yard, and surrounded by mountains of scrap cable and metals, I stand in a circle with three older cousins. We strip cable by hand using a Stanley knife to expose bright copper wire.

The boys talk about boxing and girls, normal chat for guys their age. They brag about the women they are fucking or how many pints of lager they sank over the weekend. I try to have camaraderie with the boys, listening with fake interest and looking for moments within the group chat that I can interject with something that shows I'm a man too.

Have you got hair on yir baws yet? Big Peter asks me, pulling at my oil-stained jeans.

I twist away from his grip and feel my face burn with embarrassment.

Joe-Joe brags that when he was my age, he was out getting girls pregnant.

How many lassies have you ridden? he asks.

None, I admit.

Ah, we need to sort that out, eh? Take you to Big Linda in town, he says, rubbing his tongue against the inside of his cheek.

Oh, aye, Big Linda will ride the fucken erse aff yi for twenty pounds, Big Peter laughs, thrusting his hips and nudging me with his elbow.

A dinnae think that laddie's interested in a woman. The voice comes from behind us, and I feel my heart sink.

Standing under the huge steel roller shutter and leaning against

131

the forklift stands my Uncle Tam. His eyes flash with menace for a moment, and his comment sends my cousins into a nervous chuckle.

Right, Pearl, come on; I need a hand, he says, glaring at me before walking away.

I put down the Stanley blade and follow my uncle out into the yard. I hear my cousins laugh.

Sweat lashes from my scalding face. The furnace glows orange whenever the huge steel furnace door is opened, releasing a searing bright heat. Part of me is happy to be working here away from the older boys' questions. Although Uncle Tam, a man of very few words, is cruel when he's hungover from a weekend's drinking.

Right, Pearl, put that cast under, he says, and I strain to yank the heavy steel ingate cast under the tap that will release the molten aluminium.

When I first started working in the yard, I figured Uncle Tam called me Pearl because of my white teeth; why else would I be called this? But as time went on, I realised that my uncle was mocking me.

You're wearing mascara, Pearl, he scolded while we were alone one day, his figure backlit against the white heat of the open furnace.

Today, I glance at him with hatred, while shadows dance upon his face, accentuating the lines of weariness and disapproval.

I can't tell Dad that I'm being so cruelly mocked by his brother.

Dad is a fair man; he loves me very much. He thinks I will grow out of this effeminate phase.

At the age of fifteen, I know what I am and I want to embrace that, to express myself. I can't stop this burning desire to show the world that I am different.

When I walk into the living room wearing a Superman crop top

exposing half of my muscled torso, Mum flips out. *Look at the state of you. The entire village is laughing at us!* Her concern is always family shame.

I play dumb in the hope she will take pity and stop the barrage of insults.

Don't you give me that side-eyed look.

I'm going to leave the village, find my birth mum and never look back.

The first time I stole money was when I tried to win over Kirsty Frame, a horrible loud-mouthed girl who picked on me daily. She had a razor blade and sliced a huge slit in my new blazer that hung over my chair in English class. Mum went mental when she found out; she didn't believe that I hadn't done it myself in some sordid act of destruction.

I took fifty pounds from Dad's safe and bought Kirsty a thin imitation-gold chain and a poster of the band Bros. I thought this would make her at least stop bullying me. It didn't work; she took the gifts and continued the barrage of abusive insults, then got other kids involved. A boy we call Smokey, a well-known knife carrier, asked me to bring him money each day or else he was going to stab me. He flashed me the knife in religious education. When I told the teacher, nothing was done. Every corridor I walk along in secondary school I am called a freak, a pervert and a poof.

So, I have decided to leave. I find Dad's safe key in his greasy work trousers where it always is, and I slowly make my way into the boiler room where his safe is stored behind the boiler. I use its ticking and humming to mask any sounds I make.

Ever so gently, I turn the key and open the safe and with my heart pumping I take a crisp twenty-pound note from each of the thousand-pound bundles. In total, I lift five hundred pounds.

Back in my room, my bag is packed. I don't need anything from here, just some clean underwear and my pencils. If I take too much Mum will notice in the morning when I leave for school. Dad wakes me early and I feel sick with excitement. I make it out of the house without any suspicion and with a huge wad of cash in my sock and fastened tight under the leather of my Doc Martens boots.

When I get to school, I escape to the toilet and get the money out of my boot; it's been digging into me all morning. But with the cash now in my pocket it feels like it's burning into my leg. I've never held so much money in my life. Dad won't miss it; there are thousands of pounds in that safe. It will be such a relief for everyone when I am gone.

I go to the library and ask the librarian for a copy of the phone book. I sit down, hidden behind a labyrinth of bookcases, and begin to slowly rip out pages from the phone book containing names from my past, names I have seen in my life-story book: Gormley, Mckelvie, Abara. Names that might have the answers. I stuff the pages into my bag, then pull out the cash, just a little look. I begin to count. With every note I turn I feel my freedom getting closer, and my heart beats faster and faster.

What are you doing with all that money? a voice behind me asks, and it's a voice I recognise, Reiss fucking Kelly.

Reiss's mum is the village postmistress, and I know he will tell on me. It's now or never, I tell myself. I walk out of the school and down the main street towards the train station. I plan to take the

train to Glasgow Queen Street; there I will find a gay youth centre and explain I need a place to live. By this time, my parents will know I have not travelled home on the school bus with my brother Jack. They will have noticed or been told about the money and possibly call the police.

I'm hovering at the platform edge, looking in the opposite direction to the other people waiting here in case I'm recognised by someone who knows my parents. The train pulls in and pulls out but I'm still standing here. I can't do it. I need them and I love them. They are the only true family I have ever known.

I arrive back to school late for my last lesson and plan in my mind how to return the stolen money.

News travels fast and all the way home on the bus kids stand around me singing 'Money, Money, Money'.

My brother Jack, sitting next to me, is mortified.

I am running away, Jack, I tell him.

He looks at me with disgust and moves seats. As I trudge home, I know that my fate has already been sealed. Jack has raced ahead to reveal my planned escape. So I sit on the edge of my bed and then pull out the bottle of holy water from Lourdes and gulp – it tastes disgusting – and I pray.

Mum bursts in, red faced with fury.

What's this about running away? she screams. *Where do you think you will go? You don't even have any friends to go to.*

With my face buried into my pillow I silently scream to myself.

When Dad gets home from work, he comes to me and sits down on my bed.

What's this about running away? he asks. *Have we not given you*

everything? When are you going to turn over a new leaf, eh? Your mother is so upset with you.

Dad knows how to comfort me; his calm tone levels things, but the firmness in his words lets me know things have to change, but how?

I hang my head at dinner.

When are you going to grow up and get that thick skull out of the clouds? Look at me and answer when you are spoken to. And you can take that glaikit look off your face, Mum says as she cuts into her gammon steak.

Then there is a knock at the door. I hold my breath. It's the postmistress. Dad has welcomed her in and from the table I can hear her explaining how her son had seen me with a large amount of money. My throat tightens.

Dad flips out and drags me into my bedroom. He is tearing the place apart; my mattress is upturned, clothes are strewn around. He is screaming and shouting in my face. Then he says something in a whisper through his clenched teeth.

Your mum had asked me to hit you, start crying. Again, he says it, *Start crying.* So I wail and sob, while Dad continues to shout and bang things around, but he doesn't lay a finger on me.

Mum won't even look at me, and when she does catch my eye, she yells, *Take that glaikit look off your face. You make me sick.*

Mum is wrong about me not having any friends; I do have a couple at school. I met an older boy who works in the chip shop in Coatbridge, too. At school lunchtime, he serves me. Sometimes he takes a break

and stands outside and smokes, chatting with the popular boys who are fussed over and adored by the popular girls. When he does this, I purposely keep my distance, and head elsewhere for lunch.

Then he joined Dad's boxing club and somehow over the training we bonded. He is a boy called Mario. We never speak at lunchtime in the chip shop; in fact, he goes out of his way to ignore me when he sees me standing in the queue to be served and sometimes he laughs when the bullies call me names. He doesn't want anyone to know that he knows me.

After boxing, I sometimes walk him home along the old railway.

Over the back fields, we have a secret den in an abandoned signal station that leads to the crumbling local steelworks, far from people, deep in the trees and overgrown nettles and weeds. Here we hide out, smoke cigarettes. Mario's uncle died from AIDS in 1987 and his family are now very prejudiced towards homosexuals. They don't like me any more either.

You're Willy MacDonald's laddie! his dad had said with a crushing manly handshake the first time we met.

Having a well-respected dad, a Gypsy man, a boxer and the local scrappy, covered me as a true man's man for a few weeks, but Mario's father eventually noticed my ways, the crop tops, mascara on my eyes and the way his son would watch me through downcast lashes in the family's kitchen.

My dad says I'm not allowed you back over, Mario told me.

It seems everyone in my village knows I'm gay except my parents. The village turn their heads and laugh, but nobody ever says anything to me, they won't dare, not with William MacDonald as a father.

Things have not been the same since I stole that money and declared my plan to escape, but with time, my punishment is lifted, and I am trusted again to go outside with Mario.

So why did you do it? he asks, passing me a cigarette his lips have wet.

I dunno. I shrug. *I want to get away from here.*

Aren't you embarrassed?

Suppose so. I turn away. As we trudge through the fields, the chill of the evening air seeps into my bones.

Where would you go if you had the chance to escape? I ask him, crunching over the nettles beneath our feet.

John, I'm OK here. I just want to be happy.

We arrive at our den. Inside the signal station are the remnants of our last time here: charred remains of our campfire and cigarette ends. This building is special; it is curved like a mini lighthouse but only has three storeys. It even has a spiral staircase right in the middle. The second floor is dark and dingy, with old cupboards covered in moss, but the third floor has windows 360 degrees round. I guess they allowed the signal master to see the trains coming and going long ago when this place was in use. There are levers, switches and dials, all rusted tight. The glass is missing from most of the windows; we lobbed bricks through them for fun months ago, so everything mechanical is now rotten from exposure.

The old railway lines that once took steel to and from the steelworks are still here, but nature has reclaimed them. Behind us are the famous steelworks that were closed back in 1986 while Thatcher was in power. Amid this decaying metropolis of industry, there is a glimmer of renewal. Slowly but surely, the forces of nature are

taking hold; silver birch has taken root in the cracks of concrete and lush greenery spills over the edges of rusting machinery. The once mighty furnaces and smokestacks stand as a testament to a bygone era, yet at the same time they serve as a reminder of the resilience of the natural world.

Mario and I have covered every inch of this decaying interior. We have carefully edged along steel beams one hundred feet up, and climbed into unused pits and steel drums. It's the biggest building I have ever seen. From its roof, you can see far over the fields, all the way to Glasgow where my life started. The freezing wet air is punctuated by the sound of distant cattle mooing; we kiss deeply to their chorus.

We stay up here, only letting each other go to light a smoke, and as time passes the fog around us gets so dense that we can barely see each other's faces. Mario guides me by the hand, down the steps and out into the night. Hidden under the blanket of felty fog, we walk along the abandoned railway, hands interlocked, shivering and free.

Back in the den, we hog the fire we've made for warmth. Mario wraps his arms around me, settling my shivering body into his as we talk about life in a way I can't at home or with anyone else.

He is always curious about my past and presses me for memories. He knows how difficult it is growing up in a tight-knit family full of macho barriers and strong family pride. He speaks about his uncle, and his fear of AIDS, and he sometimes cries. We haven't been educated about what AIDS is; we are told that poofs die of AIDS. We are doomed to die.

*

With Norma's support I have been accepted into Glasgow art school on a fifteen-week course to study life drawing.

Well done, John, this is an amazing opportunity for you. I'm sure your mum will be really proud, Norma says with a smile.

Can you be trusted to go into Glasgow on your own? Mum says, standing in the kitchen, her eyes scanning me up and down.

The course helps you prepare a portfolio to apply for a first year at art school. Two pupils have been selected.

I'm relieved to spend a few hours a week away from home doing what I love. Glasgow art school is so special, the smell of oil paint and chemicals, the silence and meditation.

The air is charged with possibility, and I feel a renewed sense of purpose.

I am trusted by Mum to use the exact amount of coins to travel into Glasgow by train with my classmate Laura, who is the very first person apart from Mario that I've told I am gay.

Today I'm dodging the life-drawing class at the art school to instead observe a different kind of life. I've changed from my school uniform into one of my home-made creations, a tie-dyed double-denim shirt and flares, and I'm heading to the only gay bar I know. It is called Sadie Frost's and sits underneath Queen Street train station. My nerves run rampant as I cross the threshold and behold a dizzying array of other gay individuals living their lives without restraint. Boys saunter about with a flourish, dapper gay men in suits drink pints of lager and eat crisps, and groups of lesbians chat away – all just normal folk enjoying the simple pleasures of existence. My solitary presence is an awkward intrusion amid the throng of out-and-proud revellers.

I try my best to blend in, projecting an air of nonchalant confidence as I hover near the exit, unwilling to fully immerse myself in the pulsating energy of the busy bar. I gather up as many flyers for other gay establishments as I can, and pocket a copy of *Boyz* magazine as a reminder of this very moment, otherwise Mario won't believe me. I slip away and travel home before I'm discovered.

How was the class? Mum asks at dinner.

It was great, I lie, avoiding eye contact.

At night I lay awake reading the magazine. I read stories from different personal ads, men looking to meet each other from remote places across the UK. There are photos of drag queens, escorts, leather daddies, and snaps of happy people from different nightclubs, hugging and holding hands. I read it from cover to cover and hide it under my mattress. Later, I share it with Mario in our den.

I am sitting in my English class, reading *Romeo and Juliet*, when the school nurse appears at the door and calls my name.

John MacDonald! I look up from my work. *Your mum is here!*

I wonder what I have done wrong and dread what awaits me. I pack up my bag and walk to the school reception. With each footstep, I wonder what is in store.

Mum is standing there, but she isn't angry; she is smiling at me as I walk towards her.

Hi, son, the hospital has called, and they have a place ready for you to have the operation on your nose. She gives an excited smile; even her eyes light up.

I'm so relieved I haven't let her down again and excited to get this thing on my face fixed. Mum has already packed my bag and we drive to Yorkhill hospital in Glasgow. It is the same hospital that Mum took me to years before to have operations on my eye.

In the car, she is calm and soft.

You can play your tape if you want. She smiles and so I play Bjork quietly.

I pull down the vanity mirror in the front seat and stare at my reflection, this feminine face, these high cheekbones, these slitty eyes, and this thing protruding and bending in the centre. I can't wait to get it fixed.

Mum explains how the operation will go to the best of her knowledge and tells me of the risks involved.

But hey, you've had operations before. I'm sure it will be fine, son.

On arrival, I'm shown my bed in the ward and I'm settled down for the night, letting Mum head off to make dinner for Dad and Jack. The operation will be in the morning, so I'm not allowed any food. I just have to wait. I have my sketchbook in my school bag, so I draw my face. I draw what I think I will look like with the big, crooked nose gone. I hate the asymmetry of my face. I wonder which of my birth parents I inherited it from?

The next morning, I'm prepared for the operation and taken down to the theatre, where I wait in a long corridor. Then I'm wheeled in by a jolly male nurse, and before I know it I'm being sedated.

I wake up back in my room. I can't move my head and my front teeth are killing me. I think they are broken. Then I black out and I dream, high on the drugs, of Granny Gormley. I reach out to her,

and she smiles at me. She is so clear, every pore in her face visible. This face I haven't seen for many years. I'm four years old again. She is sitting on the bed opposite mine. Then she starts frantically banging a metal tray on the side of the bed like a drum, over and over. I wake up and look around; Mum is sitting here looking at me with such love in her eyes.

Hi, son, she whispers with a huge smile. *How are you feeling?*

She explains that the operation has been a success and that I can go home the next day. When the nurses come to take out the packing from inside my nostrils my nose explodes with blood and pain, but Mum is here holding my hand and hushing me through. I'm cleaned up and settled back down. I look at Mum and she is crying.

It broke my heart when I walked around that corner and saw you laying here unconscious and attached to wires, she sobs.

At this moment I feel her love, her care and her support. I think back to the times I've been sick with mumps, measles, cuts and scrapes. The two earlier operations on my eyes, where she held my hand and wiped away my bloody tears.

Over the weeks my black eyes slowly fade, and the swelling on my new nose gently disappears, revealing a small straight nose to match my fixed eye. Now my visual flaws are a thing of the past.

5

I walk up the hill from our house wearing my greasy oil-stained denims; the smell of diesel from the machines drifts towards me. Through the massive steel gates, I'm greeted by Aisa the guard dog; the poor thing's coat is matted with oil because she lives in a hut here, but she's a friendly dog. I often ask Dad if we can take her home to play and clean her up.

Don't be so soft! She's a guard dog, John, I'm told.

Sometimes when I arrive at work early, I go into her hut and hug her.

When metal is sold to Dad, huge trucks stop on his weighbridge to calculate the price before dumping their loads in enormous hills full of twisted scrap. As a child, I loved climbing these with Jack. It is amazing the things you can find here: old prams, crushed cars, dead machines. All had a purpose, loved by someone, used and rejected.

Our job is to slowly go through the piles, separating and breaking down the different metals that hold the items together; the most precious is the copper. Everything is recycled, and cleaned up or melted down, ready to be given a new purpose and life, a different object than how it had started. Just like me. Even here among the chaos and debris, I find creativity. Sometimes I make figures and faces by twisting raw copper wire into a rope and stand them around the yard like a magical fairy garden.

With a few determined yanks on the heavy chain, I summon the colossal roller shutter from its slumber, raising it high and allowing the daylight to cascade into the work sheds illuminating the machinery. One by one I switch on the machines, awakening the dormant giants of industry. A huge guillotine that was designed and built to cut heavy lengths of six-inch cable roars with a loud electrical buzz, and then the stripper takes that cable and slices it down the middle to reveal the precious copper, which is extracted, cleaned and heaped into a gleaming bright mountain. The stripper's huge gears crunch and gurn as they turn. Its relentless pursuit of that precious copper mirrors my mother's discerning eye, peeling away the layers of pretence to expose the core of my truth.

As I look around me, I realise that nothing is wasted here; everything is recycled and sold. There are several large buildings like this in the yard, each has a purpose and houses the process of deconstruction, granulation or smelting, reducing the elements to molten form and shaping them into sturdy ingots.

At lunchtime, I walk the short distance back home, covered in

grease and fragments of coloured plastic from stripping cable. After a wash, I sit at the kitchen table.

There's a letter for you, Mum says, placing a big white envelope in front of me.

I open it up.

It's from Central Saint Martins. I read the letter with anticipation. *They want to see me for an interview.*

Mum tips her head in acknowledgement but says nothing as she dries dishes. I put the letter in front of her. Mum's eyes scan the text.

No way; you are not going to London. You can't be trusted on your own in London. Forget it!

There is no pleading; that will only infuriate her. I eat lunch without another word, then head back out and up the hill to continue my work.

A few weeks later Mum can feel my ongoing disappointment; she tells me I can apply for a course at North Glasgow College.

At least we can keep our eye on you, she says.

It is a far cry from London, but I send away the application and start a fashion design and manufacture course.

North Glasgow College is in Springburn, slap bang in the middle of one of the roughest areas of Glasgow. I take three buses to get there each day and risk getting stabbed walking through the rough council estate in my home-made flares and super long-sleeved Bjork-inspired strait jacket sweater.

Glasgow is always a thrill. I know my birth mum and sisters live somewhere in this city. I am constantly on the lookout for the face I recognise, the face embedded in my heart from what seems a

lifetime away. I dream I will just casually bump into Birth Mum, or maybe my sister Hannah will recognise me.

At the end of the term, the college holds a fashion show at the arches in Glasgow. Mum has come along with her sister Aunt Pat, a woman who emulates Catholic morals and had scoffed at me when I applied for this very course.

Huh, a jack of all trades, master of none, she had said.

They take a seat in the front row.

When the music has stopped and everyone has had their five minutes of fame on the catwalk to an erupting audience, we go to greet waiting family. I brace myself, ready for disapproval. I'm never going to live this down, not in my village, not with my dad. Then Mum rushes towards me and hugs me so tightly. She congratulates me. I realise she is proud of me. At last.

Every August our parents take us to a place called Embo for a two-week holiday. Embo is on the north-eastern coast of Scotland and is famously known as *Grannies heilen hame.* Mum packs our big caravan with all the luxuries of home and Dad drives us, towing the caravan for six hours, north towards the highlands.

Embo has a huge caravan park next to the sea, and the clean white sands here are edged by a belt of high dunes. Ever since I was adopted this place has been a second home. I spend hours with my siblings playing on the vast golden dunes and looking through rock pools for crabs or other life forms, like space explorers on an alien planet.

It seems to be the place where Mum is most happy. She softens

here away from the routine of trying to school us and the pressures of home. My fondest memory is walking back to our caravan with my mum's arms around me. Suddenly she gasped and turned to look at the sky and we watched an orange and red fiery sunset.

This summer of 1996 I've asked to stay home and, again, prepare a portfolio, this time with the hope of applying to Glasgow School of Art. I will work in my dad's yard to make extra money. I stay in the village while my mum and dad take my brother and our wee dog away for the two-week summer trip late in August. I spend my days drawing at home or working alone in the yard. In the evenings, I spend time with my school friend Laura. Jack arrives home a week early from Embo because he is awaiting exam results in the post. He travelled home so he could be here when they arrived, leaving Mum and Dad alone on holiday. Mum phones home throughout the week to check on us and to see if Jack's results are in.

No nothing yet, Mum, he says down the line before calling me to the phone.

Hiya, son, Mum says with a cheerful voice when I answer.

She tells me how the holiday is and asks how I am doing.

I love you, son, she says unprompted, and my heart fills up.

I love you too, Mum; have a great time and see you soon.

The next morning, I wake up and get ready for work. The yard is officially closed for the summer holiday, so there is no pressure from Uncle Tam or questions from the boys; I'm alone.

I open the massive steel gate and close it behind me. After a good play with the guard dog Aisa, I head into Dad's weathered Portakabin. I call Mario's house, praying that his dad doesn't answer or else I will just hang up.

Hello, 972342, Mario says.

Within twenty minutes he is waiting at the gates, panting from sprinting the distance to meet me. I let him in, locking them behind us, shielding us from judgement and prying eyes.

Sitting squeezed between the perimeter wall and hidden behind the bottom work shed, we share a cigarette. Mario has been away for twelve weeks, doing his firefighter training. He has returned a man; his arms bulge with muscles and his enormous frame leans against me.

Tendrils of smoke rise and intertwine with the air, mirroring the ethereal dance of our emotions. Mario's gaze drifts into the detail of cracks in the stone wall; I can sense a heaviness in his demeanour.

Is everything OK? I ask.

He sighs deeply.

Yeah, things haven't been easy lately. I've been doing a lot of thinking, you know? About my future.

The firefighting? I ask.

No, not that. He smiles. *Us, this.* He squeezes my hand.

Oh, I say.

In that moment, his hand slowly slips away from mine; it feels like the wrenching separation of metal from metal.

He is embracing manhood and with that comes the realisation of the dangers a friendship like ours poses.

I break the silence between us. *I think my mum knows I'm gay.*

How? Mario asks.

I explain that before my parents had gone on holiday to Embo, Mum had been in the caravan with a basin of soapy water, washing down walls and windows, getting it just so for their trip. I asked her if

she needed some help. Mum turned to me and with a soft half-smile said, *I think it's a better idea that you clean your room, especially under your mattress.* She raised her eyebrows, an admission of what she had found hidden there. *You don't want your dad to find those magazines, John.*

My face burned red, but as her eyes scanned me, she smiled again and turned away to continue cleaning.

Mario gets up in a panic, as though my revelation could somehow implicate him. He makes his excuses and wanders back to the gates. Without eye contact, he leaves and I bolt the gates behind him and prepare to work.

The next day is Saturday. My brother and I argue over the remote control for the TV. Eventually I give in and take myself off to my room and push the video cassette for Tina Turner's story with Angela Bassett into the machine, settling down to watch it for the millionth time. As my movie plays, the familiar ring of our house phone resonates through the air, prompting me to press pause. I make my way to the hallway, where a quaint wooden table proudly holds our phone. I answer.

Hello, John, Dad whispers.

I know something is wrong. His voice is different, unfamiliar, tinged with a sense of frailty that sends shivers down my spine.

Hi, Dad, how are you? I say, trying to hide my fear and trepidation.

John, this is very serious. Your mum and I have been in a car accident and your mum has been killed, Dad blasts out between sobs.

I am suspended in time; my head vibrates and surges. Dad's uncontrollable sobbing down the phone only confirms this reality.

Dad starts giving me instructions, his voice shaky and barely audible. I try my best to focus on his words, to understand what needs to be done next. Dad asks for my brother Jack, who on hearing me knows something is wrong. He grabs the phone from my hand.

I sit curled in a ball sobbing and watch my little brother's world fall apart as Dad explains what's happened.

Holding my brother in my arms for what seems the first time in my life, we cry.

My parents had been driving back to the caravan after a day out and Mum had bought some Caithness Glass in Dornoch. She loved to collect the blown-glass bowls and they are dotted all around our home, holding flowers and casting coloured light across the walls.

She decided to take a different route, and in the Highlands many of the roads are narrow, allowing only one car with passing space every 200 yards. A drunk driver came towards Mum and Dad with nowhere to go; he collided with them at full speed. Our mum took the impact on the driver's side. Both my parents were mangled in metal. Dad was severely injured, with fractured ribs and glass embedded in his face and head. He managed to pull himself out and tore at the metal with his bare hands to free his wife. Mum's injuries were much more serious. The driver killed himself and his young girlfriend in the impact. My mother died on the way to the hospital in my father's arms.

Before embarking on their ill-fated holiday, my dad's voice echoed from the garden.

Quick, John, come and see this.

Every summer we would watch swallows glide around our property. Their long forked tails traced the sky as they swooped down low and snatched bugs from our beautiful garden.

The swallows nested in Mum's garage and would perch on the beams above her car. This year they had chicks and Mum adored seeing the baby birds and their parents coming and going, carrying bugs and twigs. She even stopped parking her Mercedes in the garage to give the avian family peace.

They are so beautiful, she said, cupping a mug of tea and watching the birds at a distance.

When I reached Dad, he was inside the open garage. On the floor lay two dead swallow chicks, twisted and still where they had landed among droppings and feathers. A huge magpie was flashing around the space. We ducked as it flapped in a panic around us, crashing against the cobweb-covered window in its bid to escape.

Fucking thing has killed our chicks, Dad said with rage.

We stood in its way, blocking its path. Dad bobbed and weaved, as if in a boxing ring, as the magpie swooped past us, shedding iridescent black feathers in its wild frenzy. Rising from his crouch, Dad unleashed a powerful right jab, connecting with the magpie in mid-air. With a puff of feathers, the bird's life was extinguished, and its limp body thudded onto the concrete at our feet.

Over the next few days people start to arrive at our home, cousins, aunts, uncles, family and friends. I have to take charge and grow up. We sit in the living room waiting for Dad to return. We do not know

what to expect. I sit on the sofa with my sister and brother, huddled together, living in our grief and desperate to hold Dad.

When he arrives, he comes into the living room with his head bent forward, holding our mother's blood-stained white sandals and her burst handbag. We cry together in a group hug, and Dad says sorry over and over. Our family dog was also killed in the accident.

As Mum is Catholic, her body is brought home to us, her family. She needs a wake before she is buried. She is laid out in our dining room in a coffin. She is pale and frozen to the touch. I sit with her, kiss her face and hands, in floods of tears. I sit in my guilt that I have not tried harder to please her.

Our house is overrun with a sea of faces; many I have never seen before and some not since I was a child. There are Catholics milling around with their rosaries. Latin chanting seems to drone on and on for days. I feel lost among it.

The priest from the Catholic school is here, sitting in our kitchen. I've never met him before in my life. He certainly never visited our home while Mum was alive.

He is going to be taking the mass for her funeral and will be leading the rosary and wake over her body. He tries to console me as I sit at the table in tears.

He speaks of Jesus and how Mum is with him now and how God is wonderful and loving and has a plan for her soul. His well-meaning platitudes suffocate me.

He speaks with such an air of certainty, as though he has all the answers to the unanswerable questions that plague me. I feel sorry for these people who worship a god who has the power to stop all

wars but chooses to watch you masturbate. I stand up and lean into the man's face.

Your god is a cruel one.

When a Gypsy person dies, it is tradition to burn all the deceased person's belongings to prevent marime; this is where a spirit lingers on the earth. That's why family members have to destroy all material ties to the dead. It's the Gypsy version of a rosary and is meant to bring about closure.

So, in the weeks following Mum's burial, Dad bags up all of her belongings and together in silence we lug them to the scrap yard. Dad has prepared a huge bonfire made out of hundreds of wooden pallets. Over two days, we set ablaze Mum's clothes, shoes, handbags, documents, ornaments and furs. We are choked with grief as we watch the fire take her material memory up into the sky in black smoke. I feel betrayed by the god my mother placed her faith in.

I help Dad at home as he continues to dismantle anything that had any attachments to our mum. The big stone fireplace in the living room that she sat at for years is taken away brick by brick until nothing is left. Our memories and our shared experiences are all tied to these physical objects and spaces, and now we are being left adrift in a world that is suddenly unfamiliar. I watch helplessly as my dad, a broken man consumed by grief, takes apart the very fabric of our existence, erasing every trace of my mum's presence. He sells off the land around our home and bulldozes our back garden, leaving muddy blank fields in its place. All the memories of playing here as

a child and sitting with Mum in the sun around the rockeries full of flowers and fruit trees are wiped out.

It takes me some weeks to come back to my senses. Dad begins the slow process of closing his business and yard; the place that had brought us so much luxury through his years of hard work now seems like a pointless burden for him to keep.

Dad never speaks about the accident; the only details we hear are from older relatives. My cousin tells me that Mum knew that she was going to die at the scene and told my dad to look after us.

I feel so much pain for Mum, who had done everything in her power to educate me and give me a home. I feel I let her down while she was alive; I wish that things had been different, wish I had tried harder. And I miss her. I pray that if there is a god then he/she will allow my mum to give me a sign that she is safe, and her spirit has survived, but I notice nothing.

I never experience the faceless dream again.

It is Friday night and I'm on my way to Glasgow. I've told Dad that I'm sleeping over with Kelly, a girlfriend from college, but I'm really going to Bennets nightclub with Jamie, Kelly's gay brother.

I exit at Queen Street station and wait for Jamie. Homeless men loiter around, ranting to each other to the rumble of trains coming and going.

I am dressed elaborately, but looks like this have only ever been tested in the village, alone and at night when everyone is fast sleep. Suddenly I don't feel safe, and then I hear him.

Hello, ma darlin, he belts in a sing-song voice.

I look around, and so does everyone else in the station, gobsmacked. Jamie saunters towards me wearing a top made from strips of leather cut from an old jacket and stapled together in a loose lattice fashion. On his legs he has bright orange trousers and big black platform boots. He is overweight, and his stomach hangs out through the strips of leather like half a pound of silverside beef tied with string, the kind Mum bought from the butcher's for Sunday lunch.

This is Jamie. A prankster, a clown, a dare devil. He lives on Sinclair Drive in the South Side, close to Queen's Park, in a big sandstone tenement, with no parents around to impose rules. He revels in the freedom to explore his creativity and enjoy an out life with nobody to answer to. Jamie and Kelly are Mormons, but Jamie was disowned by his family because of who he is.

He has been working as a hairdresser in a fancy salon in town, learning how to cut and colour. The boss had noticed money and products were going missing and Jamie was the main suspect. So, before he officially got caught for nicking, and to get revenge on her, he bought kippers from the fishmonger's and hid them in the overhead light fixtures.

On his last week, the air was thick with decay, causing a feverish search for the source of the reek. On his last day before turning over his salon keys, he threw green fabric dye over the boss's blonde hair and left, warning her never to accuse him of theft again. Even though he had been thieving.

In Bennets nightclub, Jamie has ecstasy tablets that he keeps hidden within a battered old monkey teddy, the kind a child takes

to a sleepover and keeps their pyjamas inside. It has Velcro on its hands, so he wears it like a bag.

As the strobe lights flash and the bass thumps, he weaves his way through the sea of bodies with ease, his monkey teddy slung over his shoulder like a trusty sidekick. To the untrained eye, he's just another reveller in search of a good time. But those in the know can see the tell-tale signs: the knowing nods, the furtive exchanges with shady characters lurking with rolling eyes and shaky jaws begging for another pill.

As long as he's popular and doesn't get caught, he's untouchable. He dances on, his monkey teddy bobbing up and down with each beat, a symbol of his immaturity and audacity. He's the man with the monkey bag, the king of the eckies.

Jamie appears, his face glowing with excitement and mischief, holding a small, pink pill in the palm of his hand. His eyes are sparkling with anticipation.

Open your mouth, he says, his voice barely audible over the thumping bass.

This is against everything I have been taught at home. If my dad knew I was in a gay club and swallowing an ecstasy pill I would be a dead man. I wince as an acrid taste fills my mouth and the pill washes down my throat.

At first, I don't feel anything. Then a warm sensation begins to spread through my body. The colours around me seem to brighten, the sounds become richer and more intense – I am floating. For the first time in my life, I feel truly alive.

At 2am the music stops and the lights come up. We make our way outside. Every breath feels like the first breath of a new-born being.

McCaw, Jamie yells, and a blond boy walks over with the widest grin on his face.

The staples holding Jamie's home-made costume together have lost their fight and now loose leather strips hang around his waist.

You look like an angry octopus, McCaw laughs while they hug each other. *How was Bennets?*

Jamie exhales a big funnel of smoke up into the night.

Pure shite. He turns to me. *This is John. John, this is McCaw.*

Come on, we're going back to mine. Jamie grabs McCaw's arm, who takes my hand in his other. We jump into a taxi and head off through the city towards the South Side.

Amid the flurry of bodies strewn across Jamie's house – a post-club entourage seeking an endless night and indulgence in the free pills he so generously distributes – an unmistakable presence commands the room.

Betty, whose birth name is Peter, is centre stage.

Betty is barely seventeen years old and adorned in a Geri Halliwell Union Jack costume.

Jamie waves a joint in the air, demanding, *Do that stupid dance you do, Betty.*

Naw, I'm too shy, Betty demurs, averting her gaze.

Do it, and I'll give ye a free eckie, Jamie entices.

In the blink of an eye, she springs to her feet.

McCaw, who's sitting next to me, takes my hand, and we break away from the group.

Let's hide from everyone, he says.

I find myself under a bed, in a dark room, whispering with McCaw.

They're not coming, I say.

Through the dark cramped space, I feel his arm move over me, and we kiss.

The next morning, McCaw drives me home. His parents are wealthy people from Newton Mearns. He speaks in a slurring posh accent – Queen's English that Mum would approve of – and he has been privately educated. But underneath this façade, he is a total Glasgow bam. He loves his sports car, clubbing and fighting. Back home, I introduce McCaw to my dad and brother as a friend. McCaw isn't out to his family either.

Months pass and I try to find a job. I tap money from Dad to go out; I have no real way to support myself. McCaw sticks by my side and lends me a suit to wear. It's hideous, shiny charcoal grey, and far too big for me. Eventually, I find work canvassing door to door in Glasgow trying to get people to switch from their gas company to the one I'm touting. I'm on commission and only get three pounds for every person I can sign. Without any real grasp of maths, I fumble through the sales pitch at each door, unsure how to answer the question of 'How much will I save?' if the client switched to us. In one week, I sign one old man. So, I quit with three pounds earned.

Then I get a job washing dishes for an Italian restaurant in Coatbridge. On a shift, one of the owners asks me if I am a 'wee poof' in front of all the male kitchen staff.

Driving back home one night, I tell McCaw about the children's home, Sister Pauline and Scary Man.

McCaw turns the car around.

Let's go there now; let's confront the bastard, he says with determination.

As we drive through Glasgow towards the South Side, the city comes alive around us. I start to recognise the streets. Big villas and mansions appear on either side of us, telling me we are close.

STOP! I shout as we turn up a familiar road. I look around and find my bearings. *Go right here.* The indicator blinks with my heartbeat. *OK, take a left.* A few yards more. *Stop behind this car.*

I ask McCaw to wait, and I get out and cross the quiet street. I'm standing at Sister Pauline's house. I breathe the surrounding air into my lungs. I start to walk up the big drive towards the villa. Everything looks as it did when I was last there, over twelve years ago. I haven't thought this through. What if she answers? What will I say? I clear my throat, ready to sound unthreatening to an old lady in the hope she will remember me. I knock, there's no answer, I look back at McCaw, leaning against his car smoking, and I knock again. Nothing.

We leave the car and walk the short distance to the children's home. The two villas that once stood separated by a glass walkway are still here. Even the big trees in the sweeping driveway are standing. The house I lived in is dark as we approach, but the adjacent house is fully lit.

It's a ruin, McCaw says as our eyes adjust to the blackened, burned walls and boarded-up windows.

We knock on the door of the second house and a woman greets us along with three teenage boys. The chaotic sounds inside tell me this part of the home is still a children's unit.

I introduce myself to the woman. Her name is Theresa, and she welcomes us in.

I remember you, she says with a smile, as we step into the building's old soul.

She fetches another woman, the house cook, who has worked here for many years. She remembers me also, but I recognise neither of them. They show me around; I point out the places I had played with Morag and Jane, the gummy girl with cerebral palsy.

There is a sense of comfort in being back, but I also feel like an intruder, a visitor in a place where I no longer belong. The memories are a bitter-sweet reminder of my childhood. I know I am searching for Sister Pauline, but I know she isn't here. Nor is my birth mother, who I last saw only yards from where we stand now.

I ask Theresa lots of questions about the children's home. Yes, she knew Sister Pauline but hasn't seen her for years. Yes, she remembers Sandy the dog.

The big house, my house next door, had been set on fire by kids who were housed there, so it was closed a while back, but the glass walkway that connects the buildings from the basement is still here. She leads us towards it, but it's boarded up halfway along. We can't go any further.

Too hazardous, what with the building's fire damage, Theresa says, and I'm glad of that.

Back up at the front door, I ask, *Do you remember a guy who worked here with long grey hair?*

Oh, he was a right bastard him. You used to be terrified of him. I remember staff having to hunt high and low for you when he was on shift.

She goes on, *I think he was in the army, you know. I cannae mind of his name but I remember his face. He hasn't worked here for years and years.*

As we leave, I take one last look at the magnolia woodchip walls.

Well, it was nice to see you, Theresa says.

As she closes the door, I vow never to return to my past, which weighs on me like a leaden shroud.

One Saturday night McCaw and I return home to Dad's at around five in the morning having spent a night sweating in Bennets nightclub with Jamie and Betty.

I settle down in bed; McCaw sleeps at my feet, head to toe.

I wake in the morning to the sound of Dad's van starting, its rumbling engine coughing to life. With a quick glance behind my closed curtains, I confirm that the coast is clear and crawl to the bottom of my bed where McCaw lies asleep.

As McCaw stirs, he glances around with a hint of curiosity. *What time is it?* he asks, his voice still groggy with sleep.

Nine thirty, I whisper. *Dad's just left.*

We undress each other and I lay the length of my body on top of McCaw's, looking deep into his blue eyes. Without warning my bedroom door opens.

Right, you two, time to get up.

Dad stands in my doorway watching us lying naked and exposed. With a jolt, I grab at the quilt and pull it over myself. Too late, Dad has seen us and closes the door.

Fuck! McCaw blasts. He scrambles around the room looking for his clothes.

What am I going to do? I whisper.

As McCaw starts getting dressed, I notice a palpable shift. He's angry and avoids making eye contact with me, his gaze fixed on tying his trainers.

I need to go, he says, putting on his jacket and pushing past me.

I grab at his sleeve, but he jerks his arm to release my grip and storms out. I hear his car door open and the engine start. I listen as he pulls out of the yard.

I have lived a life where every adult male I've ever known has rejected homosexuality. I have listened to cousins talk about beating poofs up outside clubs, and I've heard aunts saying gays should be burned in a big fire pit. I have been mocked by male schoolteachers for being effeminate. I am the person society says is the lowest of the low.

As I walk into the kitchen, Dad is sitting at the table, his head in his hands.

I sit down opposite him. His eyes are swollen with tears. His lips quiver as if struggling to form the words he wants to scream.

He eventually breaks the silence.

John, how many times have I told you about people taking advantage of you?

His eyes spill with angry tears. His hands are out, palms upturned to the heavens, as though he is balancing two heavy hearts. *Are you that fucking stupid that you would let somebody do that to you?*

Dad, he hasn't taken advantage of me. McCaw is my boyfriend.

His face contorts with disgust. *Your whit?* he spits, his eyes narrow.

I'm gay, Dad! I blurt between sobs.

Dad's eyes go blank, a look I have never seen in the years he has loved me. I brace myself. He stands up, shaking his head from side to side, and walks out, leaving me sitting alone. When he returns, he is composed and stands over me at the end of the table. With a deep breath, he slides fifty pounds across the kitchen table towards me.

You can stay here and live a normal life and forget the idea of being gay, or you can go. I'm going over to your granny's. You know I love you very much, but if you aren't here when I come home, I'll know what you have decided.

While I finish packing my things, my brother Jack comes home and asks me what is happening.

I'm not coming back, Jack, I say.

McCaw meets me in the street, just around the corner from our house. I have three bin bags of clothes and some boxes with videocassettes and art supplies.

So where are you going to go? he asks.

I struggle to find an immediate response.

John, McCaw yells. I look at him. *Where are you going to go?*

I don't know, I whisper, my voice barely audible.

I pull a copy of *Boyz* magazine from my bag and scan the personal ads. With McCaw's mobile phone, I call the first ad I see. It's for a bedsit in the West End. A lady answers and I ask if I can come and look today. She agrees, and we head into town.

We stop in the afternoon on Wilton Street. Beautiful big brownstones that were once large family homes line the street.

Most have been turned into flats and bedsits for students. I meet the owner and she leads me up into a large room with a big bay window and high ceilings.

It's three hundred a month. This is your kitchen. She points to the far wall that has a cooker, fridge and single unit. *There are two bathrooms that are shared and a payphone in the hallway.*

As I take a closer look around the room, the peeling wallpaper and cracks in the ceiling speak of years of wear and tear, dust particles dance in the streams of light that manage to filter through the grimy windows.

The lady doesn't ask for a reference or upfront money and agrees to let me move in right away. McCaw helps me take boxes and bin liners of clothes up to the room.

What do you think? I ask him when we are alone. But he doesn't answer; instead, he fidgets with his mobile phone.

Look, John, I need to be getting off, he finally says, looking at me. *My parents are expecting me. Are you going to be OK? I will see you tomorrow once I finish work.*

I watch from the window as he gets into his car and drives off.

The large room only has a single bed and a bedside cabinet. I have no bedsheets or blankets. The thin carpet is a dark blue acrylic corduroy effect, stained in patches. There is a clear imprint of an iron that has melted into it in the centre of the room, it points towards the door.

As night falls over the West End of Glasgow, I lay in bed fully dressed for warmth. I keep a photo of my family in a small frame by the bed. It is from Christmas, one of my first with the family, must be 1984. I'm dressed as Superman, Jack as Spiderman. We are on Mum

and Dad's knees. A big Christmas tree stands behind us twinkling with coloured lights. Dad has missed the moment and is mid-blink.

The next day I wait in, but McCaw does not come back; he has stopped answering my calls.

I look for jobs during the day and draw portraits in the room by night until my sketchbooks are full. There's a Bible here; I'm not going to read it – I've had enough Catholic masses to last me a lifetime. Instead, I draw over the verses with dirty images of men fucking. Before long my fifty pounds runs out. I pinch little sachets of sugar from cafés and cook boiled rice with sugar, which lasts a week. When I run out of tobacco, I collect discarded cigarette butts from the ground and pull out the minging tobacco that's left inside. I use the thin pages from the Bible to roll cigarettes.

The threat of homelessness is so close to me. I play over in my head what I will do if it comes to that and mentally note where would be safe to sleep as I wander around the West End. I love Kelvingrove Park close to the museum. It's amazing to me the stark contrast this place has. By night it is a sleazy haunt for gay sex and during the day children play in the same spots under the Scottish sun.

Sitting on the grass I sketch a homeless man lying on a park bench. His clothes look wet, maybe greasy. I wonder what his story is. I wonder who misses him.

Observing, I can see how people react to the homeless man. Children stare the way children do, full of curiosity, some with fear at the strange lump on the bench. Mothers and fathers, out for an afternoon stroll, shake their heads, disgusted at the man for

destroying their morning with his stink. And some don't look at all, turning their gaze away, afraid to contaminate their minds with guilt for not helping.

I'm almost finished my drawing of the sleeping tramp.

I create a flash of light by rubbing away dark areas of pencil to reveal rays around his head. I pretend in my mind I can manifest God watching over him. I see the light even in the darkest places. There, it's finished! I swipe away little fibres of eraser with the back of my hand that have rolled over my page.

The tramp is up on his feet; perfect timing. As he looks around, I notice his hair is one big, matted flap, like a beaver, or a hair blanket. He starts to rant and rave as he walks away; his voice pierces through the quietness of the park, his words muddled and incomprehensible. His body trembles with erratic energy as if he is fighting off some invisible force. I remember this chaos from Birth Mum, screaming and shouting, under the influence of beer. At home in the village, I had been protected from these kinds of figures. I watch, transfixed, as he swings his arms around wildly and stomps his feet on the ground. It frightens a young couple passing by and inside I cheer for him.

Despite the chaos of the scene, my artist's eye sees the beauty in the movement. His hair flap flops in the wind like a tattered flag, a symbol of his defiance against the harsh world that has left him homeless and destitute. His arms are like brushes, creating a frenzied masterpiece in the air.

Suddenly he is coming in my direction but stops to take a deep breath. He looks around as if coming back to reality. He catches my eye and I smile at him, hoping to convey some sense

of understanding. He nods in acknowledgement but then swings his arm up, sticking two fingers up at me. I jump, then laugh and he shuffles away, disappearing into the crowd of people moving through the park.

I stroll through the bustling city streets in the early evening and settle down with my drawings on Sauchiehall Street. Just up the hill is Glasgow art school, a beacon of artistic achievement and creative potential. The dream of graduating from that prestigious institution and becoming a recognised artist still flickers within me, though it is tinged with melancholy as I find myself on the fringes of society.

I place a few sketches out in front of me: ten pounds for the sleeping tramp; fifteen pounds for a drawing of my friend Betty; twenty pounds for a drawing of Granny MacDonald as I remember her face, weathered by years but with electric, psychic eyes.

People filter past me, but nobody looks down. My eyes are drawn to the myriad of individuals who cross my path. Among them are wee wizened-faced women, trudging their way home with shopping bags in tow. Then there are the workmen, taxi drivers, students and even drug dealers, who saunter around, seemingly searching for a quick fix.

I am compelled to observe and scrutinise every detail of their features – the curves and lines of their eyes, the shape and texture of their mouths. With each passing moment, I find myself sifting through their unique traits in search of a familiar resemblance, a glimmer of a shared heritage.

As the evening descends upon me, I wander penniless along Great Western Road. I pause outside a fish and chip shop, my eyes

fixated on the bustling scene within. Customers come and go, ordering and indulging in their meals. Through the window, I catch glimpses of their animated conversations and infectious laughter, muffled yet vivid.

My gaze becomes focused on a young woman, her lips smeared with ketchup as she takes a hearty bite from a hamburger. A wave of shame washes over me, shame for my own hunger. It's a complex and difficult emotion to process, this shame.

I walk around the corner of the street and linger by a rubbish bin. When I know no one can see me I nervously peer inside. I feel at a crumpled paper bag: it's empty.

I saunter further along the street. My hands are hidden up my sleeves, keeping them warm. Then I see a sign. Mum always told me that God will answer my prayers, so I stand outside St Mary's Cathedral and pray that maybe inside, good church people will feed me.

I push the heavy door open and ahead is a huge altar. I look around, but the cathedral is empty and silent. I walk to the pew at the very back and sit down. Memories of my mum's unwavering faith come rushing back, her fervent attempts to instil in me the pursuit of a righteous path, to work hard at school and live an honest life. Yet here I am: alone, starving and gay.

I wonder if Mum would have allowed me to leave home if she'd still been alive. I imagine her in an alternate universe where she hadn't died, a universe where her car swerved to miss the impact and she is still at home safe.

I look up to see the figure of Christ dying on the cross in a huge painting that hangs on the wall. Jesus looks emaciated and bloody,

yet despite being close to death, he seems strangely serene. I put my hands on my neck and lift the small, gold crucifix that hangs on a chain. I rub the cross Mum gave me for my eighteenth birthday.

A few minutes later, a man appears from a tall archway; he looks like a minister in his attire.

His call echoes across the space towards me. *Excuse me, we are closed.* He hurries towards the door, ready to usher me out. *Come on, son, I need to lock up.*

The door was open, I say with a smile to let him know I'm not a threat. But it doesn't work. The minister views me with suspicion.

The service times are up on the board outside. The next service is the morning one at nine am. Time to leave now, come on, he quips, tipping his head towards the open door.

He stands waiting, but I stall and pick at my fingernails, mustering the courage to ask for help.

Um, do you know if the church or someone can help me find some food, please? I ask.

I'm sorry. We don't do that here. You have to go to the council. Come on now, I need to lock up and get home, he grumbles. If only he knew.

He can't look at me as I exit.

Outside I can hear him bolt the big wooden door. I stand back and look at the building.

Fucking bastard, I grumble in anger at the crucifix that stands atop the steeple.

Stepping out onto Great Western Road, I almost trip over a homeless man sitting slumped against the railings. The man has piercing blue eyes, long unwashed hair and a nose that looks like a cauliflower, but bright red with mottled skin and thread veins.

I'm sorry! I didn't see you there, I say.

Aye well, naebody sees me any more. And you'll no find God in there, if that's whit ye're looking fir. He nods towards the cathedral.

I was asking if they could help with food.

Urr yi sleeping rough? he asks.

Not yet, I'm in a bedsit for a few more days.

The man coughs violently. *Well, you cannae stay aroon here; it's no safe fir a wee young guy like you. Nor is skippering. Go hame, lad, if you huv a hame ti go to. This is a life you dinnae want tae live.*

I know, I just need something to eat until I sort myself out.

Try the City Mission. They're at The Sheiling on McAlpine Street. Lovely people, they'll see you right, you'll be safe with them.

The month passes and soon the rent is due. With no other choice other than returning to the village, I contact my friend Jamie. I know he is living somewhere in the West End. He might loan me some money.

He visits me at the bedsit and brings me some food. He looks like shit and has lost his chubby body. He now sports a malnourished gaunt look, dressed in a second-hand full-length leather coat that is drowning his frame. He thinks he looks like a vampire, but I see death in a black shroud. He tells me he is living with his new boyfriend, Freddy, just around the corner, and that I can get a room there.

As we step inside Freddy's house, an overwhelming stench engulfs my senses, assaulting my nostrils with a putrid blend of nicotine, dampness, urine and dog shit. In the dimly lit hallway,

a carpet of dog hair and dust clings to the skirting. The walls are stained with patches of black mould. Decay has seeped into every corner.

From somewhere upstairs, muffled sounds drift through the ceiling. We make our way to the living room, where heavy curtains hang, black with dirt at the hems, blocking out the daylight and any fresh air. The room stretches out, its elongated shape occupied by two worn-out sofas, the fabric stained and greasy. But it is the figure seated on one of those sofas that captures my attention.

There sits Freddy, a weathered 68-year-old man, his sunken face more skeleton than flesh, his body consumed by the clutches of alcohol. His gaze fixed upon the television screen, the weight of his drunkenness renders him paralysed, physically and mentally.

Freddy, this is my friend John that I told you about, Jamie sings.

Freddy doesn't answer; he has an expression of anger on his face. His false teeth shuffle around in his mouth as he sits in his filthy boxers with a cigarette burning down, inching closer into his caramel-coloured fingers. There is a huge patch of fire-damaged carpet under his feet.

Freddy, git up! Jamie's voice rises with frustration as he shakes Freddy, his arm wrapped around the frail, naked frame of the intoxicated man, attempting to rouse him into consciousness.

I exchange glances with Jamie, aware that he can sense the shock and disgust that grips me. Trying to keep his composure, Jamie forces a smile.

I'll show you around.

The kitchen floor is tacky with years of spilt sugar and coffee granules melted into it. The bathroom stinks, mottled in black mould

due to the central heating being cut off. There are two bedrooms, one downstairs belonging to another boy called Craig, who is out today, sucking off a punter in a hotel.

Jamie, I'm sorry, I can't stay here. I look him in the eyes. *What the fuck are you up to? It's filthy!* I say, glancing around the dank kitchen.

But Jamie gets all offended and annoyed. *Go then! You know where the door is.*

Jamie, I can't! Where the fuck am I supposed to go?

He grins. *Exactly.*

Jamie assures me it's all fine. It's just needing a good clean. I've no other choice, so I stay a few hours until the other boy returns.

That evening, I'm introduced to the older boy, Craig Patterson.

Jamie has called for a 'family meeting' in the living room. Craig starts smoking smack from tin foil. The smell is like burned plastic. Jamie asks if I can stay. Craig tells me in a threatening manner that I must do rent (prostitution) if I want to stay. I tell them my stay would only be temporary, and that I will try to get a rent cheque from the housing department.

Let's try that on, Craig says, undoing the clasp on my gold chain and crucifix behind my neck. I don't stop him, I'm too scared, and I don't get it back. He says he is keeping it as collateral until I contribute money.

Later that night I sit with Jamie, who is clearly under the control of Craig, and ask him why he wants to stay here.

I love Freddy, he tells me.

Jamie explains to me that Craig has bullied Freddy ever since he moved in, ripping the old guy off. He has applied for credit cards in the drunk's name and gone on sprees. But the credit has run out.

Craig has turned the house into a brothel and Freddy always gets his hands on a boy and drinks in exchange.

Jamie then tells me that Craig has a warrant out for his arrest; he had slashed a man's face outside a bank and robbed him. Jamie has a plan. This is our chance to get rid of him for good.

That night I try to sleep in a small cupboard under the stairs, which is the only safe place available. I could crash on the sofa, but sometimes Freddy gets up in the middle of the night and drives off to the park, returning with a boy.

The cupboard has a small four-foot-square door that opens to a crawl space, then enough space to sit upright or lay down the length of my body. To me the small, confined space is like a womb.

Over the next couple of days, more and more of my belongings are taken by Craig until I have only the clothes on my back. He is physically abusive to Jamie and Freddy. One evening he batters the old man around the head for no reason at all and Jamie doesn't intervene because he fears Craig's blade.

Finally, after a couple of weeks of this living hell, we call the police while Craig is unconscious in his bedroom on smack. Jamie tells me I must do the call, or I can't stay.

With nothing to lose, I agree. We wait outside the front of the house for the police to arrive. Jamie has the key in the front door so that Craig can't escape should he awake. When the police turn up, we let them inside. Craig flies out of his room, screaming like a banshee, and the house descends into chaos. He bolts upstairs, escaping the police by inches by jumping out of the top window and into the night. The police tell us that Craig is a violent criminal, and should he return to call them, but he never comes back.

Jamie has won. He has power over the house and control over Freddy.

We spend weeks cleaning the house up. I wash down walls, skirting boards and windows, just as Mum had shown me those years before. We throw out bags of used needles and condoms from Craig's bedroom, and lift the stinking carpets.

Freddy, when he is sober, is a clever man. He has worked for a TV production company as a music librarian but was fired because of his drinking. He is a Doctor of Music, a title I never knew existed until now. He manages a job playing the organ at a big cathedral in the West End and conducts for different orchestras.

Between them, Jamie and Freddy tank a litre of vodka or gin a night, which works for the first couple of months, but eventually the drinking takes its toll.

They wrestle and punch each other in the living room, smashing bottles and toppling chairs. There is no calming the situation down; if I get caught up in the fight, they just turn on me. One night, Jamie punches Freddy's false teeth clear out of his mouth and stamps on them, breaking them to bits.

YOU PUCKING BASTARD! the old guy yells, skelping his gums together in rage. The next day everything is forgotten, and the lovebirds continue a distorted domestic bliss as Jamie settles into life like a housewife, cooking and cleaning between spells of drunken chaos.

As a child, phone boxes always fascinated me; they are like a Tardis or a time-travelling machine that you can step inside and call

someone, be with them in a different place through space and time. I have only ever used them to wind people up by playing pranks on locals back in the village with Mario.

This one at the top of Kelvin Walkway smells like pish and cigarettes. It's not the cool vintage red box that I love; those are long gone and replaced with the BT glass box at the end of the Eighties. Here I wait while Jamie disappears into strangers' cars, earning extra money to pay for drink and partying.

I look at the man etched onto the glass door in a leaping pose and blowing his BT trumpet. The leaping man has been drawn over with a marker with the words 'Martin Mullen is a poof' and 'Benders die'.

I unfold a page from a phone directory that I've kept in my pocket. The page has a list with the last name Gormley. My finger moves down the page and stops at a name and number; others I've tried over the months are crossed off. The phone is filthy, so I pull my sleeve up to protect my skin from whatever the substance is that is smeared over the keys. I pump some coins into the slot and dial with my covered finger. The telephone rings a few times and I wait, biting my bottom lip with nerves.

Hello, a soft voice answers.

Hello, I'm trying to find Mrs Gormley! I try to sound chirpy.

Aye, this is Mrs Gormley. Who's this? the lady quizzes.

My name is John, I'm trying to find my mum; she is called Margaret Gormley, she gave me up for adoption when I was a wee boy.

I'm sorry, you have the wrong number. This is Dianne Gormley; I don't know any Margaret Gormley. I'm so sorry, she says in a sympathetic tone.

OK. Thanks anyway, I say, deflated.

I hang up the receiver and score a line through the name and number.

Weeks later, Freddy stands in his living room with the minister from his church, who is about to give a blessing to Freddy and Jamie. I can't believe Jamie is going through with this. He has invited drug-dealer friends and they have turned up dressed as if they are going to a proper wedding. Jamie wants the full works, like a child playing at getting married.

He had invited his Mormon parents in person, but when he and Freddy showed up at his parents' house to make an introduction they were affronted by the old man and said there was no way they would attend, telling Jamie he will surely burn in hell.

I have a cassette player on my lap, and I'm instructed to press play. On cue, Jamie saunters in wearing a white suit and the full-length white jacket that Freddy had spent a fortune on. He looks ridiculous and is carrying a tiny chihuahua belonging to one of his friends. After the 'wedding' and later that night, they fight again, drunk on gin.

Over the weeks, Freddy brings different rent boys home, and Jamie, now a full-blown alcoholic himself, flips out and beats him up. Other nights, Freddy simply gets so drunk that he attacks us both.

After a final fight, Jamie decides enough is enough and packs his bags to move out.

The day Jamie leaves, Freddy gets blind drunk and staggers out into the street wearing only his piss-stained boxer shorts. In a

desperate attempt to stop Jamie, he empties Jamie's bags all over the street. Jamie goes crazy, jumping on Freddy's head and beating him so badly that he has to have stitches in his head. Freddy doesn't get Jamie done by the police.

I am now alone with Freddy; the last one standing. I haven't got the skills to get myself away from this danger; the fear of being lost and homeless is too much. Freddy is always drunk and attacks me most nights, then in the morning he acts as if nothing has happened. I move out of the cupboard and into the back room of the house and bolt my door at night.

The old drunk rants and raves like a madman all night, shouting and sobbing for Jamie to return. Then his calls get darker. *I want sex, you fucking bastard, I want sex.*

Freddy has been sober now for a week and we play some old reel-to-reel recordings from BBC archives of *Round the Horne* with Kenneth Williams.

Later I fall asleep, forgetting to bolt my bedroom door. I wake up to the old creep sitting on my chest and choking me. His eyes are wild and bulging out of his head and his false teeth are protruding from his mouth, threatening to fall onto my face. He chokes me harder and harder; I try to get him off by wriggling my skinny body and kicking. His knees are pinching my arms at the elbow, pinning me down, and his big lanky frame barely budges with my kicks. This is it; I'm going to die. I start to see floaters, those tiny particles of light that dance in your eye when you stand up too fast.

When I come round, I can hear clattering coming from the hall. I jump up to defend myself, but Freddy is gone, and the house is

dark. I get dressed and look for the old bastard. My arms ache and my neck is bruised and sore.

I rush outside to see Freddy driving off drunk in his car. He could have killed me. I don't understand what happened, only that I am in so much danger and must get away from this dark house.

In the morning Freddy is sober, polite and happy. I ask him why he had hurt me.

Look at my fucking neck, Freddy! I scream. But he claims to have no recollection of doing it. No apology comes and the choking incident is never mentioned again. I go back to the cupboard under the stairs as I know he can't get in there and I feel safer. I think about my options. Go back to the village, live that life again where I have to pretend, or go to the streets to escape this hell. Maybe I should give in and sell my body like my friends, sleep in the bushes and wash in the public toilets; perhaps I could save enough to get myself going, perhaps I will meet someone who will love me and save me.

In this diverse and bustling city, I am constantly on the lookout for a long-lost relative, someone who shares my blood and my story. I watch people like a voyeur, soaking in the details to sketch when I am safe to do so. Maybe I have drawn my birth mum without even realising. No, surely not. Surely, I would recognise her.

None of my drawings sell; mostly people look at me as though I were begging for money, stepping over my drawings, or they take a quick glance and then steer away.

The shops are slowly closing for the evening and as the grey sky changes and threatens rain, people hurry to escape to the different

districts around the city, back to the safety and comfort of family and home.

I stop outside a small gallery called The Third Step; it's in the Trongate area. In the window hangs a small Peter Howson painting of a big burly man, blown out of proportion with huge, clenched fists and crazy eyes. He is looking back at me through the gallery window. He stands in a fighting stance, his face contorted, ready to shout, *Come on then, ya fuckin bastard*. He fills me with dread and fear, but I love him. He reminds me so much of my cousins, the Gypsy boys back home, the boxing I had attended, the scrap yard I had worked in, sweating and swearing with the other men. Mostly he makes me miss the safety and strength of Dad.

I paint and draw with whatever materials I can get my hands on, sometimes scraps of printer paper or old food wrappings. Most of the drawings I give away or destroy. But Freddy holds on to a few that I have done of him. He encourages my art and is sympathetic to my story of adoption because he was also adopted, many years ago. His heart, like mine, resonates with the aching void that often accompanies such an experience. Alas, it is too late for him to embark on a quest to unearth his biological lineage, and this regret casts a shadow over his head, leading him to alcohol and bitterness. Yet, despite this, he extends his hand to me, offering to aid me in scouring the local social services for any trace of my own flesh and blood.

Before I do, and feeling inspired by the Peter Howson painting that reminded me of Dad, I try to call home. It's been so long since I spoke to Dad, perhaps he has forgiven me.

The phone rings out, but nobody answers.

*

I contact the social services office in Glasgow and give them as much information about myself and my adoption as possible. The kind lady on the phone tells me that there will be a file. Everybody who has been through the care system has a file; it is just a case of locating it. I make an appointment to meet her; I hope by then she can find something about my history that might help give me some closure.

The office is like any other council building, ugly and stark, with orange plastic chairs and water dispensers with plastic cups that pop out the bottom, next to screened-off rooms. I'm greeted by the lady I had spoken to over the phone. Her name is Pamela. She escorts me into a small room.

Can I get you a cup of tea while you wait, John? I decline, and she disappears through the offices.

On the walls pinned to a noticeboard are many charity organisation leaflets and posters for child welfare and women's aid. There's a box of tissues on a desk and a little vase with a plastic yellow rose in it.

Five minutes pass and Pamela returns with a huge pile of files, papers, envelopes and letters. She sits down and smiles.

OK, she says, placing her hands down on top of the files. *Here are your adoption records, health records, social work records and everything you need. You are free to look over as much as you like. I'm just in the next room, so don't hesitate to call me if you need any support.*

I thank her and with that she leaves me alone with the files. I start looking through the papers; they are not in any kind of order, so it's a difficult task. The first things I lift are letters still in their original envelopes addressed to my parents' house. I open one up.

Dear Mr and Mrs MacDonald,

We have been contacted by Hannah, the half-sister of John, requesting contact.

In the same envelope is a photocopied reply, handwritten from Mum.

Dear Mr Shaw,

John is settling into his school and doing really well. We have discussed the idea of John meeting his half-sister, but we feel it would cause him unrest. So, we have decided to deny any letterbox contact for now.

There is also a copy of my sister's original letter. Which reads.

Hello, I am looking to make contact with my little brother John who was placed in the care of the Glasgow city council. I would love for him to know he has a nephew called Reiss and a niece called Rosie.

At the bottom of the letter, there is a return address.

There are around two hundred pages from my time in the children's home, detailed accounts of my behaviour, my progress, my manners and eating habits. Everything I was is documented and signed off by different names. I read about meetings that had been held with social workers and Margaret. I see the minutes signed

with her name, Margaret Gormley. My health record is signed by a doctor telling the staff to change my shoes because my feet are being crushed into shoes that are too tight.

My eyes scan the photocopied pages seeing phrases like, 'Mother charged for soliciting, children in moral danger' and, 'Mother charged with abuse and neglect'. My thoughts drift to my adoptive mother.

I spend an hour poring over everything, my eyes dripping with tears and my throat sore with the lump I am choking on. My poor sisters, I think, as I read about the situations we had been in together. I bundle the photocopied files together and hold them to my chest; it is as thick as a phone directory or Yellow Pages, and I want to take it all in. Finally, I'm a person, I have an identity.

Pamela returns and places a hot tea in front of me, then plucks a tissue from the dispenser. She wraps her arms around me as I sob. When I've calmed down, she looks over a few pages and we locate some addresses. I am not allowed to take the entire file away, but I can take several copied pages home. Pamela tells me she will contact the address for my sister and try to get in touch.

I will let you know as soon as I hear anything, John, she says.

I go back to Freddy's, my mind fried and excited that maybe my sister still lives at the last address she had left. That night I pore over the records and can remember many of the times referenced. It is amazing when you go back in time, how clearly it comes home to you.

I give thoughts to the village, to my dad who is probably worried sick about me. But I have gone too far this time, and I know he will never forgive me for abandoning the people who brought me up with so much love and pride.

Reading my files and seeing that Margaret had been charged with soliciting makes me empathise with her. I have been travelling a similar path, living among the lowest of classes who sold their flesh for money, drugs and drink.

I dream of Margaret looking as I remembered her. Although I can't remember my sisters, Hannah and Colette, now there is a chance to make memories. My Aunt Crystal and Granny Gormley, what would they be like? Would they be happy to know me after so many years apart? Does Granny Gormley still have Tinker Bell the tortoise?

The house phone rings, and I crawl like an animal out of my cupboard under the stairs to answer.

Is that you, John? asks the voice.

Yes, I answer.

It's your sister Hannah.

I know, I say.

My heart starts thumping out of my chest with excitement. I recognise her voice; somehow, I know it. It has a similar sound and tone to my own. I have as many questions as there are stars in the sky and I throw them at her, repeatedly. I can feel my bloodline mystery unravelling with every question she answers. I confess to having no memory of Hannah or our other sister Colette.

Well, it's probably better that you can't remember; those days were pretty dark, she responds. *There's a lot you don't know, John, and we can talk about it in person if you like?*

Hannah quickly changes the subject. She tells me that she was raised by our Granny Gormley, after a brief time in the care system.

She has always lived in Drumchapel and although she isn't close to Mum, she does pop in now and again to check on her. My heart races: my mum is still alive, and Hannah has contact. Hannah takes a deep breath, thinking about how to explain.

Mum doesn't keep well, John, she admits.

My heart sinks, my bottom lip starts to shake and that horrible lump returns to my throat.

Is she OK? is all I can manage.

Mum has autism, John, and borderline personality disorder. It's affected her entire life. She has been in and out of psychiatric units most of her adult life. But she's doing OK just now, Hannah says with a more optimistic tone. *She has her house and keeps it clean.*

That's good, I say, knowing that at least there is a chance.

Hannah goes on. *She has a bad heart also, so she takes a lot of different medications.*

Tears drip down my face and plop onto the mouthpiece of the phone.

I'm sorry, I don't mean to upset you. She explains to me that our mum is mentally and emotionally wrecked from a lifetime on a cocktail of drink and pills and that we will have to plan an introduction very carefully. First, Hannah will announce my contact to Mum in the doctor's surgery in case she has a heart attack.

Mum has self-medicated with alcohol her entire life, before and even after her diagnosis.

Did you know you had a big brother? Hannah asks.

No, I had no idea, I say with surprise.

Yeh, he died when he was two years old. Mum never got over it. His name was John!

WHAT? I gasp.

Yeh. She insisted on naming you after him.

But on my birth certificate, my name is Juan.

Hannah scoffs. *Yeh, your da named you that. He was a junkie.*

Was he Spanish?

No. He was mixed race and South African. We don't know why he gave you that Spanish name. But WE always called you John, Hannah answers.

I hate the idea that Mum had given me the name of a dead brother.

Everything I ever wanted is coming to fruition, even though the fruit might be a little bruised. Finally, I am going to have a mother back in my life. Another chance. The day to my endless night is coming, just peeking through the clouds, and it feels warm and tingly.

The next day I take a taxi to Drumchapel to meet Hannah in person. The drive along Great Western Road takes me through Anniesland; soon the beautiful red sandstone buildings give way to smaller council properties in Knightswood and before I know it, I can see the run-down, grey flats in Drumchapel looming.

I pass a shopping centre on my left; from the window, it looks rough, the kind of place I've always tried to avoid. The kind of place where people like me get harassed. Hannah is living in one of the ominous high-rise buildings, but before the taxi takes a right to approach them, I see a park then a row of houses and I instantly recognise the street where Granny Gormley may still be living. I twist my head around as the taxi turns away and towards the high-rise flats. I'm amazed that after so many years I can remember this street. Memories of schemes and slums, hunger and chaos trigger

familiarity, and little dots connect in my soul. I feel excited but also wonder if my sister has had a happy life living here.

There she is waiting for me, Hannah. Her eyes crinkle at the edges and a big, beautiful smile spreads across her face, a smile like mine, and dark hair and eyes just like mine. I feel good to make that parallel. I step out of the car, and she hugs me so tight, an embrace I never dreamed possible.

It's so good to see you, John, she beams, cupping my face in her hands and gazing into my eyes.

Our eyes scan the details of each other's faces, tracing the mouth, the shape of the jaw, the hair colour.

You look like Mum, she admits, linking my arm. I look down at her, she's only four foot something inches, much shorter than I had imagined.

Hannah takes me up in the elevator towards her flat and inside she introduces me to my nephew and niece, Reiss and Rosie.

She makes us a coffee and we sit in her living room to talk. Hannah doesn't have much, that's clear from the minimal furnishings in her tiny flat. But she has something much more important, she is so kind, graceful even. Her voice is soft, full of patience, acceptance, curiosity and empathy; and after everything I have gone through, that's priceless.

We talk about my life, where I grew up, and what life has brought us both. I tell her all about my adoptive mum and dad, brother and sister, the MacDonalds, and the privileged life they gave me, but confess to struggling at home, always yearning to be with my own and longing to see Mum. I ask about Granny Gormley.

I'm sorry, John, but Granny Gormley died a few years back. She would have loved to see you.

Hannah can't answer all my questions. *I think it's important that you speak to Mum first and let her tell you about your birth dad.*

Hannah makes a telephone call to our mum's twin sister Crystal who lives three floors down with her partner.

Hiya, it's me, can you come up a wee minute? I've got something to tell you.

My sister hasn't told our aunt about my contact.

Crystal can't keep secrets, Hannah explains.

When my aunt arrives at the door and walks in, she sits down not expecting the surprise to be me. Hannah smiles, nodding over to me sitting on the sofa.

Do you know who this is, Aunt Crystal?

A puzzled look falls over our aunt's face. I look into her black eyes, forcing direct eye contact.

Oh, my God! It's John, she screams, throwing her hands up and jumping to her feet. She gives me the most massive hug. *Your mum will be so happy,* she wails, sobbing into my shoulder. *It is all she ever wanted, and her biggest regret was losing her wee boy.*

I really want to believe that.

I am desperate to meet Mum. I wonder how alike she is to her twin, who seems very anxious, fidgety and unsettled by my presence. But no, I remember Mum is different, with darker eyes and sharper cheekbones. It's difficult to place her faded memory, but it isn't gone completely, and parts return to my mind as I recognise similar details in her twin's face and mannerisms, especially the anxiety.

Hannah tells me Mum has lots of mental health issues.

Aye, she's no well, son, Crystal interrupts.

Hannah explains Mum has BPD, borderline personality disorder, and Asperger's.

It's a form of autism, she says.

Aye, autism, son, Aunt Crystal interjects.

Hannah glances over at her and continues. *It runs through some of our family, John.*

Aye, through the family, son, Aunt Crystal adds.

And unfortunately, Mum didn't get the support she needed as a young woman.

Aunt Crystal shakes her head. *She never got the support. The teachers called her stupid,* she moans.

I must be patient. In a week, they want to arrange our official meeting at the same flat. I have waited fifteen years.

Back in the cupboard under the stairs, I hide from Freddy. I was hoping to tell him how it went, but he is upstairs crumpled in a ball, wrecked.

Will Mum like me?

What if I don't like her?

How will she deal with me returning after so long?

How will I react?

Will she reject me again?

I think about my dad at home, and I imagine his pain if he finds out I have returned to the family who, in his mind, abandoned me to care.

The long-awaited day has come. I arrive wearing orange and green pin-stripe trousers and a black shirt borrowed from Jamie.

It is far too big for me. Jamie has moved into another property with an old friend from the Mormon Church, a stark contrast from the people he has been living with.

I head up into the sky of the high-rise, up to the twenty-third floor, towards my sister's flat, closer and closer to my mum. Hannah answers her door and takes my coat. The house seems quiet, and my sister seems off, almost sombre. Maybe Mum has had second thoughts?

As I turn to look down the dim hallway, I recognise her. This tiny dark-eyed woman. It feels like time has slowed down as our eyes meet, as though all the air in the world has been sucked out around us and all that's left is a silver thread of recognition binding us.

John, she shouts, and throws herself around me. *Oh, my big, beautiful boy,* she wails, muffled into my chest, clawing at my back.

Oh, what a beautiful big boy! she bawls, brushing my tears away with her shaking hands.

It is the best, most monumental feeling of my life. Everything I ever wanted was in the soul of this strange little woman. How tiny she is, much smaller than I had remembered. She trembles furiously, part nerves and part delirium tremors from alcohol withdrawal. Hannah takes us into the living room and leaves us alone, giving us space.

I talk about Ronnie drowning; Mum can't remember that period. Her memory is disjointed, big chunks are gone, drowned with Ronnie and washed away in cans of cheap lager, cider and wine.

I ask about my birth father.

You don't want to know him, son. He's a bad man, Mum hisses.

Although the answer she offers is limited, I accept it for now. I ask about my past and why I was put into care. Mum gives a half-hearted excuse, saying she was ill and that I was taken from her by force by the social work department, and that all she ever wanted was for me to return.

I always wondered about my birth and my first words. Mum tells me I was born still inside the placenta – a cowl baby it is called in Scotland and apparently means the child would be special, lucky, psychic or talented, or so superstition dictates. I was also born with a long black rat's tail of wet hair that wound around my neck. My older sister Hannah was born with long hair also, as though our hair was trying to strangle us inside the womb. My first word was 'yubya', meaning Hannah. And as a young baby, I was surprisingly good at counting and used to be able to add and subtract at a very young age. This seems strange to me, because I cannot count now and I struggle to tell the time and read bus timetables.

I ask Mum if she can remember the tadpoles in a Stork butter tub from Barrhead Dams, or eating unset jelly in front of the fire, and she remembers it all.

When it's time to leave, it's difficult to say goodbye.

Aw, don't go, son, she cries.

I go back to the cupboard under the stairs.

I think of Mum and Dad, my adoptive parents, and everything I have gone through. The life they have given me and the distance between me and my adoptive mother. My birth mother has nothing to give me, only her love in this moment, the love of a mother. Even though she had put my life in so much danger as a child, the bond

between a mother and a son can never really be broken, and the umbilical whiplash yanks me back to her.

Days pass and we arrange for Mum to visit me. I am restless with nervous energy. I scurry around Freddy's house, tidying every nook and cranny, ensuring everything is just so. The thought of her seeing me living in this cramped cupboard under the stairs, with Freddy, the creepy old drunkard, lurking above, fills me with shame.

When Mum arrives in a taxi, the driver traps her fingers in the door and she screams, *Ya fuckin bastard.* Her wee nicotine-stained fingers turn black and blue, but I notice she tries to hide the discomfort throughout the day.

In her presence, I feel like a child reborn, free from the weight of adult worries. As she flips through my sketchbook, tears stream down her face.

I was good at drawing too, you know? She smiles. We talk about the children's home, and I tell her about Sister Pauline.

They stopped me from coming, son. I tried so many times to visit you, she lies, clutching my hand in hers.

She doesn't know that I have seen my adoption records, that I know all about her past troubles. I have read the reports by social workers about the many times she failed to appear for scheduled visits to the home.

Beneath the surface, I sense a darker undercurrent, an unspoken pain that threatens to spill over. We skirt around the edges of our troubles. I don't want to wade too deep into the darker memories.

Mum is horrified when Freddy arrives home with a young boy, and her intuition kicks in. Having worked the streets herself, she

sees the predator lurking beneath his façade and calls him out for what he is.

Hello, you must be the screaming skull, she sneers, sizing him up with steely eyes.

Freddy storms off to his room, offended, with his boy.

When the taxi arrives to take her home, Mum pleads with me to pack my things and come spend some time in her house. She lives alone since splitting from her partner a couple of months before. I agree. The next time we see each other I will be moving in.

I arrive with the few belongings I have the next day. So, this is what truly going home feels like. I feel complete, with no expectations to be like anybody else, just allowed to be me and to be with the one person who was me, and I am her.

Mum lives on Drumchapel Road in a two-up two-down council house not far from Hannah and Aunt Crystal in the flats. Close enough for everyone to occasionally pop in and keep an eye on her.

Her house is grim, unadorned by trinkets or tokens of a life well lived. It is sparse, lacking the embellishments that make a house a home. But it is immaculate in a way that betrays the care of its inhabitant.

It has two bedrooms with double beds, hers with a dresser, but no wardrobe. Her clothes are in the dresser, and she has very little: three outfits that she rotates like clockwork. On top of the dresser, she keeps two little empty bottles of ancient perfume.

The room she gives to me is at the back of the house and faces the backcourt and communal washing lines. Alongside the double

bed there is an old cooker lurking in the corner. It reminds me of my childhood and the many places we had lived in, bare and sad.

The bathroom is worse; all the tiles have been stripped off the walls leaving bare crumbling plaster, a job done by Kenny Snouter, also known as 'Pig's Feet'. He is Aunt Crystal's crazy partner, who is more in prison than out, and who promised Mum a whole new tiled bathroom once he had stolen some new ones, but it never materialised, so she must make do. It's the one room that bothers her.

I wish he had never touched it, she moans.

It turns out that Pig's Feet has a problem with other people's belongings. Mum says he has cut cables to televisions, broken ornaments and cookers. Her toothbrush sits on the window ledge next to a black eyeliner pencil, an inch long from months of use.

Her kitchen is basic, with unit doors missing and a bare concrete floor. It is very similar to the kitchen we had in South Nitshill, but it's spotless apart from the corner where the cooker sits. The wall there is burned black right up to the ceiling. Mum tells me that she was cooking fish on the grill with Aunt Crystal. They had a few drinks and forgot about the fish and were wakened by firemen breaking in the door because the fish had burned to coal, and the house was spewing black reek.

Her living room has a TV and a sofa, and a small cuckoo clock on the wall, her pride and joy. It doesn't wind up, and I never see or hear the cuckoo call. I feel sad that she has never had any luxury, but I remind myself that her house is so much better than a cupboard under the stairs.

Mum bakes me macaroni and cheese, roasting cheddar

on top to a glossy shell in the oven. She thinks I'm too thin and wants me to gain weight. We sit before her TV, with the gas fire roaring, in a cosy cocoon of warmth. We chat, but her gaze flits away, never quite resting on me. Like me, she's troubled by direct eye contact, a battle between wanting to connect and a fear of being seen. I put my issue down to my eye operations and my shame as a child about my funny-shaped eyes. She shakes a lot and must be desperate for a drink. Hannah told me she is going to try her best to give me a proper welcome home without sitting at the bottom of a tin of beer. She calls her TV 'the kennel' and when I ask why she tells me that she used to babysit a wee boy for a woman, and when the woman dropped the child off, he was as good as gold, but as soon as she left and Mum and the boy were alone, the child turned feral, cursing and causing chaos. So, Mum made him sit behind the TV unit, 'the kennel', the entire time he was with her.

Git in yir fuckin kennel, ya fucking bad dug, she chuckles.

She thinks that this is a legitimate way to treat a child.

In the darkness of the night, she comes to me with a plea, her voice pitiful and fragile.

Can I sleep beside you, son? I have scary thoughts at night. She whines like a child.

And so she crawls into my bed, seeking refuge and comfort from her fears.

Do you need a wee blue [Valium] to help you sleep? she offers, but I decline.

I'm wakened up early. Mum is standing over me with a tray of fried food – sausage, bacon, eggs, beans, mushrooms and toast – and a big cup of tea.

Morning, son, she grins.

She sits beside me watching each mouthful I take. Only when most of the food is gone does she go up to get her own cornflakes. I flush the rest of the food down the toilet while she is in the kitchen.

I feel like she is making up for the many breakfasts she didn't give me. But I can't bring myself to eat it all; it's just too much food. It's not about the food; it's about the love that it represents. Mum's way of showing me that she cares, that she's sorry for what she couldn't give me before. And I appreciate it.

Aunt Crystal visits us often and when the twins are together it's chaos. They have nicknames for all the local people they know. Lobster Laura works in Lidl, and Mum greets a man in the queue, who has had his voice box removed due to cancer caused by smoking, as 'The Dalek' because he uses a voice synth to talk.

With our tobacco in our pockets, we head into the store for the weekly shop. At the busy checkout, Mum lifts up Aunt Crystal's skirt exposing her knickers, and holds it long enough to make sure everyone else sees.

Zat you two at it again? the woman serving tuts.

Today Mum has an appointment to see her doctor.

My heart's no right, she's always saying.

I go along with her. The local surgery is no more than a big run-down shed. Inside it feels like a damp old Scouts hut. Rows of orange plastic chairs face a small window in the slatted wood.

I fuckin hate coming here, she moans, keeping her head down and avoiding eye contact with the receptionist.

Hi, Margaret. Take a seat and Dr Coffey will call you, the receptionist sings to Mum like she's a naughty infant.

I hate these chairs; they don't feel right on my skin. Mum fidgets and twists in the seat.

She complains about the lights being too bright, the man's breathing three rows behind us being too loud, and the magazine stack in the corner not being neat enough. Mum gets so exasperated, and we've only been waiting five minutes.

Watch this, she says, getting to her feet and approaching the receptionist. *These lights are making me awefy dizzy,* she groans at the receptionist.

The receptionist looks up at Mum.

Just sit down then, Margaret. I'm sorry, but you have to wait your turn.

Suddenly Mum wobbles, gripping the shelf at the window, and slowly slides down onto the floor in front of the receptionist. I rush towards her with concern, but the receptionist has seen the act before and purses her wrinkly lips; she's annoyed to have to help. Mum fakes coming round. And of course, she's taken directly into the doctor's office. She reappears twenty minutes later with a long prescription for all the pills she wants and a sly grin on her face.

Outside she turns to face me, her eyes looking somewhere between my nose and mouth.

I am not fucking waiting in the queue, she giggles.

It seems she just isn't good with people at all, her social skills are limited, she has no patience and can be incredibly blunt. She can remember details from a long time ago, but is selective on what she offers. Just like my almost photographic memory, but if you ask

us both what we ate yesterday we can struggle. I have always just thought I was stupid; I was raised to think that. My adoptive parents told me so almost on a daily basis.

John can't even read a map, Dad would say in the car on a drive with the family.

As thick as two short planks, Mum would chip in.

Sat on the sofa one evening, I ask Mum questions about my childhood; I approach the subject with care. Mum says she has been so ill over the years that she just can't remember. She gets agitated and fidgety, rocking softly, eyes fixed past me at the cuckoo clock on the wall, her mouth slightly open. Now I am the parent and Mum has the glaikit look on her face. Over the years, she has spent months in and out of psychiatric hospitals. I have read this in my social work records, but Mum doesn't ever talk about why.

Slowly, can by can, she starts to drink in front of me.

Just a wee tin, son, she pleads, standing in the local shop, her eyes fixed on cans of White Lightning cider like a little girl asking her mum for sweeties. We only came in for milk. I allow her the one can, thinking everything is going so well, and it might help her nerves, I can see she is struggling.

But as soon as that one tin goes down, she wants more. She thinks I don't know about her secret stash: a litre bottle is hidden outside the front door in the coal shed. I saw her through the keyhole having a sly swig when she said she was taking bedsheets out to dry on the line.

Pissed, she is irritable and extremely nasty, cursing, demented

and unreasonable; in the morning she acts as if nothing has happened. Just like Freddy, she's a Jekyll and Hyde.

The gaps of sobriety become fewer. One Friday evening, as the sun goes down, she puts her jacket on.

I'm just nipping out for milk, son. I'll only be five minutes. She smiles, popping her head around the door into the living room.

I beg her not to buy alcohol and she promises she won't.

I wait thirty minutes for her to return, but nothing. The shop is only a five-minute walk from our street; she should have been back at least fifteen minutes ago.

I dwell on the memory of being left at home alone as a baby, and wonder what kind of person does that to a child, just fucks off out and leaves them to fend for themselves for days at a time? Is this part of her mental illness or is she just a selfish bitch?

Growing up in our village, my parents kept me so safe. One time, age seven, we were on a shopping trip. I was overwhelmed by sensations and ran amok around the store. I had been told to stay beside Mum and Dad, but being so hyperactive and curious, I had to see and touch everything while running around the aisles with excitement. I stopped halfway down an aisle and turned back. Hang on, did my parents go this way or this way? Looking around I couldn't see them anywhere. I realised I was lost. My lips started to quiver with real fear, and panic set in. I ran in circles looking for them, going deeper into the maze of cereals and tins lining the aisles. Just before I burst into hysterics, I heard a voice.

Hoi, sir! Over here. I looked up.

It was Dad, standing behind the condiments. He had been

watching me the entire time. I let my body relax and breathed out a huge sigh of relief.

Oh, Daddy, I thought I was lost. I trembled.

Being lost was a big fear of mine as a child because it was a real thing. I had been lost and left behind many times by Mum.

Living with my adoptive family I used to have a horrible daydream. My family and I would be waiting on a bus. When the bus arrives Mum and Dad get on with Jack and Deborah and the driver pulls away before I get on. My birth mum's abandonment has had serious consequences, it is a wound that cuts deep and refuses to heal.

After forty minutes I head out to the shop and ask the shopkeeper if Mum has been in for milk.

She came in an hour ago. Bought a litre of cider and left, he says.

Where is she? I think. Walking back home I see the woman who lives in the house upstairs approach me. I ask her if she had seen my mum.

Aye, she got on the bus twenty-five minutes ago. She said she was going to Clydebank to visit a man.

I'm furious she lied and left me worried, just as she had when I was four years old. Fucking selfish. I chew my nails and wait on her.

Around ten o clock, I fall asleep. Bang, bang, bang. I awake, jumping to my feet. It's one in the morning. *JOHNYYY!* comes a slurring raspy voice from behind the front door. I rush out into the hallway to see Mum's beady black eyes looking through the letter box. I open the door and she stumbles in, tripping over her feet and stinking like a pub.

Mum, where have you been? I ask, looking her up and down, assessing the damage.

In a fuckin pub! she shouts.

There's no point in arguing with her. I guide her into her bedroom, and she flops onto the bed. I start to get her undressed.

Come on, arms up, I say, as though undressing a toddler.

Her top pops off and she sits in her chewing-gum-grey bra and I notice she has heart-monitor stickers around her chest, the kind they attach wires to. Surprised, I take a step back and look.

What the hell are these? I blurt.

Oh, I fell off a bar stool. I was in the hospital; I had a heart attack. She cackles with laughter.

She lays in silence for thirty minutes, while I think about what's best to do. Then she's up on her feet again, staggering to the bathroom. I sit on her bed, thinking about the years and years I'd invested in wanting to meet this wonderful mother, only to see this horrible, demented side of her. I hear a loud thump, followed by a whimper coming from the bathroom. I rush to the scene: she is unconscious, wedged between the toilet and the wall.

My escape is spending time with my sister Hannah. Mum can't give me any answers about my childhood, about my birth dad and about my sister Colette, who lives in England and wants nothing to do with Mum.

A drive with Hannah to South Nitshill and Barrhead Dams reveals all.

Are you sure you want to do this? Hannah asks, leaning over to fasten her seatbelt.

Yeh, I'm fine, I tell her, although I'm unsure of what lies ahead.

We have decided to take a drive around Glasgow, an opportunity to revisit the places we lived in the hope it might bring us closure. We head out of Drumchapel and drive back down Great Western Road towards the West End. A light rain pitter-patters on the window and I sit back as Hannah drives. We talk about the past, about Mum and her illness.

So, your da was called Jagsy. He was a heroin addict from Maryhill, he moved to Scotland when he was just a wee boy with his mum and dad. I think his dad was in the military.

I listen with such curiosity at the revelations. Hannah goes on. *Colette and I lived with Mum and our dad, Thomas, until our baby brother John died.*

How did John die? I tentatively ask.

She glances at me, then back at the road.

We're not sure, she says, letting out a long sigh. *Mum and my dad were swingers, they went to a party in the flat above, leaving us all asleep in bed, and when they came back down John was dead.* Hannah keeps her eyes on the road ahead.

They just left you? I remark with shock in my voice.

Yip. John, it was the Seventies; they did that all the time. So anyway. It affected Mum; she never got over losing John and she didn't have any support. I remember Granny Gormley telling her to get on with it. But Mum just started drinking. It got worse; she was fighting with my dad all the time. Anyway, Mum started sleeping around, guys would pay her for sex and she would buy a drink. I feel such despair rise through my being. Hannah goes on. *My dad came home one night and found her on the sofa half-naked with three men in the house. One of them was a local hard man and threatened my dad. He wasn't going to fight, so he just*

turned and walked away and eventually he left us. He moved down south with his new partner.

Why did he leave you and Colette with Mum if he knew she was unstable? I query.

He was just a young guy, John. In those days it was the woman's place to look after the kids. So Mum moved with Colette and me into another alcoholic's house. A guy we called Bugsy. He was a bastard and battered us constantly. It was while we were there that Mum met your dad, Jagsy. It was 1976. And the place we are visiting now is the place we first moved into together.

Hannah swings the car into a street.

I know this part of the West End well; it is where I first lived after I left Dad. As we turn up Wilton Street, I look at Hannah.

This is where I lived in a bedsit.

She smiles, pulling into a parking space and stopping the engine.

Well, that's funny, because this is where we lived, on Wilton Street. This place has been regenerated. The house we lived in was so run-down that you could see the floor below us through the rotten floorboards, she adds as we walk.

We stop outside my old bedsit and Hannah points to the same building.

We lived here on the second floor. She squints, looking up at the windows.

I'm dumbfounded as Hannah points up to an apartment below the bedsit I had lived in.

It was horrible, full of rats. She shudders.

I can't believe it's the same place I lived in, Hannah; directly above where you had lived.

Wow, that's some coincidence.

We walk around the corner, looking up from the street to the windows.

This is where the abuse started. Mum would disappear to make money and leave me and Colette alone with Jagsy. After he had molested us and Mum returned, he would batter us all and take Mum's money to buy heroin.

Hannah's words come out in a matter-of-fact way. She shrugs her shoulders, in a way that says, nothing can help. It happened, and she has had to live with that.

Back in the car. We drive away from the West End and head east, to Barlanark. Our voices are low as Hannah explains the extent of the abuse.

Parked on Bressay Road we wait for the rain to break. The area does not look so bad. Hannah explains that back in the Seventies it was a notorious gangland full of slum housing. When the sky permits, we head out for a walk. She points out the location of the flat we had lived in. In its place sits a newly built red-brick Barratt housing scheme. In front of that stands another building similar to the one I was born into, so she uses it to illustrate her words.

We lived in a third-floor flat, just like this one. We had very little, no furniture. Mum was always drunk and disappearing. Jagsy would fill our heads with stories about demons and black magic. He told us that as soon as we were old enough, we would have to go on the pill so that he didn't get us pregnant.

When you were born, we lived here for about two years. One night Colette and I had had enough and set fire to an old sofa. It didn't catch initially and just smouldered, so we closed the door and forgot about it. During the night

the entire room went up in flames and the fire brigade had to rescue us. Jagsy and Mum ran out and left you and Colette alone in the house.

I think back to my memories and recall climbing through a smashed window and being lifted out of a house on fire. The little girl in my memory must have been my sister Colette.

Mum and Jagsy used to sell black magic spells around this area. Jagsy claimed he was a prophet and took charge over the ceremony. Sometimes the house would have twenty people all gathered waiting for evidence of his power to summon spirits. 'In a moment you will smell flowers,' he would say, and on cue Mum would squeeze a bottle of Zoflora that she had hidden up her top, releasing the perfume into the air. The poor people in the room would gasp in awe, thinking Jagsy had the real power to summon the dead and hand over more money. Hannah laughs.

Ugh, it's all in the past, John, she says, giving me a reassuring smile.

But her pain is real. I think of Colette, the sister who wants nothing to do with Mum, and now I understand why.

Why didn't you go to the police? I ask tentatively.

Hannah lets out a deep sigh. *We were too scared. He threatened us. Mum was extremely gullible. The drink and drugs meant she couldn't always tell what was real and what was fantasy. I remember he would throw ornaments around the room while no one was watching. He convinced us that the house was haunted. It was terrifying. Mum took knife wounds trying to protect us when he was flipping out. I've discussed with Colette about going to the police, but she can't bear the idea of dragging it all up. What Jagsy did to her was horrific. Mum knew that we were being abused by him. She would purposely take me out shoplifting and leave you and Colette behind to appease Jagsy. He never sexually abused you, John. You were his golden boy.*

I kick at the dirt around my feet. I feel guilt by association.

Aw, honey, don't cry; he will get what's coming to him one day. Hannah rubs my back. *Come on, let's get away from here.*

Back in the car we drive away. Hannah passes me a cigarette.

The NSPCC were never away from the house, John. I remember Jagsy attacking Mum with a hammer, and it was the final straw. She took us to live with Aunt Crystal and we never saw him again. Then Mum met Ronnie.

What was he like? I ask.

Oh, he was dead nice. Hannah smiles. *He was an alcoholic but still managed to work as a builder and did his best to keep us together and fed. It was a good period. But over time Mum slipped into depression and would disappear, or they would get drunk together so there was still a level of neglect.*

We stop the car on Woodfoot Road in South Nitshill. It is difficult to place my memory here because the old slums have been partly demolished and new properties line the street. I tell Hannah about my last memories of living here alone with Mum after Ronnie drowned. I tell her about the tadpoles, the hunger and the torturous times that men visited the house.

The last stop on our trip is Barrhead Dams. There are several large lochs here; it would be impossible for me to pinpoint an area that I recognised. It is a fleeting visit. I say an internal thank-you to Ronnie as we drive past Balgray Reservoir. Thank you for trying.

I try to reason with Mum over the next weeks. She sobers up for a week and it is fun, pure comedy and happy times, then she descends into darkness and misery again when she gets inebriated.

One evening while she is sober, I press her for answers about

our past. I bring up the situation with Jagsy; I ask her why she had allowed my sisters to be abused. Mum doesn't cry; instead, she stares at the wall like a child. *If I can't see you, then you aren't here.* She says she has been so ill over the years that she can't recall any of it. I don't believe her because she has been able to remember other minute details from my childhood. But she does offer me advice: that I should never under any circumstances make contact with Jagsy no matter how curious I become.

After this, Mum's mental health takes a dip. She spends more time at home drinking and her behaviour becomes erratic and aggressive towards me. She admits to seeing little shadows hovering around the house. I wonder if it is her guilt or the drink. I try to keep her calm and keep the conversation light. Sitting in the living room, I ask her what I can do to help. She tells me that she often just wants to leave the gas fire on without igniting it, close the door and sleep for ever. I can't get to the heart of her pain. I don't have enough knowledge about her condition and demented energy.

My mum lost her mind years ago.

Hannah and I stand on the veranda of her flat. Up here, seagulls squawk, gliding with ease on the air, close enough to reach out and touch. We can see all the way over rolling hills and gentle slopes that paint the land with shades of green, forming a lush tapestry that contrasts with the grey urban sprawl of housing schemes, roads and shops below. Hannah breaks our silence.

See over there, she points, *that's Bishopbriggs, then Lenzie, then past*

that is Moodiesburn. And I think, she squints, *your old village would be in that direction.*

I follow her pointing finger and copy her squinting, as though making my eyes narrow will magnify the extreme distance and allow me to see the village I left behind, but it's too far away.

Amazing that I was there all that time. If you had a telescope, you could have seen me, I laugh.

The distance from here to the village feels like a massive wound in space and time, one etched deep within my soul, a reminder of the separation and the longing that has persisted throughout my life. That wound should have healed by now, now that I am home with the mother I longed for. But it lies even wider and stings with a longing for my dad and my Granny MacDonald back home in our village. I flick a finished cigarette and watch it fall. Gazing down upon the sprawling Drumchapel, our eyes lock onto a figure moving along the footpath strewn with litter and broken bottles. It is our mother making her way towards us at the high-rise, a fragile soul burdened by a past riddled with horrors. The sight of her stumbling amid the shattered fragments creates a mixture of concern and anguish because her journey has inflicted scars on our own lives. Yet we still love her.

Here she comes, steaming drunk. Hannah sighs.

Your hair is like Jagsy's, Hannah says as she mixes peroxide bleach in a small basin.

Sitting now with a towel around my shoulders, I look at the black curls she has just buzzed off my head lying around me on the floor. I feel glad to have a slight transformation.

Can you remember the day I was born? I ask, as she starts to apply bleach to my head.

Oh yes. She takes a breath. *They had been fighting. Mum had a chunk of hair ripped out of her head and was hiding in her bedroom away from Jagsy. She had a little horseshoe-shaped tartan purse, and had saved some money for your birth. She kept it hidden away so that he wouldn't spend it. I went in to check on her and ask her for money for an ice cream, but her purse was missing. Then her waters broke right in front me.*

With my eyes closed to stop the peroxide from nipping, I imagine the scene. I try to remember back, back, back as far as I can to this very moment.

She made me and Colette search the full house for her purse. But we couldn't find it. She was bolting around the house going absolutely mental, and the full time you were on your way.

Me and Colette knew that Jagsy had taken the purse, but he just sat there and let us all search, and we couldn't put the blame on him directly because he would have battered us again. Jagsy blamed a neighbour who had been popping in to check on Mum. Anyway, darling, you're done.

Hannah finishes the bleach and covers my head with a plastic bag to develop.

Did he go to hospital with her? I ask.

No.

She went out in the ambulance alone, screaming at the neighbour. Later, playing in the back garden, I found Mum's purse trampled into the dirt under some old corrugated iron, and empty. When I looked up at our window that bastard was standing watching me with a grin on his face.

The front door knocks, and Hannah goes to answer: it's Mum.

In the bathroom my head is bent over the side of the bath as Hannah washes the peroxide from my head. Mum sits on the toilet. Even with the smell of the peroxide I can smell the drink reeking from her.

I was just telling John about the day he was born, Hannah says as she flushes shampooed water from my hair.

Oh aye, that's lovely, I hear Mum say as the water rushes past my ears.

Well, it wasn't lovely for us. Hannah laughs with nerves.

There's silence from Mum as Hannah shrouds my head with a towel.

Remember your purse went missing? my sister asks.

Oh aye, Mum moans.

I peek at her from under a towel as I dry my hair. She is staring away into space.

And when you went into hospital, we were left with Jagsy?

A cannae remember that.

Oh yes you can, Hannah sings.

I rub hard at my head.

Aw, don't make me feel rotten, hen, Mum pleads.

Make YOU feel rotten. How do you think we feel? How do think this boy feels at me having to tell him all this?

I lower the towel and catch my reflection in the mirror. My once black hair is shaved down and glows bright orange.

Mum tuts, and sneers at me. *He's not a fuckin boy; look at the state of him.*

Don't you dare turn on him to avoid answering, Hannah barks.

*

My hatred for my birth father grows into a hatred of myself for having his blood in me, and I feel guilty, as if my connection to him holds me hostage. I start to blame Mum for what happened to me in the children's home and what happened to my sisters. And I worry that when I'm older I will go mad like her. It is all too much for me, the past, present and fear of the future. I become so anxious. At night I can hear chatter and conversations going round in my head, like I have tuned into a radio station with a weak signal.

Isolated from friends and my adoptive family, I reflect on everything I have learned about who I am and the people who spawned me into this cruel world. I can't relate to any of what I have been told and seen. On reflection, my life growing up in an idyllic village surrounded by love was a good one. It was me who had pushed against it all, thinking there was something better outside of my reality. But that life is gone; now I'm faced with a harder reality than I could ever imagine, and I don't want it, I just want it all to end. So, one evening, I wait until my mum is plastered, take a handful of her Valium, washing them down with her flat sweet cider, and wait for them to take effect. I stagger into the bathroom and look at my face in the dulled old mirror. This fucking ugly face, these messed-up features, a mixture of a drunken whore and a junkie paedo. Leaning on the sink, I close my eyes and shut out the faces of my birth demons. I dream of home, my real home in the safety of a beautiful village, beside my real parents, the MacDonalds, the people who sang to me, took me on holiday, taught me how to ride a bike, to swim. Nursed my colds and allowed me to believe Santa had come every Christmas. I wish things had been different. Why didn't I try harder in my youth to appease my adoptive family? They worked so hard to break me from any lingering trauma I had from my

childhood; they tried to protect me from all this, and in my infancy I had not understood. I was unreachable to them.

I open my eyes to look upon my face in this old mirror; here I am full circle, back where it all started: in the slums living with a mad drunk.

I break open a razor and hold the tiny blade in my hand. I want these blood ties out of me. I smack it down twice on my wrist and watch as my skin opens like a screaming mouth, vomiting out my blood. Numbed by the Valium, I put on my jacket and stagger to the living room where Mum lies drunk. I sit next to her on the sofa. I can feel the sleeve of my jacket drink and absorb the wet red. I think to myself, she is so drunk she won't notice, and I can just go to sleep here with her. Nice and quiet.

Mum stirs and mumbles something, but I'm going too fast to hear it properly.

I wake to a cacophony of chaos, Mum's voice piercing through the air like one of Granny MacDonald's banshees. Fuck, I'm still alive. My eyes flutter and struggle to focus as I gaze up at a blurry figure looming over me, his presence as menacing as a storm cloud. I slip into unconsciousness once again, my mind a murky abyss.

My next awakening is within the confines of a sterile ambulance, the piercing sirens slicing through the night. I slip back into the darkness, only to be jolted awake once more in a stark hospital room.

As I gradually regain consciousness, the tang of hospital antiseptic fills my nostrils, and the sterile surroundings of the room swim into focus.

My gaze falls upon a weary-looking nurse who is tending to me. Her facial expression speaks volumes about her disdain for having

to deal with a suicide attempt. Summoning my strength, I muster the courage to speak up and request my mum.

Can you please tell my mum to come in? I whisper.

The nurse's reply hits me like a hammer blow to the chest.

I'm sorry, she says, *but your mother told me to inform you that she was heading to the pub.*

I collapse back onto the bed, feeling utterly sick.

Wrapped in bandages, I'm sent home early the next morning. As I step in the door, I'm met with a familiar sight: my mother, incapacitated by White Lightning cider, refusing to acknowledge my existence.

Days later, Hannah gives me a stern lecture. Her resilience is nothing short of awe-inspiring; she could have easily succumbed to the same desperation that drove me to the edge, yet she never has. I can't fathom how she has endured the torment of PTSD for all these years and still found the strength to support our mum.

As the days turn into weeks, there is a glimmer of hope on the horizon. Mum's sobs, shouting and night terrors give way to sobering up. The Valium aids her through the difficult times, and Hannah's unwavering support is the shining light that guides Mum through the darkness. Hannah gets her out for walks with Rosie and Reiss, my dear niece and nephew. Even on a grey day, the kids bring a smile to Mum's face.

As we gather around the table, Mum serves us her signature dish, a poverty pasta of macaroni and grated cheese, a nostalgic favourite followed by canned grapefruit, Mum's staple. Mum likes things to be the same. The same simple meal day after day. The canned grapefruit's bitter aftertaste is like a sharp sting on the tongue,

lingering long after the last bite had been swallowed. It is a flavour that seems to match the bitterness in her heart, a reminder of the struggle she faces each day to keep her demons at bay.

Mum's only confidante in this world is a woman named Mary – a nosy, plump and grey-haired old bird with a nose like a strawberry. Her teeth are rotting and missing like a broken and burned picket fence. Her ankles are a dark purple, and she has some difficulty walking. She wheezes and whistles when she speaks, the unfortunate result of her two-pack-a-day habit. And yet, despite her flaws, she has a certain charm that draws my mum in, especially when they share a lager or two during one of their gossip sessions. Sometimes she stops us outside in the close, her neck twists and strains, desperate for a look inside our house. But Mum never lets her past the front door. Mum's clinical and minimal home can't be contaminated by Mary. Mum has given her the unflattering moniker 'No Neck Mary', thanks to her generous double chin.

One evening, while my sister and I are left to our own devices, our mum spends hours in Mary's flat, chatting away like old friends.

I hope she's not drinking up there, Hannah says, looking at the ceiling with concern.

When Mum returns, she is sober and practically bursting with excitement, clutching a folded-up piece of paper in her hand. It's an address, given to her by none other than No Neck Mary herself, for a man named Norbert who lives in England. There is a small photo inside, the kind you get from a photo booth. Mum passes it to us and explains.

He is newly single after losing his wife, poor guy. He is due to visit No Neck in a few weeks. I spoke to him on the phone just now and he sounds lovely.

My sister rolls her eyes and passes me the photo. The man is not bad looking; he is wearing a shirt and tie, black suit and has a bald head. Our mum has already made up her mind to write to him.

As she folds then unfolds the paper, reading the name and number over and over in her head, her eyes gleam with a sense of possibility, a glimmer of hope that she might find something beyond the bleakness of our daily lives. And though I can't help but feel sceptical at the idea of her reaching out to a stranger, I also see the joy in my mother's wee face.

The postman's familiar footsteps echo up the stairs, and Mum's anticipation is palpable as she eagerly awaits the arrival of her next letter from Norbert. The stranger's words spill from the page, and Mum pours her heart out in response, investing precious time and energy into her written exchanges with this mysterious figure.

The letters bridge the physical distance between them, and Mum's pen pal becomes a beacon of hope in her life, inspiring her once again to cleanse herself of the destructive habits that plague her.

But not everyone shares my mother's excitement. My sister Hannah has borne witness to the dark side of male companionship, seeing our mother beaten and broken time and again.

She is determined not to let history repeat itself. She has her reservations about this Norbert character and decides to be present when he finally arrives at our doorstep. She stands beside me, her presence serving as a silent warning to this stranger.

*

As we stand there, observing Norbert, a strange aura surrounds him. His tall stature and enigmatic presence fill the doorway, commanding attention. His grey, almost colourless eyes, constantly shifting and never settling on any object or meeting another's gaze, give off an uneasy vibe.

My mother, however, seems oblivious to these subtle cues; she has a childlike energy and smiles a lot. He has the same shirt, tie and blazer on from the photo Mum has of him. Our mum is smitten, blinded by a thirst for love and companionship that has long been denied her.

As the night wears on, my mother and Norbert find their way to No Neck Mary's upstairs quarters, leaving Hannah and me to entertain ourselves.

We wait for Mum, surrounded by the quiet of the empty house, listening to the muffled sounds of her laughter and chatter drifting down from above. Hannah turns to me, her eyes searching for something in mine.

What do you think? she asks, her voice low and uncertain.

He seems all right, I reply, trying to sound more confident than I feel.

How long is he staying? she presses, her gaze fixed on me.

I shrug, feeling a sense of unease settle over me.

I don't know, I say. *As long as Mum wants, I suppose.*

Hannah nods, her expression inscrutable. She has reservations about Norbert but, like me, she is unwilling to voice them aloud. We sit in silence for a while longer, sipping tea, each lost in our thoughts.

Eventually Mum and Norbert stumble in, arm in arm, swaying like a pair of reeds. Norbert towers over Mum and she gazes up, her glassy drunken eyes fixed on him.

They head off to Mum's room and close the door. Sounds of their childish laughter fill the air, drowning out our mirth as Hannah and I try to make sense of what seems like a ridiculous situation. The truth is that Mum's struggles with mental health make it difficult for her to navigate relationships. She is vulnerable and easily taken advantage of, a fact that we can't help but acknowledge.

Soon enough, Norbert has made himself at home, a constant presence in our lives as he and Mum embark on a relationship fuelled by cheap wine, cider and tins of beer. Her bond is unbreakable, forged in the crucible of addiction and emotional neediness. And as the days turn into weeks, Mum's obsession with Norbert deepens.

One fateful night, my mum stumbles into my bedroom. She holds me tight and pours out her affection, recounting memories of my infancy, an infancy she has imagined. She expresses her constant boundless love for me.

Don't ever leave me, Johnny, she says.

The morning brings with it an eerie emptiness, and it isn't until we stumble upon Norbert's hastily scribbled note that the reason for the silence is revealed. Norbert has fled in the dead of night, leaving behind a scathing note of judgement about Mum sleeping in beside me, and him being left alone.

Stupid fucking dirty cunt, Mum mocks.

But as quickly as our moment of levity had arrived, it is just as swiftly shattered when Norbert makes an unexpected return and Mum is livid, unleashing her wrath upon him in a furious tirade, hitting him on the head, each smack harder than the last. He just stands there like a stookie, staring into space, and as I look on, I can't help but feel a creeping unease at the strange and unpredictable situation.

Mum is a strong-willed woman who doesn't take kindly to being controlled, but under a cocktail of drink and drugs, she seems to bend. Norbert issues commands like a general on the battlefield, and she obeys, albeit grudgingly. I watch him correct the way she speaks, the way she walks and what she wears.

But it isn't just the control that bothers Hannah and me, it is the oddness of his behaviour. He will stare at us, mouth agape, with a vacant expression, as if he were peering into some other dimension. And when Mum calls him stupid or hits him, he just takes it.

Hannah takes it upon herself to voice our concerns, but as usual, our mother refuses to listen. She is smitten with this strange man, and nothing can sway her. So, when she announces that she is planning to get married to him and move to England, we are shocked and dismayed. We know it is a bad idea. Mum needs her routine, she needs her same meal, her same faces, her same environment, otherwise it just can't work. But there is no convincing her.

Mum is arranging a get-together at her house. She has invited Aunt Crystal and her partner Kenny Snouter, aka Pig's Feet. I have been in Glasgow staying at a friend's in the West End and enjoying the Kelvingrove Art Gallery and Museum, allowing the lovebirds some time together at home.

When I walk in Mum is sober and makes me a cup of tea. She tells me that she had a psychic dream the previous night. She says that a wine glass had been toppled and smashed in the dream, even though we don't have wine glasses. Aunt Crystal was also involved in the dream and there was shouting.

I head off to my bedroom and lie down, listening to the slurring
bullshit coming from Norbert as he patronises Mum in the next
room. I hear the door knock and in walks Aunt Crystal. She sounds
happy and chirpy – any excuse to get well oiled with drink. She joins
the couple with a carryout; I can hear tins of lager snap and hiss
open and the three get plastered. After an hour of sleep, I wake up
to the door getting hammered again and when I answer, in walks
Pig's Feet.

I take him into the bedroom where Mum, Aunt Crystal and
Norbert are, passing drink around. I stand in the doorway feeling
nervous at the crowd before me; something is off, a mix of dark
energy sparkles in the air.

Aunt Crystal turns to Pig's Feet. Her eyes are barely able to focus
on her partner and myself standing over them.

*We have been laying here for hours drinking. Margaret fell asleep for
a while.* She looks at my mum, who just gives a drunken grin. Aunt
Crystal continues, *While Margaret was asleep, Norbert was commenting
on my tits . . .*

The room falls silent, as though the air has been vacuumed out
around us.

Whit? Ya dirty fuckin bastard, Mum yells at Norbert, although she
is unable to sit up.

Norbert looks at Pig's Feet, who says, *Oh Norbert, I hope this
isn't true.*

My Aunt Crystal looks at my mum as she struggles to sit up
like a beached whale and says, *Aye, it is, Margaret, it's true he was
commenting on my tits when you were sleeping.*

Pig's Feet pushes past me and storms out of the house and

Norbert starts to panic, the blood now drained from his face. He stands up and starts to plead sorry to Mum and Aunt Crystal. I try to help Mum to her feet, but she is a dead weight in my arms. Her eyes and tongue are the only part of her functioning. Seconds later, Pig's Feet returns, rushing into the house with a huge solid steel bar, which I recognise as part of the hand railing from the steps to the entrance to our building. Without warning, Pig's Feet starts to whack, smack and finally crack Norbert's arm. Norbert then scrambles over Mum's bed, getting tangled in the bedding, sending tins and an ashtray flying and smashing bottles of alcohol. Mum lunges out, taking swipes as he stumbles around. Pig's Feet doesn't let up and continues the assault, which Norbert tries to shield himself from as he crawls away, out of the house to the safety of No Neck Mary upstairs.

Pig's Feet trembles uncontrollably, his gaze fixed upon us with wild eyes, gripping tightly onto the steel bar. For a second, I worry that he will go on, beating the rest of us, but a calm washes over him.

Get your things together, baby doll, we are going, he says with a nod towards Aunt Crystal. She gathers up a few tins into a carrier bag, and without another word they leave us.

Mum is up and pacing the house. She is almost numb, and seems to sober up with the chaos. She looks at me with a nervous half-smile.

See, I told you. Always listen to psychic dreams.

I start to clean the mess and broken glass.

We wait for hours before Norbert returns with his arm in a cast. He hasn't got the police involved.

Mum welcomes him back, and everything continues as normal,

but I rarely speak to Norbert again; his attempts to win me over fail, although Mum won't hear a word against him.

The next week even Pig's Feet and Aunt Crystal make up with Norbert, and the four of them return to drinking together. I spend the night with my sister Hannah. Reiss and Rosie are put to bed, and we sit in the kitchen smoking a joint and discussing Norbert being around.

We talk about Norbert's controlling behaviour over Mum. I feel suspicious; how they met was strange, he is strange.

The more time he spends around my mum, the more controlling he becomes, not orders, but patronising her as if she were inept, trying to turn her broad Glasgow slang into proper English words. *No, Margaret, that's not the correct way to speak; it's windows NOT windies. And it is child NOT wean. If you can't speak properly, Margaret, then just don't speak at all.*

Who the fuck do you think you are talking to? I spit one day, bursting into the room to defend my mum.

Aw, I'm only having a laugh with her, son, Norbert laughs, standing over Mum's drunken body.

I'm not your son, I have a dad, I say, enraged.

Mum suddenly comes to life from the sofa. She jumps to her feet and gets into my face.

Your da is Jagsy, she blasts, spitting into my face and barely able to stand.

Is he fuck! My father is William MacDonald, I say, looking down at her. She flies into a rage, her face burning red.

You better decide who the fuck your family are, you poofy wee bastard.

*

For God's sake, Mum, John has only just come back into your life, and you are running away again? You are fifty years old, not fucking fifteen. Hannah is fuming.

Mum stares at the wall, unresponsive.

She has packed a couple of plastic shopping bags, her knickers, a bra and her benefit chequebook. Norbert has booked the Megabus for Saturday. Mum plans on leaving everything behind; she wants nothing from her house.

On the Saturday morning they are up and ready. Mum stands in her hallway, shaking with excitement, nerves and needing a drink. She hands me the keys to the little council house that has been her sanctuary for the last five years. I'm so fucking angry; she looks ridiculous, pathetic and scared. I want to lift her up and drum into her that she isn't capable, that she is making a big mistake – the way my adoptive mum spoke to me when I had big ideas to run away. But that's pointless; she is a grown woman and needs to live her own life.

She kisses me goodbye at the front door as the taxi waits to take them to the bus station.

I'll come back and visit, she mumbles, but I know from experience that she won't.

I feel flat. I've tried so hard to get her to understand me and acknowledge my needs as her son. With one last attempt, I look into her black eyes, without flinching, ensuring she connects.

Please don't leave me again, Mummy, I plead. But she looks away.

Don't make me feel rotten, she whispers, her voice barely audible over the hum of the waiting taxi's engine. She walks away without a glance back.

*

Since then I've kipped on the sofas of friends, here and there, with nowhere to truly call my own. I just can't seem to find my footing in the world, preferring to stay indoors, away from people, sleeping all day and coming to life at night. I'm so angry at the world, at Mum and at my adoptive family back home.

Right now, it would be so easy to give in to drink and drugs; most of the people around me have. But my art becomes my addiction, a powerful force that consumes my mind and body. Like a drug, it is all-consuming, filling my every waking moment with a need to create, to express myself; it's where I feel safe.

When I am awake during the day, I slink off to the Kelvingrove Art Gallery and Museum.

As I step through the huge doors, I am immediately enveloped in a sense of calm and stillness. The noise and chaos of the outside world fade away, replaced by the quiet hum of visitors gliding from one exhibit to the next. The space is vast, with high ceilings and wide hallways that seem to stretch out before me endlessly. Huge sweeping stone stairways guide me up from the lower levels where the stuffed animals and Egyptian artefacts live, up towards the art, higher and closer to God. Each room leads to another, beckoning me forward with the promise of new discoveries and fresh perspectives.

The light in the gallery is soft, casting a gentle glow over the artwork and creating an atmosphere of hushed reverence. It is as though the space itself is sacred, a temple dedicated to the pursuit of beauty, creativity and ideas.

For a while, I forget about the outside world entirely. I don't think of my two mums, or my dad, or my granny, or Sister Pauline.

Time seems to slow down. It is a chapter of peace and tranquillity, a moment of respite from the tumultuous world outside, and the chaos I have lived. Of all the places I have searched for home, searched for Mother, this place feels the closest.

I step into Gallery 5, as I've called it because it's the fifth space I visit each time I come. It is early and quiet and, despite being alone, I am not. A colossal canvas stands before me, its subject a woman mid-dance, suspended in the air as if defying gravity. She balances precariously on one foot, her fiery red cape held aloft like flames engulfing her. It's reminiscent of a Gypsy woman dancing barefoot.

Further on, my eyes wander to another painting, by James Guthrie. Born in 1859, Guthrie was a self-taught Glasgow Boy. The canvas portrays a group of mourners gathered around a child's coffin. But what catches my attention is a man. He is not clad in mourning black, instead donning a brown leather coat. In his hands he holds something, perhaps his tammy hat or perhaps a scrap of fabric belonging to the deceased. His head is bowed, and the grief etched on his face is palpable. It's as if Guthrie captured the essence of my father on the day we buried my adoptive mother. I can still recall the unbearable pain, confusion and anger on Dad's face as we lowered his wife into the earth.

The painting stirs emotions deep within me, and I yearn to call home, to hear Dad's voice once more. But my attempt fails again when the phone rings out and nobody answers.

*

I come across an advertisement in a Glasgow newspaper for a live-in care assistant: 'Immediate start, NO experience necessary. Must love art.'

A raspy voice answers, weathered by years of living.

I'm 74 years old and paralysed from my waist down by polio since my youth, Mr Hamish McDonald tells me.

After our introductions, we agree to meet in a Glasgow café.

Hamish arrives in a full tartan suit pushing the wheels of a red wheelchair forward to greet me. His long white beard and kind face exude warmth and hospitality, putting me at ease instantly. He asks me about my interests, and when I show him my drawings, his eyes light up. He offers me the job.

My duties are to be cooking, cleaning, gardening and shopping.

I like to travel Europe; do you have a passport? he beams.

No, I haven't been abroad since I was a wee boy, I explain.

Hamish explains to me that I will have my own separate living space but won't have rent or bills to pay. I accept the job offer and make plans for the move.

It is March and we have had the worst snow in Scotland for years. Hamish left the Borders in his hand-controlled car on Monday to pick me up. But he has been stuck in the snow and had to stop at hotels along the way. It's now Wednesday.

His car pulls up at 7:30 in the evening and he assures me the snow has let up enough to make the three-hour trip back, so I pack my things into his car and we set off.

On the way, we chat and laugh about life. Hamish is an educated man and has all the knowledge about every artist I mention.

Did you know that Picasso's full name was actually Pablo Diego José Francisco de Paula Juan Nepomuceno María de los Remedios Cipriano de la Santísima Trinidad Ruiz y Picasso? He was named after a variety of saints and relatives, and his name is said to be so long because his parents wanted to honour all of their family members.

I think about my own name and how many variations I have had. I was called John Mckelvie by Mum because Ronnie was a Mckelvie. Then I was named John Gormley while in care by social workers because Gormley is my mother's maiden name. And then there's my legal name, John MacDonald, a name that everyone around me growing up associates with hard-working and hard-fighting Gypsy men. Knowing that I'm named after a dead brother fills me with guilt, and although my birth father Jagsy caused so much pain to my sisters, I actually prefer the name he gave me: Juan Gonzales Diaz Abara. I've shortened this to Juano Diaz. Considering I've always been searching for my identity and never truly felt I fitted in with either side of family life, I feel it's legitimate. Hamish addresses me as Juano.

We drive through Glasgow with no problem, then to Edinburgh and the roads seem OK. After thirty minutes it starts to snow again; thick white flakes lay on the roads ahead and by the time we get to Galashiels we are stuck deep in snow, and have to wait until morning for the blizzard to stop.

I jump into the back seat and try to sleep. Hamish sleeps sitting up. He has driven through chaos to get us back and must be exhausted.

At six in the morning, it's light enough to continue. With the snow stopped and the sun shining, I can see further along the country

road. I've never been to this part of Britain before and the scenery is stunning. Hills of bluish-white tumble all around me, sparkling in the bright sun.

Eventually, we make it to Jedburgh, where a kind farmer tows us the rest of the way in his tractor to a tiny hamlet.

The landscape here is so beautiful, and in a small valley sits a handful of little houses. Through a winding track, we reach Hamish's picturesque little cottage. I help him out of the car and into his wheelchair. Inside his cottage, it smells like spices and polish, a pleasant mix which brings comfort in the knowledge he is at least a clean man.

He shows me around. A simple bedroom, beautifully decorated, a huge grandfather clock, a spotless living room full of antiques and endless low shelves with books. Everything has been adapted to accommodate his chair. Doorframes are wide, the kitchen units are low, and his bathroom is an A-septic wet room.

Outside there is a spacious garden with a gently flowing stream at the bottom and next to Hamish's cottage is a tiny self-contained house, a single room and bathroom the size of a caravan; it's here I sleep.

It's a small paradise.

Over the months I work hard, making sure I do as much as possible for and with Hamish, and it soon becomes clear that I have made a friend.

Hamish had moved from Edinburgh to the small hamlet after his wife left him. Instead of choosing defeat, he found a new zest for life and moved into his own house.

Sometimes we go to the opera, and since he is a wheelchair

user, he gets to take his carer along for free. We even see *The Planets* performed by the Royal Symphony Orchestra in London.

I set out to create and frame as much work as possible, making images late into the night.

As the days pass, I begin to see myself in a new light. Through my art, I have found a way to express my innermost thoughts and emotions, to create something beautiful out of my own experiences, of the different names I have had, and the different families and influences. And as I gaze at the many faces staring back at me from the frames stacking up, I feel a sense of pride and accomplishment.

One evening, we are sitting in front of the fire. Hamish drinks a schooner of sherry, and holds an image I have made, then he turns to me.

You know, laddie, you've got a real talent for this. You're going to be famous some day, mark my words.

And so I continue to experiment and push the boundaries of my art, never knowing where it will take me, but always striving to create something new and unique. In this small house in the quiet borders of Scotland.

I haven't spoken to Mum or Hannah for some time. The last time we spoke, Mum was cruel and cutting.

You're not my fucking son, she said down the phone line.

Regardless of her outbursts, I decide to call my sister.

John, why are you calling? Hannah gasps down the phone in a tone that tells me she is angry about my disappearance from her life.

I'm sorry, I just wanted to see how you were all doing. Are you mad at me? I ask.

No, John, I'm not mad at you. I have been frantically trying to reach you for the last couple of weeks. She takes in a deep breath. *I've called everyone to get your new number, but nobody knew where you were.* Her voice is urgent; I know something is wrong.

Is everything OK? I ask.

Mum and Norbert were fighting, and Mum fell down the stairs. John, Mum is in a coma. Hannah's words are shaky. *I don't know, but I'm worried she won't make it; please come with me to the hospital to see her.*

Oh Mum, I whisper.

Without a word to Hamish, I escape out into the night and walk the endless fields and hills.

In my early childhood I had tried so hard to capture the likeness of my mother in a drawing, something to hold on to. I clutched my pencil tight and sketched a happy and beautiful woman. Even though my memories were dark, I was determined to bring her face to me. But the dark shades that lurked beneath her skin eluded me back then. After we reunited, I tried once more to capture her image, but the passage of time had ravaged her, leaving only a vague resemblance to the woman I had known. Looking back at childhood drawings of her, I can see how inaccurate they were.

In this moment, I know that my search is over. I have found my mother, not in life, but in death.

I meet Hannah the next day in a McDonald's restaurant in Carlisle. I find her staring at her un-happy meal.

Hannah is the strongest person I have ever met. Her life has been ruined by the actions of this woman we call Mum, yet she chose to stay behind all her life and try her best to look after her. It is heart-breaking to see her normal smiling face now unmasked, revealing exhaustion and worry.

She throws her arms around me, and we fight back our tears, too proud to let the customers in the fast-food restaurant see our distress.

Hannah, I'm so sorry that I wasn't there to support you, I say.

John, it's OK. It's not your fault. I don't want to talk here. She glances at a weary family who have stopped to eat, their children delighting in the free plastic toys that come with the food. I find Hamish and thank him for dropping me off, and Hannah and I set off on the long drive south.

As we hit our cruising speed on the motorway, Hannah's eyes flit between mine and the busy road as she recounts the story.

A few months ago, Mum got badly beaten up by a drunk neighbour she had entertained at home. She pressed charges and got compensation for her injuries.

What the fuck? I cry, my hand covering my open mouth. *Did she recover?*

Yes, she did. It sobered her up and she and Norbert decided to move away and got a beautiful new house from the council in her name. I went down and visited them, and Mum was doing better.

So, what happened? I press.

Well, Mum and Norbert got into a fight, and she ended up in the hospital with a head injury. As Hannah recounts the story to me, I feel like shit, and wish I had done more to protect Mum.

Fuck's sake! I groan, shaking my head in tears as I listen to the horrific story.

Where is Norbert now?

We don't know.

Arriving at hospital we make our way to Mum's ward, but are stopped by her doctor outside.

I'm glad you're here, the doctor says. *Your mother has come out of the coma, but I need to be honest with you about her condition.*

She's in a vegetative state, he goes on, *which means she's awake but unresponsive. She won't be able to communicate or move on her own.*

We stand there in silence, trying to comprehend what the doctor has just told us.

Is there anything we can do? Hannah asks, her voice barely above a whisper.

We'll need to keep monitoring her condition, but at this point it's unlikely she'll make a full recovery, the doctor replies.

We both thank him and, as he leaves, Hannah turns to me.

I need a coffee; you go in and meet me after? I'm super stressed, she mumbles.

I nod in understanding and walk towards the ward where Mum is being kept.

Bleep . . . bleep . . . bleep . . . hiss . . . click . . . gargle . . . bleep . . . bleep . . . bleep . . . hiss . . . click . . . gargle. The sounds ring in my head, making my heart rate rise as I slowly make my way through the intensive care ward towards her bed. My senses are engulfed

by plastic sheets, screens, tubes and that unmistakable smell: a mixture of disinfectant and warm body.

My eyes focus on the bed ahead of me and my heart hurts as I approach. Her wee four-foot ten-inch body is lying there with tubes coming from her arms, nose and mouth. The gargling sound is coming from her throat, and it seems as though one of the machines is using steam to help her breathe. She is unconscious.

My hands wrap around her hands, and I kiss them over and over. I look at her bruised face, her closed almond eyes, now puffy and blue, her lips and mouth, cracked and still. The beeps coming from the machine behind her echo the sound of her heartbeat.

My poor mammy, her big loud voice reduced to a harrowing gargle, her wee body surrounded by the many frightening sounds that support her. I stroke her face gently, afraid I might dislodge one of the tubes that come from her nose and twist around and over her ears.

Oh, Mum, is all I can say. Choked on my grief, I need to get it out.

I cry for everything we have gone through – my childhood before she put me into care, the abuse, the neglect, the children's home. The adoption where I spent years with a different family, wondering what I had done wrong to deserve such upheaval so young in life. All the birthdays and Christmases we missed out on over the years and the short time we spent together when we were reunited. That time hurts the most because now it seems wasted.

When I sit back up, I see her face in profile. I feel a tingle of cognisance rush through me. Her face mirrors a self-portrait I had made only days before.

I try to fix her hair a little. Only a few months ago, she was darker,

but this is her natural colour – a kind of strawberry blonde. Her slicked-back Elvis style is still here, only matted and messy and missing the signature raven-black box dye that she adopted later in life. I feel immense sadness and anger, but also I feel relief. Relief that her struggles are almost over, the years she suffered from mental illness and alcoholism are gone.

I sit up close to her ear.

I love you, Mum. I am sorry I was not there for you. I am glad we had some time together. I pause and take in a deep stuttering breath. *I will carry your spirit.*

Our moment is interrupted by a happy nurse who comes in to check on Mummy's vitals.

Hi, Margaret. I hope you aren't going to give me any trouble today! she says as she fiddles with things attached to tubes.

I can hear Mum's voice in my head telling her to *Fuck off!* and I smile a little inside as I get up and return to meet my sister, Hannah.

Walking back to the hospital canteen, I feel numb and in shock. Every footstep I take reminds me of the many times we were separated before.

We talk about Mum and the fight that eventually put her in this situation. We discuss the times we pleaded with her not to move away from us. We drink insipid tea from a vending machine and furiously smoke cigarettes, our distress at the situation growing.

When it is time to go back in, the nurse says, S*he is awake.*

Mum is the same, only now propped up like it's a tea break on the *Thunderbirds* set. Hannah and I sit at opposite sides of her body and lean in towards her. She is unresponsive but one eye is slightly open

and looking around. When we speak, she gives a tiny smile, and a single teardrop rolls down her face.

I think she can hear us!

Hannah takes out her mobile phone and plays 'GI Blues' by Elvis Presley, Mum's favourite song. We wait for a response, as if the magic from the music will suddenly bring her back to her manic self, but it evokes nothing.

How could this little woman have experienced so much hurt in one life? How do you lose three of your children to the care system, live in such poverty and continue to be abused in every relationship you enter? Alcohol.

Hannah undoes the buttons on Mum's gown to look at the marks on her body. There is a dark blue bruise in the centre of her chest.

We call over the duty nurse, but she says she doesn't know what the bruise is; it's possibly resuscitation bruising. She is only here to clean up, give drugs and keep Mummy comfy; she doesn't have that kind of forensic knowledge. We look at each other in despair as our mother lies here, her chest rattling and wheezing through the steaming tube in her throat. With unrecoverable injuries.

So many thoughts rush through my head, but I must remain calm; this moment must be special between us because it will be our last.

A buzzer sounds around us: visiting time is over.

We need to go, John, Hannah says, leaning over Mum's body and gripping all of our hands together in hers.

We have had so many goodbyes in our life, maybe my brain wants to block out this one, the big one.

I still cannot remember it.

*

235

I've lost them both now, Birth Mum several times, and my adoptive mum once. I am motherless. I think I always have been.

Just dial the number, John. My sister smiles, sitting next to me. I have decided to try to reach out to my dad again. We haven't spoken in three years, and I fear he will hang up on hearing my voice. Anyway, why wouldn't he after all I've put him through? With a little distance, I'm able to see how absurd my behaviour has been growing up.

Hannah and I left Mum in hospital a week ago. Hannah will return in a day or so to be by her side. But I can't. It's too much seeing her in that condition, knowing that she will never return as the person she was, and do I want her to anyway? Hannah has discussed the possibility of Mum coming home, but who would look after her, hand feed her, entertain her and wipe her arse, should she recover enough? Hannah already has two children to look after and what kind of quality of life would Mum have attached to cables and wires? Would she do the same for us? Had she done the same for us? The answer is no, she had not. For whatever reason in her life, she simply was not able to look after her children or herself. Had I not had the opportunity to reconnect with her, perhaps my life would have turned out the same.

Hannah leaves me in her hallway, and I dial Dad's number.

Hello, Dad answers.

Hi, Dad, it's John, I say, squeezing my eyes closed.

John, son. How are you? he replies.

I'm sorry, Dad, I wail down the phone.

Dad lets me cry for a minute; I fear the call will end here.

Hoi, sir, give yourself a shake, he says in that same way he had done most of my life, that loving command that sounds harsh yet is an empty threat. I've heard it a million times before. *Where are you staying?* he asks.

I'm in Drumchapel, Dad. I've met my sister Hannah and Margaret my birth mum.

Dad is silent for a couple of seconds.

Oh, OK, he says. I can tell he is both surprised and hurt. *And are you keeping well?* he adds.

I'm OK, Dad, been better, I laugh.

Aye well, John, that's been your own decision, son. There's a long pause. *Will I come and see you?*

If you want to, Dad, I smile.

I would love to, son, he whispers.

The next day I wait alone in Hannah's house. The intercom sounding makes me jump, and I buzz Dad up.

It takes two minutes for the elevator to travel up to the twenty-third floor of the high-rise flats towards me, and I fidget and pace while I wait. When Dad walks in I try to smile, and then sob into his arms in the same place I had cried with Mum when we had reconnected. Dad comforts me as I apologise over and over.

Hey! Behave yourself, he says.

Dad takes a seat and I hand him a coffee. He inspects the mug before taking a sip, as though checking the level of my hygiene. He looks around the bare council flat and I can see he is disappointed. By now my adoptive brother is at university studying computing and my sister owns her own shop and house.

Are you washing your clothes? You smell of damp, he gripes, looking me up and down. I am dressed in dowdy cheap jeans and a sweater from a bargain-bin shop.

How is everyone? I ask.

Dad purses his lips.

You know your granny died a year ago, he says, shaking his head. *Took a massive stroke,* he adds.

I apologise for not being there. I know my absence from such an important person's funeral will have caused quite a scandal in the Gypsy community. Selfishly I'm glad I haven't seen Granny's coffin and can keep my last memories of her alive.

Aye, she was some woman! His words speak to the passing clouds as he gazes out the window before turning back to face me. *Hey, do you remember her telling you about the banshee?* he laughs.

Yes, her stories were amazing, I answer.

There is a long pause before Dad speaks again. *Your mum and I knew you were gay, John, but we worried so much about you. We knew you had come from a very rough background, and we didn't want that for you. The world is a big bad place and we only tried to protect you. But times have changed, and I guess we have to move on from here. Hey, I've done things that I'm not proud of as well, so don't give yourself a hard time. Let's move on,* he says, putting on his coat.

Standing in the hallway before he leaves, he turns to me.

You know, John, when your mum and I were looking for a child to adopt we went to the children's home because your mum wanted to adopt a wee girl; we had no intention of adopting a boy. The social workers had arranged for us to see this wee lassie. But when we turned up, I noticed you playing in the garden. 'Come and see this wee guy,' I told your mum.

You looked so lost and scared. There and then we fell in love with you. I persuaded your mum into adopting you. I wanted a challenge and by fucking God I got one. He smiles.

My birth mum Margaret died of her injuries in hospital on April Fool's Day 2003. Of all the days she could have chosen to pass, she chose the fool's day, her last big offensive joke.

At a small service in a crematorium in Drumchapel I sit at the front beside my sister Hannah. I have cried so much for this woman during her life, and now in her death my eyes are dried up and unable to spill. I squeeze Hannah's hand tight in mine as Mum's small coffin disappears through a curtain. After the service, the minister takes me to the side and places a small palm-sized blue bag into my hand; inside is a lock of Mum's hair.

I have to accept what has happened, otherwise it will consume me and I won't let it. The devastation I feel at the loss of my birth mother, just like the loss of my adoptive mother, both passing in such tragic circumstances, could destroy me, just like Mum was destroyed by the loss of her son, my big brother John.

I am severing the spiritual umbilical cord that binds me to her and breaking the cycle.

It is 2022, and I receive a letter from Sister Pauline. I have thought of her often over the years but expected I would never see her again. After doing some research online I discovered she is living in a retirement home for elderly nuns.

Dear Juano

It is such a joy to hear from you after so many years, I remember you with fondness when you were just a little boy living in the children's home. You were a beautiful child and I loved sharing moments with you at Troon beach, do you remember? It is so good to hear that you will become a father, adopting a child yourself is a huge triumph and this makes me very proud.

It is exciting to hear that a feature film is being made about your life experiences. I look forward to listening to it one day.

I hope that after this lockdown we will be able to meet again, my only regret is I will not be able to see your face as I am now almost totally blind.

Thank you for the letter you wrote, and I do remember how you used to love my music room and playing with the metronome. It is funny how the ticking of time plays tricks on us. We first met when you were in care and now, we meet again when I am in care.

We have so much to catch up on and God willing this pandemic allows us. Please keep in contact and God bless you and your new family.

With love, Sister Pauline

As It Was in the Beginning, Is Now – and Ever

Since being back home in Scotland, I've been thinking about how much our physical world, and our perceptions of life, change over time. Where there were once small, family-owned shops with hand-painted signs, there are now sleek storefronts, all glass and steel, reflecting the blank sky back at you. The areas where slum children once played are now gentrified with the most exclusive properties in Glasgow. But these children don't play as we did; they are hunched over, transfixed by their smartphones. Even the hills in the distance feel different; they were vibrant green when I was young, stretching endlessly into the distance, all possibility, all adventure. Now they appear subdued; like the skin on my hands, they have become worn by the lives they have held.

It is February 2024, a few days before the release of *Slum Boy*. I'm visiting the site of my old children's home in Glasgow with journalist Pauline McLean to film a segment for BBC primetime news. The home was closed in the 1990s and it's now a private residence. It's also been forty years since I was last here. And yet, I feel a part of my childhood self is still trapped in this building, somewhere. I try my best to stay composed, but when I take my first step inside, I am overcome.

Everything remains just as it once was. The level of detail I recall

astonishes me; a memory map preserved with miraculous precision for the last forty years. Like a painting hung in the backroom of my imagination, waiting patiently to be rediscovered.

The huge staircase is as imposing as ever. Standing at the top looking down, I remember the brutality of that long-haired man. His cruelty like one of the initials scratched into the wood – permanent. Yet the light filtering through the stained-glass windows casts a familiar glow. It welcomes me, telling me I am home. I can feel the presence of the children who once lived here, the rush of their bodies sprinting past. Their spirits in communion with that of dear Sister Pauline, whose boundless support still urges me on now: *You can do this, son.*

I long to be alone, to collapse, to beat the banisters in frustration, to weep.

Is it emotional being here? Pauline McLean asks as they film me standing next to the huge stained-glass window.

Can you remember the wee boy? she asks again.

I'm so choked, embarrassed by my grief that I can't muster up an answer. I just nod.

A detail on the stained-glass window catches my eye. The word, ART, emblazoned beneath a woman painting at an easel. *I walked past this window each morning and night, completely unaware that art would become my future. It was a sign, an easy sign for a child to miss,* I say to Pauline.

Wow, that's really some coincidence.

The moment she says it, I notice the intricately carved wagon wheels set into the banister at every two feet. The very same wagon

wheel that's on the flag of the Roma people who adopted me from this children's home.

That evening, after a day of filming, I return to my father's house. In the living room, I look at the painting hanging over our fireplace – the first painting that ever captivated my imagination. Dad was always so proud of it.

It's of a gypsy camp. As a child it held so much mystery, but as an adult, I know this scene well. I know its magic, its pride, its strength.

I sit on the sofa so I can stare at it, commune with it. And it pulls me through time back to Appleby Horse Fair. The jewel of the Romany calendar.

The sun hangs low over the camp, casting a soft golden light on the rolling fields enveloping the town. The fairground stretches out like a patchwork quilt of moving colours. The air is heavy with horse sweat mixed with the aroma of frying onions and candy floss. There is noise everywhere. The symphony of a hundred Roma-accented conversations.

Caravans stand in rows, their painted sides gleaming like freshly unwrapped sweets. Each one different yet familiar. Their doors hang open, revealing busy interiors with kettles boiling on small stoves and children's toys scattered on the floor. Men and women huddle together on plastic-coated cushions, sharing stories, songs and laughter. Traders call out, offering everything from gleaming horse tack to bright shawls fluttering like flags in the breeze. Dogs, small and large, dart in and out of the crowds, tails wagging in the shared excitement of the day as their sleek bodies weave through the

legs of people and horses alike. Children too run freely, their joyful faces smudged with dirt as they play games that seem, to onlookers, without rules.

We are walking down the well-trodden path – me, my brother and sister, Mum and Dad, Granny and Granda. People greet us with a reverence I don't understand at the time. All of us are dressed to the nines in the regal splendour of our ancestor: the king of the gypsies. The ladies are sparkling queens in diamonds and corals, gold and pearls. The men sharp, strong and suited with dangling pocket watches and neat cravats.

Granda sports a glossy cane with an amber handle, which he uses to lift the bowed head of horses hitched to the wagons so he can look into their eyes. Gypsy wagons, vardo as we call them, stand strong like guardians of tradition, each one a work of art. The wheels, sturdy and worn, look like they have endured a thousand miles of country roads. Deep fern green and rich cadmium red. Others are bright cobalt blue and sunflower yellow.

Among the vardo, newer transit vans mingle, their utilitarian shapes a stark contrast to the ornate beauty surrounding them. These vans are practical vehicles used for transport and work by the older boys, who are involved in activities such as fighting, trading scrap metal and raising horses, all of which are key parts of their tradition. Horses are a constant at the fair, their presence *felt* as much as seen. They come in all shapes and sizes, from massive shire horses with feathered legs that look like they could pull a house, to sleek, nimble ponies whose eyes glimmer with intelligence.

My brother tugs at my sleeve, pointing to a group of boys around our age holding the reins of a small pony. The boys' faces are alight

with pride, their bond with their animal palpable even from a distance. Jack and I are dressed in matching outfits, holding not horses on reins but metallic helium-filled balloons bought from one of the stalls. We look out of place, like tourists among the people we call family. We were often called *half-breed gorgias* by the other children because we didn't have a gypsy mother.

As the day stretches on and the light deepens to a warmer hue, fires are lit across the fairground and the sounds of the bustle soften into intimacy. We find a spot near a group of musicians, their fiddles and accordions filling the air with a song that is somehow both lively and haunting. A man sings of long journeys, open roads and the freedoms of a life lived on one's own terms. It's a story I don't yet understand, but I can feel it in my bones.

A wagon painted midnight blue sits next to us. Stars and moons are scattered across it as if it were the night sky itself, but the door is adorned with a golden sun. Its rays stretch out like welcoming arms inviting me to step closer. Sitting inside is a woman with black eyes and gold hoops in her ears. She holds up a deck of tarot cards, smiling at me. Granny's face lights up and she nudges me towards the woman's table. She knows this art of card reading well. The woman turns the cards towards us, and there it is: The Wheel of Fortune.

The card is intricate; a wheel encircled by symbols of the elements, celestial bodies and mythical creatures. At its centre, golden spokes radiate outward like sunbeams. The wheel seems to be turning before my eyes.

Granny leans in close and whispers, *This is your card.* Her voice is filled with certainty and pride. I hold that tarot card for what

feels like an age, folding it over and over in my hand, making the wheel turn, until finally, I return it to the clairvoyant woman. In that moment, the nine-year-old me feels the stretch of my journey – every turn, every struggle, every triumph. I know then that, somehow, through the turning, I will find my place.

There, in the heart of Appleby Fair, surrounded by a world that seems of another time, I feel a sense of belonging and connection to something bigger than myself. The fair is a living, breathing thing and as the music echoes through the fields into the gathering night, I know this memory will stay with me forever. And it has.

I have often wondered where this deep, unrelenting desire to create came from. Painting is not just what I do; it's as vital to me as breathing. From those early years, when I first picked up a pencil to draw my lost mother's face, art has been my sanctuary – a place to find solace and meditate, to explore, to grieve and heal. I realise, in returning to my old life, that art was always around me, always with me. Art was in the patterns of mould that decorated my empty bedroom in the slums. It was there in the still lifes of dried-up tadpoles. In the stained glass of the children's home. In Granny's mystical tarot cards. Even in the scrapyard, among the twisted and discarded remnants of other people's lives, art somehow grew, defiant and alive.

Art is a language and lifeline rooting me in the present as I process the past, layer by layer, stroke by stroke, making intelligible the chaos of experience and shaping meaning from all I have lived. It is through this process that I have come to understand the enormity

of creation, the act of making something new. Painting transcends thought; it is instinctive. In making, I feel connected to something greater, as though channelling something from beyond. My work often reveals truths I didn't know I was carrying, didn't know existed.

Sometimes, as I watch my son's bold strokes of crayon and hear his songs fill our home with light, I can see my own journey clearly: the child I once was, the artist I became and the father I am now. I see what I couldn't as a child: my adoptive family was growing alongside me. Together, we stumbled, adapted and became. Love, like art, is a process of discovery: imperfect and ever-evolving. Ever-changing and ever-becoming.

Resources

Below is a list of different charities that I have used or could have used at some time in my life.

Glasgow City Mission: www.glasgowcitymission.com

Alcoholics Anonymous: www.alcoholics-anonymous.org.uk

Scottish Women's Aid: womensaid.scot

LGBT Youth Scotland: www.lgbtyouth.org.uk

Suicide Prevention UK: www.spuk.org.uk

Stonewall: www.stonewall.org.uk

Adoption UK: www.adoptionuk.org

Equality Network: www.equality-network.org/

Acknowledgements

I extend my heartfelt gratitude to my publisher and editor, Romilly Morgan. Throughout the editing process, Romilly not only delved into the intricacies of my story but also became an integral part of it, and a mirror of myself. Your unwavering support and profound understanding of the significance of this narrative are deeply appreciated.

A big thank you goes out to my agent, Sophie Lambert, who has been by my side from the very beginning. Sophie's guidance has empowered me to show, not just tell, this story.

I am immensely grateful to everyone at Brazen Books and Octopus from the legal team to marketing for their meticulous and seamless work in bringing this book to fruition.

To Andrew O'Hagan, your belief in my writing and your trust in my story, leading to the guidance of incredible agents, holds a special place in my heart. Thank you for your kind words.

My sincerest appreciation goes to photographer Nick Hedges for generously allowing me to use his incredible photograph and to Mel Four for crafting the beautiful cover art that graces this book.

I offer a special thanks to Alice Hoskins at C&W for her unwavering support, and to Pauline Bache at Brazen, who consistently answered my calls and emails, even during late hours, proving to be a diamond in the publishing world.

My heartfelt thanks go to Grace Jones. A huge influence in my

life, a constant source of divine inspiration and a wonderful friend to my family. I am truly thankful for the lyrics you allowed me to use at the start of this story.

Sophie Fiennes, your love and support for my writing have been a fundamental source of inspiration, and I am truly grateful.

To the remarkable artist, Tracey Emin, I am forever grateful for the words in your first book *Strangeland*, which ignited the courage within me to pen my own truth.

Leigh De Oliveira, thank you for your innovative approaches to writing, which greatly inspired me.

To my incredible dad, who has loved me unconditionally and been my biggest cheerleader, I extend my deepest love and gratitude.

A massive thanks goes to my beautiful sisters and brother for sharing this rollercoaster of a life with me and for enduring my endless questions and pestering throughout the writing process. Sylvia, your strength and love have been an incredible source of inspiration, and for that I am profoundly thankful.

I owe a debt of gratitude to my amazing partner, David, who provided steadfast support as I burned the midnight oil, reliving this story time and again. Your ability to wipe away my tears and share in the laughter during our discussions meant the world to me.

Lastly, I want to express my love and appreciation to our son, Kayde Hero, who has been the shining light in my heart. Your presence has been my greatest inspiration and joy.

Special thanks to all my friends who have supported me. David Tinto, Elaine Hutchison, Stephen Thompson, Steven McCaw,

Krissy Mobley, Paul Rodgers, Douglas Stuart, Damian Barr, David MacNicol, Howard Trigg, Dr Vincent Wong, Peter Howson, Marcus Leatherdale, Joey Arias, Max Pugh, Anna, Sylvia, Helen, Paulo Goude, Debi Mazar, Paul Stewart, Angela Stewart, Evelyn Mcammont, Melanie Cantor, Einar Örn Benediktsson, Grace Jones, Norma Landels McKay, Pauline Vance, Björk Guðmundsdóttir, Davy Stewart, Raphael Santin, Fiona McPherson, Pierre Commoy, Ian Pattison, Jennifer Trigg, Patrick Gale and Peter Malham.

About the Author

Juano Diaz is an internationally acclaimed artist and collaborates with many others including Pierre et Giles and Grace Jones. His work has been exhibited in galleries across the world including at the Museum of Modern Art in New York. Juano lives in Wiltshire with his partner David and their son.

This **brazen** book was created by

Publisher: Romilly Morgan

Junior Commissioning Editor: Jane Link

Senior Editor: Pauline Bache

Copyeditor: Alison Tulett

Design Director: Mel Four

Typesetter: Jouve

Senior Production Manager: Katherine Hockley

Sales: Lucy Helliwell, Marianne Laidlaw and
Dominic Smith

Publicity & Marketing: Matthew Grindon, Karen Baker
and Charlotte Sanders

Legal: Maddie Mogford and Samantha Thompson